BEYOND THE VISIBLE TERRAIN THE ART OF ED MELL

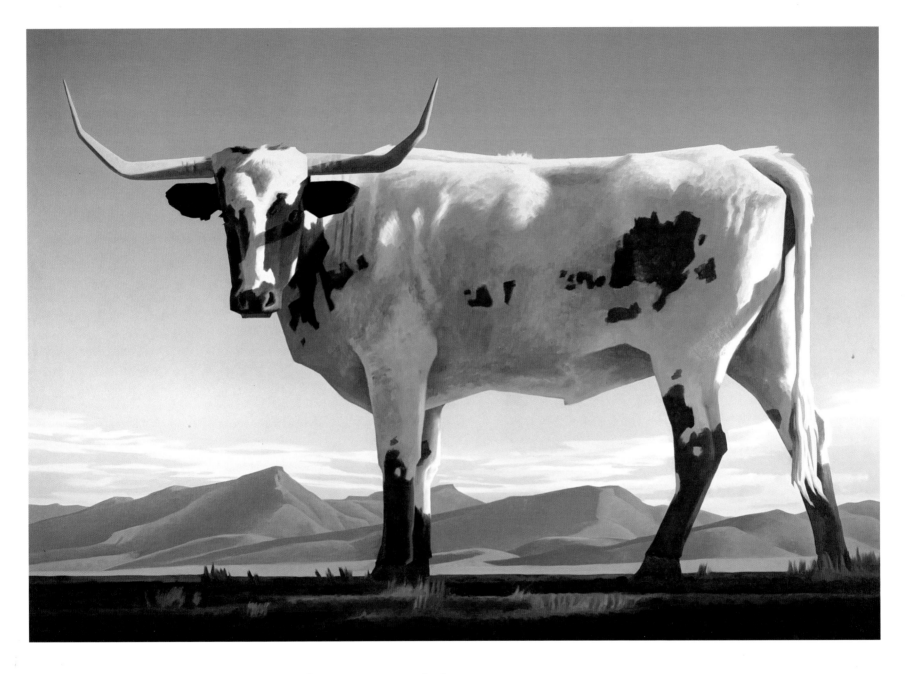

by Donald J. Hagerty

Northland Publishing

The text type was set in Shannon Book
The display type was set in Shannon Bold
Composed in the United States of America
Designed by Sullivan Scully Design Group
Edited by Erin Murphy
Production Supervised by Lisa Brownfield

Frontispiece: Southern Arizona Longhorn, *oil on canvas, 50 in. x 72 in., 1992. Collection of Winston Lauder.*

For information about acquiring art by Ed Mell,
contact Suzanne Brown Galleries
7160 East Main Street
Scottsdale, Arizona 85251
(602) 945-8475,
or Owings-Dewey Fine Art
76 East San Francisco Street
Santa Fe, New Mexico 87501
(505) 982-6244.

Every attempt has been made to include appropriate ownership credits for the paintings pictured in this book. If you have any information that has been omitted, listed incorrectly, or that has changed since the date of the first printing, please contact the publisher at P.O. Box 1389, Flagstaff, Arizona 86002-1389.

FIRST IMPRESSION 1996
ISBN 0-87358-651-4 (cloth)
ISBN 0-87358-660-3 (limited edition)

Library of Congress Catalog Card Number 96-12999

Library of Congress Cataloging-in-Publication Data
Hagerty, Donald J.
 Beyond the visible terrain : the art of Ed Mell / by Donald J. Hagerty.
 p. cm.
 Includes bibliographical references and index.
 ISBN 0-87358-651-4 (hardcover). — ISBN 0-87358-660-3 (limited)
 1. Mell, Ed—Criticism and interpretation. I. Title.
 N6537.M43H34 1996
 709'.2—dc20 96-12999

Manufactured in Hong Kong by South Sea International Press Ltd.

0588/10M/300 ltd./9-96

For Lee Carlton Mell (1949–1995)

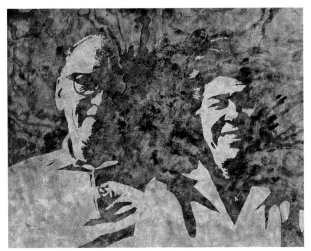

Untitled acrylic on board, 15 1/2 in. x 20 in., 1972, by Lee Mell.

contents

acknowledgments

Numerous individuals have a hand in the formation of this book, and I am indebted to the following people for their invaluable assistance. They are partners in the creation of this publication.

Ed Mell assisted with the selection of his paintings and sculpture, and with quiet patience and humor responded to endless questions about his art and life. His parents, Edmund and Gertrude Mell, were delightful subjects for inquiries about their son's early life. My thanks also go to Gail Petersen, who provided information on her husband's start as a painter, as did his brother, Frank Sargent Mell.

Suzanne Brown and Linda Corderman of Suzanne Brown Galleries offered perceptions from their long relationship with Mell, as did Ray Dewey and Nat Owings of Dewey Galleries and Owings-Dewey Fine Art in Santa Fe. Bill Schenck and Bob Boze Bell, both artists, are important resources for insights about the formation and growth of Mell's art. Schenck is best known for his images of the contemporary American West, subjects such as figures of cowboys, cowgirls, trucks, and Cadillac automobiles done in a flat, simplified manner with the colors of pop art. Bell has gained fame with his books on Billy the Kid, Wyatt Earp, and Doc Holliday, meticulously researched and illustrated with his own art. Troy Irvine and Jon Cordalis were eager and helpful with information on Mell's New York period and his work on the Hopi Reservation. Vernon Masayesva provided thoughtful background on the formation and operation of the Hotevilla-Bacavi Community School, and on Mell's contributions.

Whenever I visited Phoenix to gather material for the book, Michael Collier and Patti Valdez ensured through their generous hospitality that my stay there was productive. Collier has created the handmade, hand-gilded frames for Mell's paintings, works of art in their own right, since the early 1980s. Jerry Foster, now a newscaster and helicopter pilot for NewsChannel 3 in Phoenix, described the various helicopter trips that he took Mell on, and the adventures they had on those excursions. I went on one of those trips in the mid-1980s with Foster and Mell and have forever etched in my memory the grandeur of the Colorado Plateau seen from the air. Royal Norman, meteorologist for NewsChannel 3, produced a television special in 1990 about how Mell created and developed one of his paintings. Norman's observations about the helicopter trip he and Mell took to northern Arizona's Coal Mine Canyon, and the results of the project, were most helpful.

David Jenney, the publisher of Northland Publishing, deserves full credit for the concept of this book. Both he and Erin Murphy, my editor, were enthusiastic and always supportive throughout the process of the book's creation.

Finally, I extend warm thanks to my wife, Rebecka, and to Kristina and James, for their support, patience, and encouragement.

—*Donald J. Hagerty*

First I would like to thank my parents for giving me the support and love that one would expect from the best of parents, but especially for recognizing and encouraging the creative leanings of my brothers and me.

Further thanks to the following:

My older brother, Frank, who first inspired me to draw. My younger brother, Lee, with whom I shared the visual dream. Taylor and Carson for being the sons a father like me could live and laugh with. Gail Petersen for her help, understanding, and support over many years.

Don Hagerty for his confidence in my work from the beginning, and for putting my story into words. Jon Cordalis for reintroducing me to the Colorado Plateau. Jerry Foster for giving me new perspective on the landscape.

Robert Bonfiglio and Claire Hoffman for recruiting me to create paintings for the Grand Canyon Chamber Music Festival. Suzanne Brown and her associates, Linda Corderman, Bill Lykins, and Randy Jones, for services above and beyond the call of duty, including their help on this book. Ray and Judy Dewey and Nat Owings for enlarging the reach of my work. The D'Ambrosi family and Arizona Bronze for bringing my work to a new dimension.

Dave Jenney for his early support and continued enthusiasm during the course of this project. Erin Murphy for her keen insights while editing this manuscript.

Thanks also to the following, for the help and insights that only friends can give: Bob Boze Bell, Michael Collier, Marc D'Ambrosi, Kent Usry, Dan O'Neill, John Kleber, Jim Cherry, Kevin Irvin, Troy Irvine, Bill Schenck, Royal Norman, Robert Knight, Debra Hopkins, John Douglas, Kenny Richardson, Bob Steinhilber, John Mardian, Nancy Wagner, Tom Gerczynski, Kari Schad, Kat Von Rhau, and Mike Campbell.

Special thanks to Lee Ann Brotherton for her concern and support.

I would also like to express my gratitude to the many other friends and collectors who have enhanced my life and career.

—Ed Mell

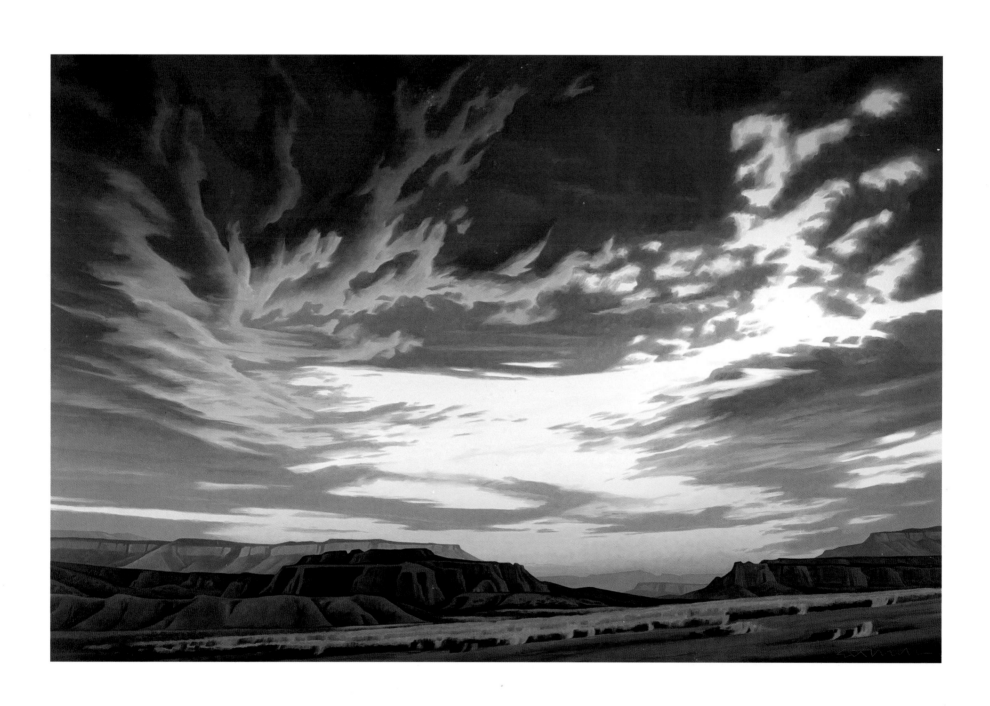

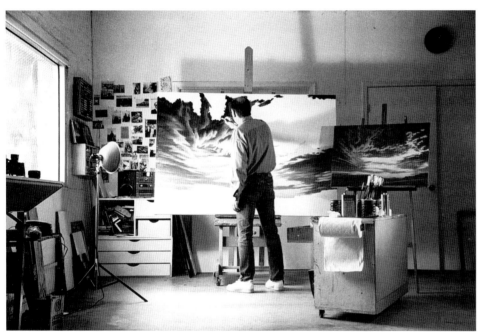

Ed Mell in his studio, 1996. (Photograph by Jim Cherry.)

Opposite: Sky Fires, Hosta Butte, *oil on canvas, 48 in. x 72 in., 1996. Private collection.*

The studio sits in an older residential section of central Phoenix, a few blocks from North High School and the Good Samaritan Regional Medical Center. Once a grocery store, the yellow-painted brick building with a metal roof, perforated by a few windows and guarded by several large cactuses, gives no hint of its contents.

The studio inside is filled with paint cans, easels, brushes, books, posters, Navajo rugs, photographs, cowboy memorabilia, back issues of *Arizona Highways,* a chrome-and-vinyl l940s sofa, clay models of potential sculptures, and other idiosyncratic lifetime acquisitions. The room seems alive with light, color, and grandeur, not from the persistent Arizona sun that probes through window openings, but from the shimmering skies and landscape vistas of the American Southwest found on the canvases around the room.

Landscape paintings lie scattered on the floor or perched on the walls, some small studies, others large finished pieces. All of them reflect the feel of vast space, and their titles reveal magic places. Embedded on canvas, watercourses meander as curves toward the skyline, buttes and mesas lie jumbled about the terrain, and rock spires reach skyward, erect like galleons in a fleet, prepared to skirt slopes and sail over the horizon. Clouds arch and billow over the land, their definable shadows a counterpoint to the landscape. Like the topography, the clouds seem constructed by ancient gods, their shapes companions to the landforms below. It is an art that fills the room with intense presence. The smell of paint permeates the studio, but the smell of the land is there, too. Among the landscapes are other subjects, perhaps an Arizona longhorn, a night-blooming cactus, or a rose. They are images enhanced with graphic design, painted with economy, and awash in light and color. The signature on the paintings is almost abstract and looks much like an Anasazi symbol chiseled on rock. *Ed Mell,* the signature reads.

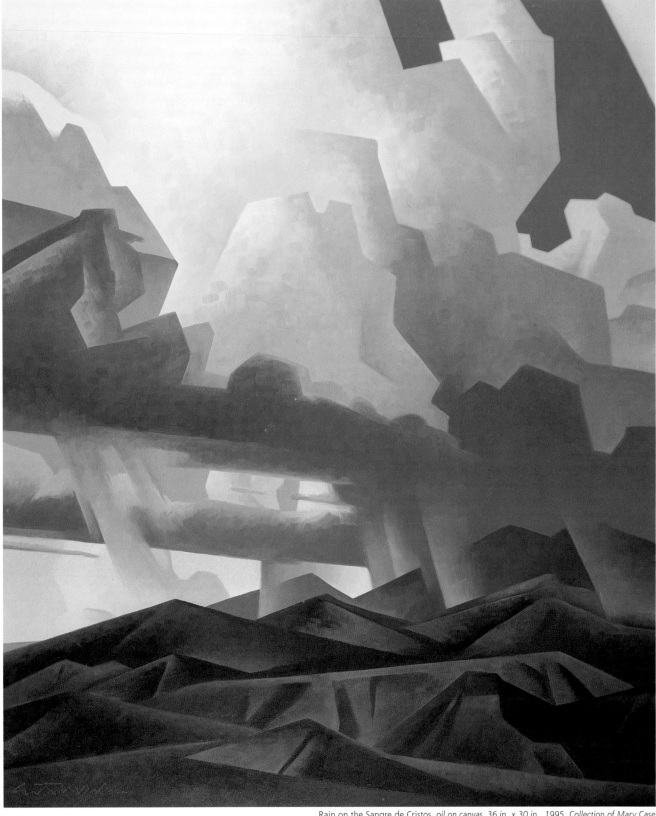

Rain on the Sangre de Cristos, oil on canvas, 36 in. x 30 in., 1995. Collection of Mary Case.

Mell himself stands before an unfinished work, brush in hand. In his early fifties, although he appears younger, Mell has a slight and wiry frame, thinning close-cropped hair, and a wistful smile. He greets visitors with dry humor and a soft, husky laugh. There is an impression of shyness as he chooses words carefully. As usual, he is dressed in his trademark style—jeans, a conservative shirt, and tennis shoes or cowboy boots. Friendly, steady, somewhat reserved brown eyes gaze forth from behind rimmed glasses. From time to time his eyes lift, as if searching for the placement of buttes or mesas against the horizon line. No flair surrounds him; no struggle with larger-than-life ego. He is an easygoing individual, anchored by workmanlike habits distilled from nearly twenty years of practice in the studio. However, out of that gracious veneer and almost boyish excitement, pride emerges as he describes the painting on his easel.

Born in Phoenix, Arizona, Mell has roots that reach deep into the region. His mother came to Arizona in 1915; his father came in 1924. After graduation from North High School and two years at Phoenix Junior College, his passion for drawing anything mechanical led him to major in advertising and design at the Art Center College of Design in Los Angeles. When he graduated from there in 1967, he migrated to New York, where he became an art director at a large advertising agency. Two years later, he started his own operation, Sagebrush Studios. By this time, Mell's airbrush illustration techniques, and particularly his use of angular forms inspired by art deco and 1930s and 1940s cartoons, had brought national recognition. His work appeared on covers of *National Lampoon, Esquire,* and *Psychology Today,* and in advertisements for Air France, Helena Rubinstein, Tang, Fabergé, and other national accounts.

Mell, however, missed the Southwest's open spaces. Restless, burned out by New York's frenetic pace, he spent the summer of 1971 on the Hopi Reservation, teaching art to children and adults at the Hotevilla-Bacavi Community School. Images of melodramatic skies, vast horizons, and a Hopi spiritual world danced in his mind. Should he pursue his profitable career in New York or was there something else? Two years later he was back in Phoenix as a freelance illustrator. Whenever time allowed, he painted landscapes. By 1978, he had made the transition to full-time landscape artist.

In recent years, Mell has added other images—longhorn cattle, square-jawed cowboys, and, in particular, flowers—to his portfolio. Eager to experiment with other mediums, he started to produce sculpture in the mid-1980s. One of his bronzes, *Jack Knife,* a cowboy on a bucking bronco, eventually was selected and cast as an eight-foot-tall public sculpture for the intersection of Marshall Way and Main Street in Scottsdale, Arizona. Limited-edition lithographs, and especially striking posters, done for such events as the annual Grand Canyon Chamber Music Festival, have given him increased exposure to a national and international audience.

Drifting Clouds, Navajo Desert, *oil on canvas, 30 in. x 50 in., 1993. Private collection.*

Summer Light, Painted Desert, *oil on canvas,*
44 in. x 72 in., 1992. Private collection.

Mell's landscape work in the late 1970s and through the early 1980s was hard-edged and geometric, influenced by his commercial art background. These paintings were defined by bare-bones images honed to flat planes or structural forms by the use of straight lines. Details were swept away and less became more in Mell's personal vision, a theme that still runs through both his realistic and his abstract paintings. Over time, he establishes rules for his art, but often becomes restless, and, afraid of stagnation, breaks them to push his work to the edge of personal vision.

By the early 1990s, Mell's landscapes softened and became more intuitive, as he moved between abstract and realistic images. The artist Paul Klee felt that painting is not the replication of reality, painting is the invention of reality. Mell's interest in painting nature seems fueled by his own inventive kinship with the plateau's unique landscapes. For over two decades now, he has merged visions of the land and a distinctive art through perceptive observation of the Southwest's outback, the "out there." The result has been an almost metaphysical sense of place in his painting, an alliance of land, light, and sky.

No Vibram-soled wilderness hiker, Mell has often found inspiration for his images from the seats of helicopters. For a number of years in the 1980s he hitched rides to remote places on the Colorado Plateau with television newscaster and helicopter pilot Jerry Foster. The best way to view this country is to fly over or perch on wind-swept tops of solitary buttes, for hovering several hundred feet above the terrain reveals a different visual world. The helicopter showed Mell a vertical scale and a horizon-to-horizon cinematic perspective that no earthbound traveler could see. These aerial voyages shaped memories that continue to find their way into his paintings.

From the top of the San Francisco Peaks to the bottom of Marble Canyon, Mell has carved out the Colorado Plateau as his own. That intricate network of mesas and canyons, both horizontal and vertical spaces, requires time for comprehension. It is a lithic place, with radiant colors, mostly multihued reds,

Rosa Caliente, *oil on canvas, 36 in. x 48 in., 1992.*
Collection of Philip and Becky Smith.

imbedded in ancient sandstone rock. This landscape seems planned, marked by buttes, mesas, pin-nacles, soaring monuments, and natural arches, like masterpieces of Gothic architecture. For Mell, they are cities of stone. Above is the vault of blue sky, at times quiet and empty, at others full of motion as white clouds drift slowly across the landscape, their shapes casting pockets of light and shadow upon the earth. Sometimes they are dark with the promise of violence and piled high with receding levels like great Chinese pagodas.

Ed Mell has been to the places on this land, and he knows their names: White Mesa, Ward Terrace, Moenkopi Plateau, Royal Arch, Coal Mine Canyon, Navajo Mountain, Vermilion Cliffs, Little Colorado River Gorge, Cummings Mesa, Rainbow Plateau, Monument Valley, and the countless canyons tributary to Lake Powell. He sees the country with a rush, is inspired by its beauty, and responds with his art.

The painting response arrives in two ways for Mell. One is an expressive realism, a dialogue between color and paint, form and design, almost a visual conversation between the artist and the landscape. First and foremost, he wants to bring emotion to a painting. Mell presents a natural world, yet one that seems a paradise, with selective fragments of sky, clouds, light, and land that seem in synchrony. His goal is that viewers imagine both the reality and the mystery of landscapes through his art. What Mell sees out on the plateau he translates into paintings. Windows, he calls them, canvases that open onto the eternal spaces of the West.

The other approach to the landscape uses abstraction, with lines and planes suggestive of landforms and clouds. An abstract painting usually begins with a line as a basic reference on the canvas. There is no attempt to make a design, no photographs as guides, just the glimmer of an idea. He uses some rules and lets go of others. To him, it is painting on the edge, as the work dictates where it goes. He never knows how it might turn out. Sometimes he even feels it may be a failure until finished. While his realistic landscapes are quiet and harmonious, the abstract ones are full of restless energy, broken shapes, refractive light, and sometimes violence, as a lightning storm confronts the earth. These abstract paintings are his most inner reflections created and made visible upon canvas, a process in which thoughts about the painting are translated into imagined places.

Mell began to paint flowers—cactuses, petunias, roses, and others—in 1988, to keep his landscape work fresh. Because of their magnified scale and clarity, the flower paintings seem endowed with panoramic space beyond the frame. In fact, the term *flowerscapes* may be appropriate for these images that capture not only the transparent tissue and texture of the blossoms, but bestow them with the attributes of landscapes. Like Georgia O'Keeffe's flower paintings, Mell's flower images require time to look at them, to see color, shape, and texture beyond the ordinary. His flower paintings, with their intensified color and sensuous contours, have, in turn, influenced and enhanced his landscape painting. Flowers, like the plateau's landscapes, have become Mell's own private visual garden.

Like other perceptive interpreters of the western landscape, such as Maynard Dixon and Ansel Adams, Mell creates art as a vehicle, a way to explain what he sees, and not only what he sees on the surface, but a world beyond the visible terrain. Many artists have looked at the Colorado Plateau, but few have seen. Count Ed Mell among those who have seen. Mell understands the meanings of the names on the land, for he has ventured among them through his art. That line he puts on a canvas to start a painting is never finished.

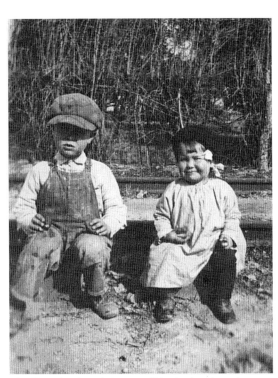

Ed Mell's mother, Gertrude Sargent, with her brother, Maynard, Mesa, Arizona, 1916.

Opposite: Edmund Mell Sr. (the artist's father) and brother Gordon, Papago Park, 1925.

Phoenix in the war year of 1942 was a farm town on its way to becoming a modern metropolis. Located in the Salt River Valley, the city had encountered rapid change as the result of World War II. Because of excellent year-round weather, seven army flying schools, one of them the largest in the world, had been established in the Valley. An influx of military and civilian personnel flooded Phoenix and nearby Mesa, boosting the area's population to above 150,000.

It was here that Edmund Paul Mell Jr. was born on September 17, 1942, the second son of Edmund and Gertrude Mell. Their first son, Frank, had been born in 1938. A third son, Lee, followed in 1949. In time, all three sons would become professional artists.

The Mells have been longtime residents of Arizona. Gertrude arrived in 1915 from Kansas, while still an infant, to live on a ranch her father had purchased near Mesa. Her mother died when Gertrude was two years old, and her father, unable to care for her, sent her back to live with an aunt and uncle in Kansas. When Gertrude's father remarried in 1918, she returned to live with him and her brother and stepmother. Gertrude attended Alma School in Mesa, then went on to graduate from Mesa High School and Arizona State Teachers College at Tempe (now Arizona State University).

Edmund Sr. arrived in Phoenix on a train from Minneapolis on September 19, 1924, at the age of twelve, and immediately fell in love with Arizona. His father, who had contracted tuberculosis, brought the family to the state in an attempt to restore his health. Phoenix was wonderful then, Edmund Sr. recalls. Although city streetcars ran only two blocks from their house, he and a brother would ride their horses to Madison School on Sixteenth Street, a long ride from where they lived. Their teachers would recoil from the two boys, since they usually arrived in clothes soaked with horse sweat. Edmund Sr. went on to attend Phoenix Junior College, then Arizona State University in Tempe, where he majored in journalism. Afterwards, he went to work as the editor of a trade publication for Arizona's liquor industry.

Edmund Sr. and Gertrude met in the mid-1930s and were married in 1937. Edmund Sr. was drafted by the army in 1944, when his second son was only eighteen months old. He served with the

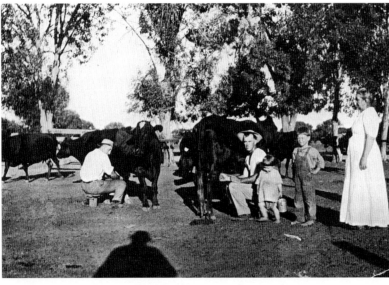

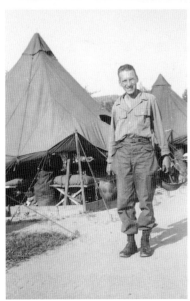

Fifth Army in Italy and was finally discharged from the service in 1946. During the late 1940s and through the 1950s, the Mell family lived on Phoenix's Yale Street. To escape the hot summers, they would spend several weeks at their grandparents' house in Prescott. Mell's grandfather, Frank Mell, who was the treasurer for the old Arizona Power Company, had built a stone cabin there in 1931. From Prescott, the family often ventured to Flagstaff, Sedona, the Grand Canyon, the White Mountains, Wickenburg, and other places around the state, geographical influences that seemed to set in Mell's mind early.

Top: Gertrude Sargent as a toddler, third from right, with (from left) a hired man; her father, Frank; her brother, Maynard; and her grandmother, Mary, Mesa, Arizona, 1916.

Bottom: Edmund Mell Sr. in the Fifth Army, stationed in Italy, 1945.

Mell's parents and brother Frank remember him as an innovative, curious child who would always bring home something to tear apart and work on. He made his first sculpture when he was about seven years old. Frank, young Ed, and another friend would search for the best clay formed in an irrigation ditch that ran down the alley behind the Mell house. They would collect the

The boys' interest in art seems to have been born in them. They started drawing as soon as they were able to hold a pencil or crayon. —*Gertude Mell*

mud to form into sculptures. Mell created one piece in their "school of art," a lumpy ashtray about four inches wide, painted in chartreuse, with a black zig-zag stripe around the edges. He gave it to his father, who took it to his office and proudly placed it on his desk. One of Edmund Sr.'s friends in the liquor business dropped by on a regular basis, and he would always comment, "That ashtray is enough to make a guy quit smoking."

Mell's grandparents gave the boys stacks of paper and colored pencils, and his parents supplied them with crayons and used press releases from the liquor magazine. A major influence on Mell's early creative growth was his brother Frank, who drew incessantly, particularly drawings of World War II combat aircraft and soldiers in trenches. The boys kept their crayons in a cigar box and used them until they were stubs.

When Mell attended grade school, he developed an affinity for plastic and wood model cars. He customized them with an X-Acto knife, cutting off doors and rearranging hoods and fenders. A local hobby shop awarded trophies for the best models, and Mell won his share of them. In the late 1950s, when he was a teenager, Mell was attracted by General Motors automobiles, especially their "dream cars." He studied General Motors annual reports, with their announcements of forthcoming automobiles, to the point that he could make drawings of what he thought future designs might look like.

Edmund Sr. remembers that his son avidly watched television for announcements of new car designs. Once, Pontiac or Chevrolet showed new models on television, using attractive, scantily clad women to set off the vehicles. Mell complained to his father, "I wish those girls would get out of the way so I can see the cars." Even now, Mell can look at some of his paintings and see that streamlined form prevalent in late 1950s and early 1960s automobiles. When Mell's parents bought him a 1931 Ford Model A, and then a 1954 two-door, hardtop Buick, his love of cars soared.

His interest in automobile design began to lead him into art, although by his own admission he was a mediocre student in high school. He did, however, paint pictures of friends' cars while there, and once sold a painting of a 1957 Chevrolet for seven dollars. After graduation from North High School, Mell attended Phoenix Junior College, where he took art classes. Upon graduation from there in 1963, he seriously considered a career in advertising or illustration design, but was unsure how to proceed.

A friend, Mel Abert, had decided to attend the Art Center College of Design in Los Angeles. One day he brought some of his class work over to show Mell. Mell thought that he and Abert had equal ability at that time, but discovered that after one semester at the Art Center, Abert was "ten times better than me."

"A light went off in my head," Mell recalls. His father and mother remember asking him, "Do you want to go? We'll pay for it." Mell certainly did, with that incentive, and eagerly started to work on

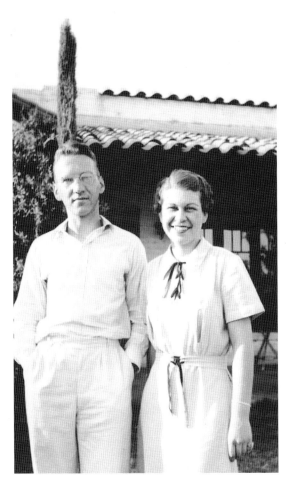

Edmund Mell Sr. and Gertrude Sargent Mell, Phoenix, 1936.

He drew cars beautifully, but I wondered how he was going to make a living. —*Edmund Mell Sr.*

the portfolio needed as a part of the entrance requirements. He worked on it for a month in a space created for him in the family garage. Finally, he received word of acceptance from the Art Center and left for Los Angeles in the fall of 1963. Before he arrived, Mell decided to select illustration and advertising for his major.

Mell credits the four years spent at Art Center as formative ones in his career. Exposure to teachers who were noted professionals in their field, along with students who had the same interests as he, fascinated him. The school's curriculum emphasized the basics of composition and drawing, besides the pragmatism of layout and design. Students attended one class a day, from early morning to late afternoon, and learned the value of discipline from the heavy workload. Frank Mell saw what his younger brother had accomplished after one semester at Art Center and decided that he too would attend. About six months after Ed started, Frank arrived to join his brother and a select group of aspiring illustrators, many of whom have since become noted artists. The two Mells and their roommate, Nick Gaetano, lived in a boarding house near Third Street and Highland Avenue.

Commercial art teaches you techniques. It is always something I will be grateful for, that and the discipline. In commercial art school, skill is stressed as much as imagination. You needed to do things right. Students were taught to approach art that way so that somewhere in the future, when they discover their imagination is the most important thing, they will always have the discipline and the skill to draw upon. —*Ed Mell*

"We were always on the dangerous edge of getting thrown out of Art Center," says Frank, "for such infractions as not having our shirts tucked into our pants, not having regular haircuts, and for having too much facial hair. All of us, including Ed, were influenced by the Beatles, Bob Dylan, the Byrds, and Jefferson Airplane. Squares, we weren't. I was older than the rest of the guys, and it was scary being a mature person dealing with artistic geniuses who were socially immature."

In late spring of 1965, after Mell had spent three semesters at Art Center, Gaetano advised him to submit his portfolio to the New York advertising company Young and Rubicam, then the hottest agency in the country. Young and Rubicam offered a summer intern program, which employed two individuals to work with the company's professional staff: one in photography, the other in the art department. Usually, Young and Rubicam filled their intern slots with applicants from the East Coast, but Mell was selected for the position in the art department. He considers his summer at Young and Rubicam a great experience, a place where, he says, "I learned to stand up to my artistic convictions."

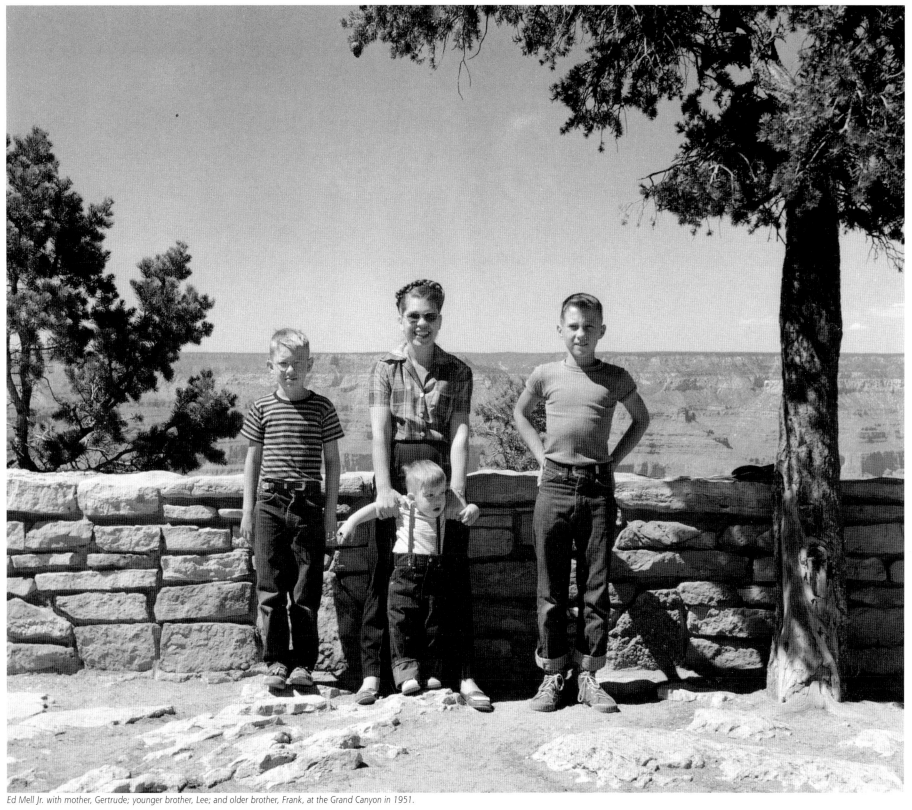

Ed Mell Jr. with mother, Gertrude; younger brother, Lee; and older brother, Frank, at the Grand Canyon in 1951.

Upon graduation from Art Center in June 1967, Mell returned to Phoenix for several months. His experience with Young and Rubicam, though, led him to pursue jobs in New York. Frank, who graduated from Art Center with his brother, had moved there in September, and was employed as an illustrator by an advertising agency. In addition, a friend, Troy Irvine, then a writer for the *Arizona Republic*, wanted to work there. Soon Mell secured a position as a junior art director with Kenyon and Eckhardt, a major advertising firm.

In November 1967, Mell moved to New York. He lived with his brother in Brooklyn for three months, then found an apartment with Irvine not far from Lincoln Center. The apartment faced out on the Hudson River, with its bustling port, and midtown Manhattan. Among other residents in the apartment complex were jazz musician Thelonious Monk, actor Robby Benson, and several soap opera stars. Mell and Irvine furnished their apartment with antiques and furniture obtained at swap meets in New Jersey. There was a small alcove in the apartment, where Mell painted a landscape on one wall, then decorated the space with sheepskin rugs to serve as a mini-guest room.

Their apartment became known as the "Southwest connection" for friends from Phoenix who lived in New York. Once the roommates hosted a Phoenix party and over thirty people showed up. They hired a mariachi band from the Upper East Side that prompted one guest to start singing operatic arias in Spanish. Mell recalls one guest who attended—Corrinne Calvert, an actress who appeared in movies during the 1940s and 1950s. Irvine had met Calvert through his work and invited her to the party.

Besides their frequent parties, Mell's and Irvine's lives revolved around the vibrant New York music scene. They attended numerous concerts—Jimi Hendrix, the Rolling Stones, The Who, Ike and Tina Turner, and other icons of 1960s rock and roll. Mell, influenced by this cultural environment, let his hair grow down to his shoulders.

For Mell, New York's commercial art world was a high-energy challenge. This was the "big time," and if you were successful, as Mell became, it gave you enormous self-confidence and pride. Among Mell's accounts at Kenyon and Eckhardt were Helena Rubinstein and Air France. His layouts for Air France's *Après Ski Guide*, for example, were among some of the agency's most noted images.

After ten months, however, Mell discovered the advertising industry culture stifled him. One day he called a friend, Skip Andrews, who was working in Los Angeles at the time. Mell had been pondering a move to Los Angeles, but Andrews told him there were no prospects for work, and, in fact,

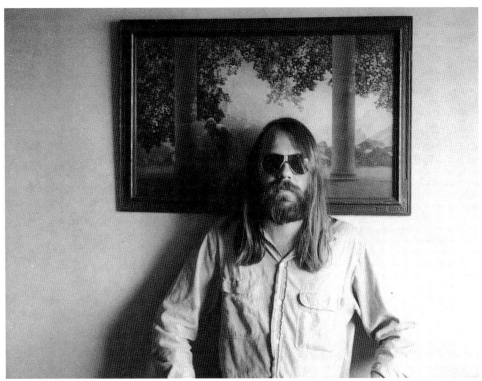

Ed Mell, New York City, 1971.

he himself was planning a relocation to New York. When Andrews arrived in 1969, he and Mell surveyed the options, and after lengthy deliberation they decided to establish their own illustration studio. They called it Sagebrush Studios.

Sagebrush Studios became an immediate success, particularly through Mell's and Andrews's mastery of airbrush illustration. They were among the few artists in New York to use that medium at the time. Mell also became noted throughout the United States for his cartoons, taken from the clean, angular lines of art deco and from 1930s and 1940s cartoon images. In fact, he helped lead a revival of the graphic images from the 1930s in New York's commercial art scene. The older art directors resisted the idea at first, since many of them recalled the Depression years. Eventually they came around, and Sagebrush Studios poured out editorial illustrations, album covers, and cartoons for various advertising agencies.

Mell's work appeared on the covers of *Esquire, Psychology Today,* and that whacked-out comedy magazine, *National Lampoon.* One image that gained national media attention was Mell and Andrews's interpretation of Porky Pig for *Life.* Another time Mell was hired to illustrate a cover for an early *National Lampoon* issue. He recalls that the image they did was "Minnie Mouse, baring her breasts, with flower pasties."

"Walt Disney Studios sued *National Lampoon* for ten thousand dollars," he says, "and I read years later that the amount of publicity they got from that cover saved the magazine. They lost the suit, but it was money well spent."

Other Mell creations found their way to such corporate accounts as TWA, Cheerios, Tang, RCA, Fabergé, Welch's, and numerous other well-known names.

Between his illustration assignments, Mell visited New York's famous museums and pursued the city's flourishing art scene in numerous galleries. In particular, he searched for and studied art deco examples in architecture and paintings, attracted by their simplicity and refinement of form. He brought those designs to his commercial art, eliminating complex details in his images to discover their basic components. Mell spent considerable time at the Museum of Modern Art and the Whitney

Museum of American Art, where he would wander among the paintings done by early twentieth century American modernists, studying how various painters used cubism and abstraction, and the ways they handled light, color, and shadow.

By 1971, Mell began to struggle with his fast-paced New York life. He was burned out from the daily confrontations with art directors who tried to dictate what he should produce. His airbrush illustrations, he now sensed, were sterile and tedious. The energy of the Big Apple, so exciting at first, increasingly seemed forced and burdensome. Furthermore, Mell felt confined by New York's gray vertical world and missed the light, colors, and open spaces of the Southwest.

"The East and the West are yin and yang to me," he explains. "New York was established. The West was frontier, new, fresh."

New York's commercial art world was even more political by then, as advertising agencies started slashing budgets. This invariably led, he knew, to a decline in creativity. Mell could feel his own creative desires thwarted, and he cast around for a new direction.

That direction came in the form of a phone call from Jon Cordalis, a friend from Arizona, with whom Mell had stayed in contact while in New York. Cordalis, a music teacher, musician in several of Phoenix's professional rock-and-roll groups, and recent recipient of a teaching credential, had been invited by Hopi leaders to establish a summer arts program on the Hopi Reservation at Hotevilla. He asked Mell if he would like to participate in the program. With no hesitation, Mell accepted Cordalis's overture, and he departed for Hotevilla in early June 1971.

Left: Dr. Munchies poster, 23 in. x 17 in., 1974.

Below: Playing cards Mell designed for Cudahy Bar-S, 1974.

High Beams, *watercolor, 17 in. x 12 1/2 in., 1971. Artist's collection.*

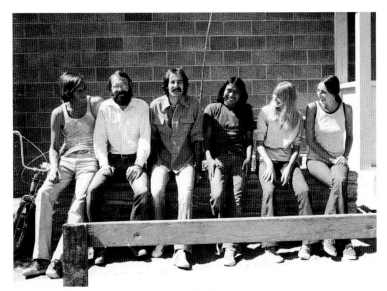

The teachers of the Hotevilla-Bacavi Community School art program, 1971 (left to right): Troy Irvine, Ed Mell, Jon Cordalis, Victor Masayesva Jr., Mary Lane, and Sherre Sutton.

Opposite: Evening Vigil, airbrush gouache and colored pencil, 10 1/2 in. x 18 1/2 in., 1973. Collection of Jon and Rita Cordalis.

Hotevilla is located on Third Mesa, one of the three finger-like extensions on Black Mesa's southern edge. The name means "Skinned Back," taken from Hotevilla Spring, which is situated in a cave so small that its walls would often scrape the backs of people who went there for water. The village was founded in the fall of 1906, when a conservative, anti-government Hopi faction in Oraibi, opposed to Anglo influence and authority, clashed with pro-government Hopi. The two groups proposed a unique Hopi solution to the schism: a massive pushing match. The conservative Hopi lost the contest, abandoned their homes, and left to found Hotevilla, about eight miles northwest of Oraibi across the mesa.

For Mell, the transition from New York's crowded urban canyons of many millions to a small village of several hundred on a remote, windswept mesa was abrupt, but dramatic and spiritual. Jon Cordalis's summer arts program was located at the Hotevilla-Bacavi Community School. He had rounded up artists he knew to work and live on the Hopi Reservation. Besides Mell, Cordalis was joined by Sherre Sutton, an art student at New York's Hunter College; Troy Irvine, who had left New York to work in San Francisco; and Mary Lane and Patsy Lowry, artists from Phoenix. Mell taught silk screen and drawing, Sutton design, Irvine drama and writing, Lane ceramics, Lowry drama and ceramics, and Cordalis music and ceramics.

Vernon Masayesva, the school principal, and later to become Hopi tribal chairman, envisioned that the school would teach fine arts, not only for children, but in night classes for adults. He and Cordalis both felt that through the creation of art, individuals are forced to make decisions, to experiment, and to plan ahead. Exposure to as many art mediums as possible would provide more choices for an educational experience, Cordalis recalls. Under Masayesva's direction, the school had undertaken the process of transformation from a government school to a community school.

"Although we had our problems," Masayesva says, "we were flexible enough to adapt to new circumstances, and always reflected the pride and philosophy of the Hopi people."

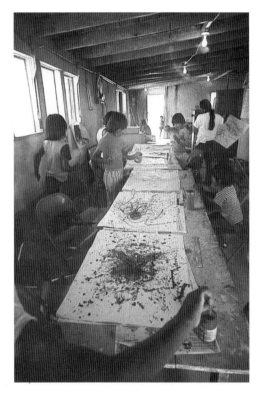

Art class at Hotevilla-Bacavi Community School, 1973.

The Hotevilla-Bacavi Community School was a forerunner in the phenomenon of traditional schools expanding into community schools, Masayesva explains. The Bureau of Indian Affairs frowned on the effort, and, at one point, informed Masayesva that he had used more light bulbs than all the previous principals combined. But Masayesva persevered, convinced that teaching through the use of the arts, to both children and adults, was a powerful educational vehicle.

Mell wanted to use his talent and experiences to accomplish the school's goals. In addition to silk screen and drawing, he taught design and gave periodic demonstrations of airbrush illustration. There were morning classes each day, and two or three classes each week at night for the adults. Mell's ability as an instructor and his skill with silk screen were immediate successes, and the children lined up daily in class with their T-shirts, eager to create new designs.

By summer's end, Mell's influence had spread throughout Hotevilla, and many of the children were adorned in silk-screened T-shirts. At first the adults showed little interest in silk screen, and there were, as Mell remembers, only two women in the first class meeting. One woman, however, made a silk-screened design for her kitchen windows. At class the next week over a dozen women appeared. Among Mell's other contributions were designs for the school emblem and a T-shirt logo for the track team—bear feet with Band-Aids.

Mell and Cordalis and some of their Hopi friends would often ride Honda motorcycles into the desert surrounding the village, to places like Coal Mine Canyon, Oraibi Wash, or Dinnebito Wash, and hike to special Hopi places of historical significance. The art instructors were invited to dances and watermelon feasts, and they became involved with the local rock-and-roll music scene. Cordalis had founded a band, Indians and Cowboys, that included Troy Irvine, who played the spoons, and Victor Masayesva

> **Each day the clouds would roll in over Third Mesa. I called them the "cloud club," and they became, I believe, the "cauldron," or genesis, of Mell's landscape painting.** — *Troy Irvine*

Jr., assistant director of the Hotevilla-Bacavi Community School and Vernon's younger brother, who later became a noted filmmaker. The band played throughout the reservation. Mell was invited once to play guitar with them; however, as he recalls, "They never asked me again."

Late afternoons and early evenings, Mell walked along the mesa's escarpment to view the landscape. The vistas to the south and west made him catch his breath. The land descended in a series of steps to the far horizon. Bands of color—red, blue, bone white, and vermilion—softened by distance, shimmered in the warm air that rose from the land, changing in intensity as sunlight became more slanted. Before him unfolded the Painted Desert, where brilliantly colored landforms lifted to join the sky. Westward, toward the valley of the Little Colorado River, windblown columns of rain would often advance across the earth. The low, broken mesas defined by Dinnebito, Oraibi, and Moenkopi Washes traced a ragged path west and southwest to their junctions along the Little Colorado River. The silence was profound, and perhaps only the raucous croak of a far-off raven penetrated the stillness. Golden eagles sometimes flew by Third Mesa's edge, their silent path traced by fleeting shadows on the land.

I found myself thinking there must be some way I could capture the strength of the landscape on canvas. —*Ed Mell*

"It was," Mell reflects, "one of the most peaceful places on earth."

As Mell made preparations to leave Hotevilla and return to New York at the end of that summer of 1971, he discovered that his time among dramatic landscapes and a spiritual people had prompted serious thought about his future. Late the next year, Mell and Andrews closed Sagebrush Studios, and Mell had the idea of starting an illustration studio with his brother Lee. Instead of joining his brothers at Art Center in Los Angeles, Lee had decided to attend the San Francisco Art Institute, then had remained in San Francisco doing posters for a local rock group. Mell joined Lee in California, but three straight weeks of rain convinced him that San Francisco was not where he wanted to be, and he finally moved back to Phoenix.

When Mell arrived in Phoenix he faced the prospect of few job opportunities in commercial art. Attracted by the cultural and emotional appeal of freelance illustration art, he and Lee, who also moved back to Phoenix, decided to start an illustration business there. In 1973, the Mells rented two small houses next to each other and converted rooms into studios. One structure had two palm trees in the front yard, so they decided to name their business Twin Palms Studios. Besides cartoons and illustration,

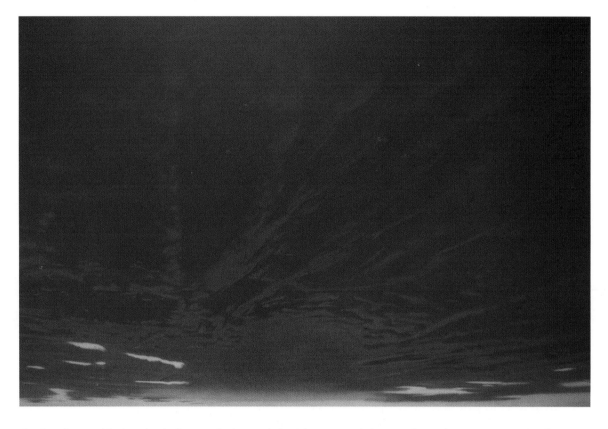

Skyline, acrylic on canvas, 36 in. x 54 in., 1973. Private collection.

the brothers added etched glass to their portfolio of commercial artwork, and were among the first artists in Phoenix to work in that medium. They created etched designs for windows and doorways by sandblasting the glass to different depths. Most of their clients were restaurants, business offices, and interior designers.

The Phoenix market did not support the level of illustration business that Mell had enjoyed in New York, so in 1974, between assignments, he began to make colored pencil sketches of landscapes. For some time he had studied the works of the Taos founders, particularly Ernest Blumenschein and Victor Higgins; early modernists Andrew Dasburg, Raymond Jonson, and Georgia O'Keeffe; architect Frank Lloyd Wright; the Bauhaus movement; pop art; and art deco. However, it was Maynard Dixon who influenced him most, with the purity and vision of Dixon's landscapes, and how he used form and color.

Like Mell, Maynard Dixon (1875–1946) got his start as an illustrator. In the mid-1890s he began doing magazine and newspaper illustrations on Western life, then progressed to books, in an era termed the Golden Age of Illustration. In 1912, Dixon, then considered one of America's fore-

Ed Mell and Bob Boze Bell, 1984.
(Photograph by Ralph Rippe.)

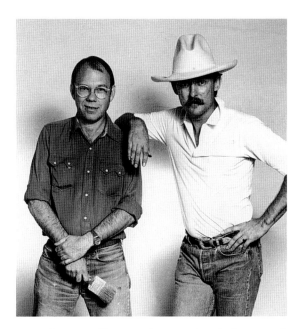

most illustrators, concluded he would no longer portray the West in false terms, and left commercial art to pursue easel and mural painting. By the mid-1920s, Dixon evolved a painting style that emphasized flatter surface treatment and bolder composition, especially in his work with clouds. A striking vocabulary emerged, drawn from his numerous excursions around the West, with a geometric feel that suggested formal abstraction. He recast nature, as he searched for an underlying reality in the landscapes. In Dixon's art are the precursors of the sparse and arid landscape vocabulary developed by a number of artists—from Georgia O'Keeffe to Helen Frankenthaler, to Ed Mell and others.

"I like the individuals like Dixon who experimented and pushed their art beyond reality to endow it with their own character," Mell explains.

Mell's enthusiasm for automobile design also played a role in the formation of his artistic sensibilities. That machine-age, art deco aesthetic, with its angular edges and clean, flowing lines, became a hallmark in his illustration work, and he now began to see the Southwestern landscape that way. In addition, Mell had rediscovered the landscape while on the Hopi Reservation, unlocking a romantic feel for the land that somehow had

The first landscape paintings were surreal, hippie, extremely pop, and on top of a cultural trend in art at that time. But he knew if he backed up and went in another direction, he would be a success. — *Bob Boze Bell*

never existed when he lived in Arizona before. Finally, he was reminded about the story that always seemed to float around art directors' offices in New York: All art directors want to be illustrators, and all illustrators want to be painters.

In 1975, Mell found his current studio, located at the corner of Tenth and Oak Streets, only several blocks from North High School and the Good Samaritan Regional Medical Center where he was born. A grocery store in the 1930s, the building appeared worn by age, but Mell liked its look. At first he

leased the structure, then later purchased it. Mell and Lee moved into the building and worked to convert the space into studios. Frank joined them that same year. About a year later, Skip Andrews returned to Phoenix and came in to share studio space. A few years later, they were joined by another Phoenix artist, Bob Boze Bell, whom Mell had met in 1973, when Bell was the publisher of a local tabloid, *Razz Review*. Bell went on to become a popular writer artist in his own right, who has kept up with Mell's work.

"Ed Mell is the most productive, dedicated worker in art I have ever met," Bell says. "He stays on course and does not make wild detours. I thought Mell's decision to pursue landscape painting was a step down, in light of his reputation as a successful commercial artist. Ed, though, has always had a vision of where he wanted to go."

Mell's first landscape paintings were highly conceptual and lacked any recognizable subject matter. He used some photographs he had taken while on the Hopi Reservation as ideas, but the paintings were, in his words, "the dry, stale intellectualism of New York art of that time." These landscapes leaned on his commercial art background, with airbrushed skies and sunsets, and the horizon line was defined by the bottom of the frame. He experimented with a few acrylic paintings, and with how his frames mirrored the color texture of the canvas. They were conceptual, minimal works, and in Mell's mind, "an intellectual art game."

> **Like many other Arizonans, I took the landscape for granted. But it becomes something special when you are not around it, especially when you find yourself trapped in a man-made environment like New York.** —*Ed Mell*

In 1975, a Scottsdale art gallery, the Limner Gallery on Main Street, invited Mell to exhibit some of his airbrush landscapes and several nude paintings, female torsos with clouds in the backgrounds. In addition, some of his paintings were included in the Four Corners Biennial held at the Phoenix Art Museum that year.

Eventually Mell started to tire of the monotony generated by vague airbrush skies, the constant cleaning of the equipment, and the lack of any tactile interaction with the image. He also realized by then that he approached his paintings as if unsure of the results. The colors on the canvases appeared muted, while the forms seemed vague and undefined.

"My first paintings were realistic interpretations of skyscapes with no horizon, just clouds,"
Mell says. "But the tedium of the airbrush and ambiguous shapes drove me nuts, so I moved on to
solid forms."

These early paintings, however, encouraged him to pursue his interest in landscape painting. He
began to schedule trips to the Colorado Plateau, taking photographs of terrain and clouds at different
times of the day in order to discover light, landform designs, and subtle shifts of mood. As Mell re-
viewed his painting results, a conviction emerged that he must convey the landscape with more power
and strength. Furthermore, he knew that he needed to develop not just a technique, but a unique style,
along with an attitude toward his art that would serve as the aesthetic foundation. In 1976, when he
married Gail Petersen, whom he had met in 1974 through an introduction from his brother Lee, the
thought of family responsibilities prompted deliberations about a new direction in his art.

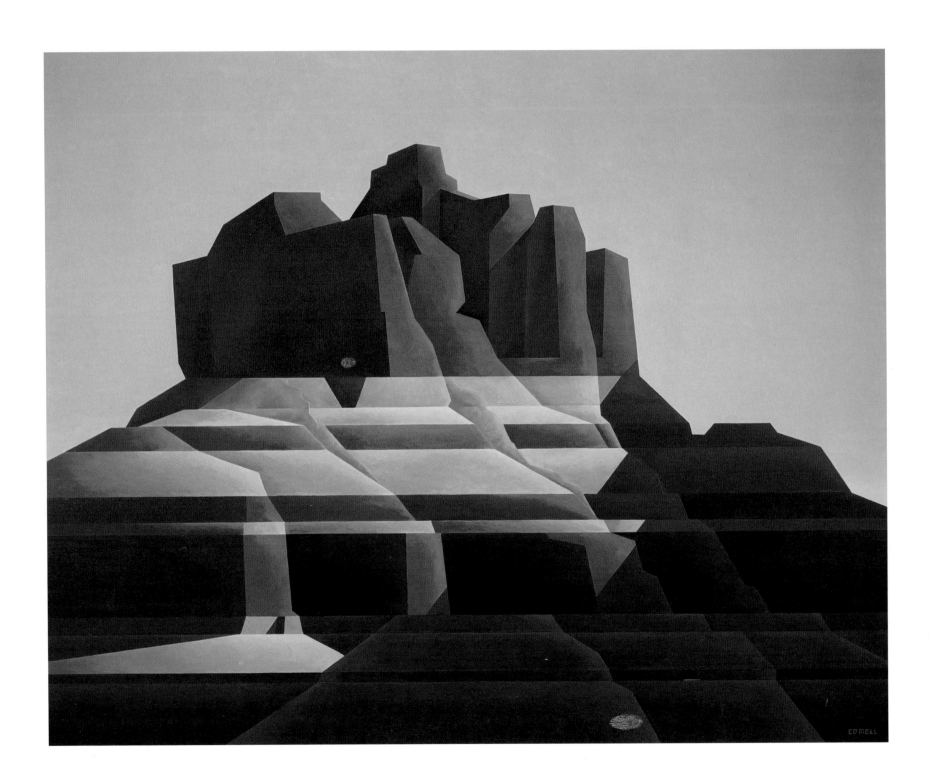

Opposite: Bell Rock, oil on canvas, 48 in. x 60 in., 1980. Private collection.

By 1977, Mell had undertaken the transition from commercial artist to landscape painter. That year he painted his first landscape in oil, an image he titled *Twin Peaks* (page 29). It was reduced to minimal forms, with two pyramid-like mountains on a flat plain, done in rust-red colors. Mell also constructed the painting's frame, fabricated out of red mud he collected in the Chiricahua Mountains. He began to acquire a vision that his images should reflect a man-made depiction of the landscape through the use of amplified colors and angular shapes.

"As a commercial artist, I adopted the angular forms and simplicity of the art deco movement," Mell says, "and I decided many of the same design elements could enable me to obtain the strength I sought in painting."

Another painting done in 1977, *Horizon Line* (page 29), is also painted in a minimalist manner, with the horizon line and clouds executed as horizontal stripes across the canvas. He still considered the frame part of the picture image. However, when Mell showed *Twin Peaks* to a friend, architect Lou McClane, he was advised, "Ed, I think you need to give up the frames." Mell took the advice, and never again considered the frames an integral part of his paintings.

As his vision started to emerge, his painting style responded. Mell's work increasingly emphasized hard edges on landscape forms, which he thought expanded the power of an image. He removed the superfluous detail and stressed broad areas of color and shapes more. As he became focused on form and color, the ill-defined intellectual ideas started to wane. His art at that time originated as a kind of afterimage from a visit to an area such as Monument Valley—a mental recall of colors and shapes.

I dealt with those lasting impressions you have after driving through an area like Monument Valley. You remember basic form, color and mood. The details are lost, but the image remains. —*Ed Mell*

In the late 1970s, Mell used relatively few photographs in the initial creation, but conceived a design in his mind. That vision of what he had seen in the landscape prescribed he would then streamline down to fundamental forms and planes. Once he worked out the image in his thoughts, he

proceeded to develop a pastel study on charcoal paper. He masked, blended, and shaded colors on the drawing to create a clear design that served as a model for the final image.

Changes in Mell's life brought about changes in his art during this period. "My first son, Taylor, was born in 1977," Mell says. "I dreamed then about being a fine artist, and there was a calculation to the decision. I wanted three things: I would do work that excited me, kept my interest, and supported my family."

Mell finally quit his commercial art business in 1978 and turned his attention to the development of landscape painting. Not only would Mell develop a recognizable personal style in time, he now identified a landscape that supported this vision—the Colorado Plateau. The name is appropriate, for this high, horizontal tableland is an island in the sky, a marvelous, intricate, wind- and water-eroded wilderness of canyons, buttes, and mesas rendered in Kodachrome shades of rock. Mell's art would focus on the compact heart of the Colorado Plateau, centered on southeastern Utah and northeastern Arizona—from Bryce Canyon to Arches National Park, to the Four Corners area where Utah, Colorado, Arizona, and New Mexico intersect; along the western and southern fringes of the Painted Desert; and around Lake Powell and the Grand Canyon.

Gail encouraged him to paint what he wanted, and how he wanted, and to buy his own freedom. A one-person exhibition held at the Elizabeth Burns Gallery in Scottsdale in 1978 led to a large painting commission for the Camelback Financial Center. Gail recalls the Mell family lived several months off the money received from the commission. She remembers too that Mell put all of his time and energy into the growth and development of his work. He often would leave in the evenings with a camera to photograph clouds and sunsets around the Phoenix area. At times, he would climb onto the roof of their house to photograph particularly attractive cloud formations. To free him for his work, Gail assumed his art business operations, including the accounting and correspondence. When their second son, Carson, was born in 1980, she handled all of the family concerns.

Painting and printmaking are man-made gestures. Instead of attempting to copy nature, I arrived at a point in the early 1980s of seeing the landscape as if constructed by man and machine. Furthermore, these early paintings and prints concentrated on the structure of my subject matter. I thought in terms then of architectural forms and streamlined industrial design—the aesthetic influence of dream automobile design— as well as nature's own forms. —*Ed Mell*

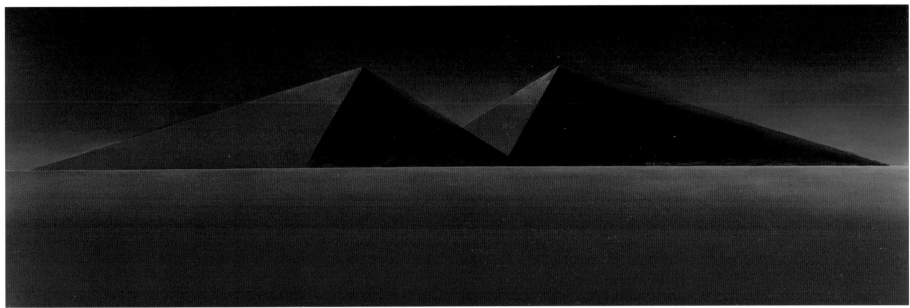

Twin Peaks, *oil on linen, 13 in. x 49 in., 1977. Artist's collection.*

Horizon Line, *oil on canvas, 16 in. x 40 in., 1977. Artist's collection.*

Around 1980, Mell decided to publish limited edition prints drawn from his paintings. He considered this decision a natural progression from painting, and he enjoyed the opportunity to work with a different medium. A series of three hand-pulled lithographs and serigraphs emerged, which he called Western Forms. His background in illustration, where he dealt with four-color separations over the years, gave him a feel for the visualization of printed effects. The serigraphs were printed in twelve colors, while the lithographs utilized six to eight colors in a run. These limited editions, signed and numbered by the artist, proved an immediate hit with collectors, as they still do. Eventually, he stopped manufacturing the serigraphs, but has continued to issue lithographs. However, it is posters that have brought him greater recognition beyond the region. Mell expanded his art to include posters of landscapes, then figurative work, such as longhorns, and finally, some of his flowers. Over time, they have proved immensely popular, and can be found as faraway as Europe, Latin America, and Asia.

From 1978 to 1980, Mell's art had further evolved into more recognizable and realistic landscape shapes, with definable skies and clouds. The minimalist approach retreated, and paintings like *Dusk* (page 39) and *Canyon Wall* (page 33) were marked by a cool, formal control drawn from cubism. They had cubism's simplified and flattened forms, but Mell executed them in a more relaxed manner, with particular attention to color.

"I had to intensify the color, as well as the forms," he says, "to make a painting have anywhere near the power of actually being there."

By the end of the 1970s, Mell painted his canvases exclusively in oil. "I prefer the qualities of oil because the surface is so important to me," Mell says. "I like to touch the painting. Because oils dry slowly, they permit me to do blends and create interesting subtleties. I mix all my colors and never use them directly out of the tube. Applying the oil with a brush puts me in touch with the work."

Furthermore, his paintings now began to show an even more definite direction in the delineation of the landscape forms, as in *Blue Sky, Orange Canyon* (page 32). Cloud forms began to emerge

I first met Ed Mell in 1981, when someone sent me to him about frames for his paintings. My first impressions were that his landscapes were different from what I had seen others do. With their color and sense of light, I felt that is how I sense the landscape too. His landscapes draw me into them. —*Michael Collier*

in his paintings, counterpoints to the earth below, as in *Clouds and Ravine* (page 34). They were still nebulous, stylized, shaped, and blocked, yet they were recognizable clouds. The flat horizon in the paintings, in the past done with straight lines, began to fill with vertical forms—mesas, pinnacles, and buttes—as in *Monument Walls* (page 35).

Beside the architecturally inspired landscapes, Mell became attracted to the strength of sunsets. Whenever possible, he wanted to avoid "sweet or syrupy" sunsets, emphasize certain colors—pink and orange, for example—and present them with as much drama and force as possible. From the start, Mell was fascinated with the excitement of Southwestern clouds, especially those that enhance the feel of places with solitude and quiet. He knew that cloud formations increase the translucent glow of light on the land. Furthermore, clouds never duplicate their forms, he believed, and are always different in temperament and intensity.

Faced with the challenge to duplicate light on a flat, two-dimensional surface, Mell painted canvases such as *Bell Rock* (page 26), where a late afternoon sky casts modernist-inspired patterns of light and shadow on a solid monolith. This was an effort, he explains, to push beyond what existed in the landscape, and to create impressions with extraneous details removed, anchored by the earth's forms or the atmospheric feel of light. Mell understood the power of color early, and he experimented and indulged in it as a method to emphasize his paintings' impact.

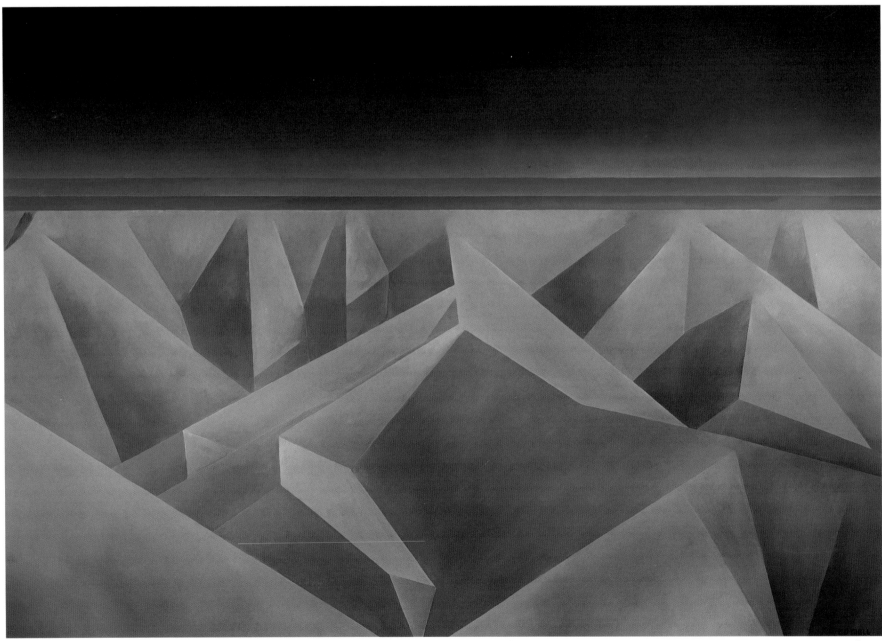

Blue Sky, Orange Canyon, *oil on canvas, 42 in. x 58 in., 1979. Private collection.*

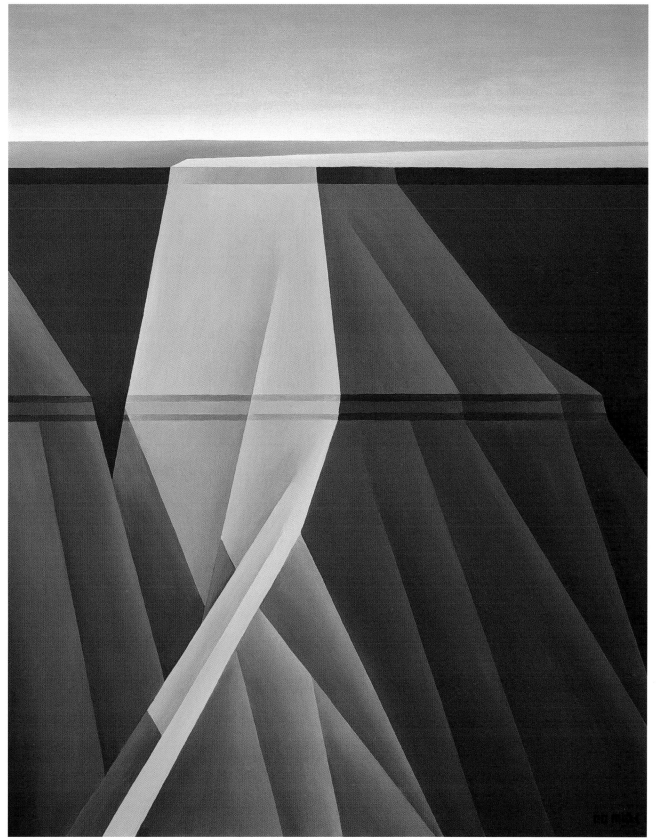

Canyon Wall, *oil on linen, 30 in. x 24 in., 1978. Private collection.*

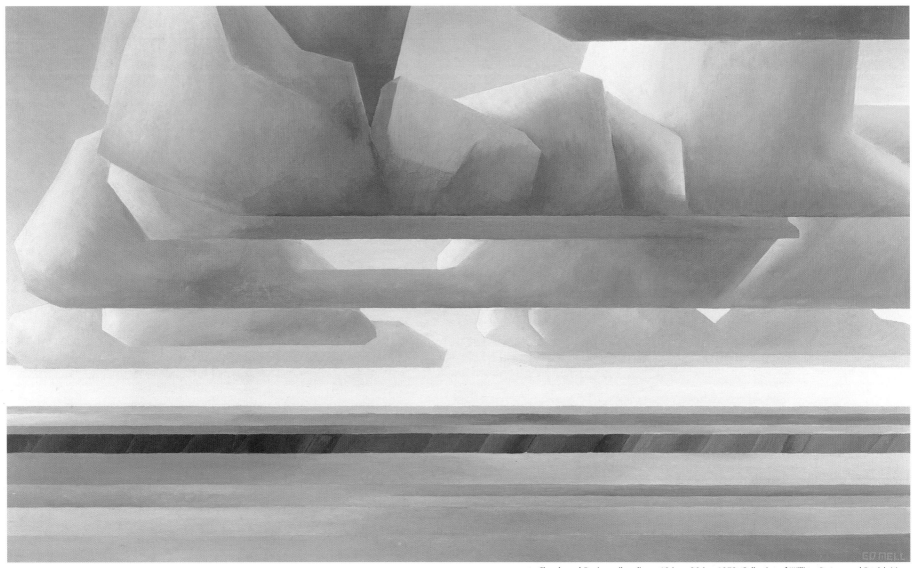

Clouds and Ravine, *oil on linen, 18 in. x 30 in., 1979. Collection of William Benner and Patrick Maas.*

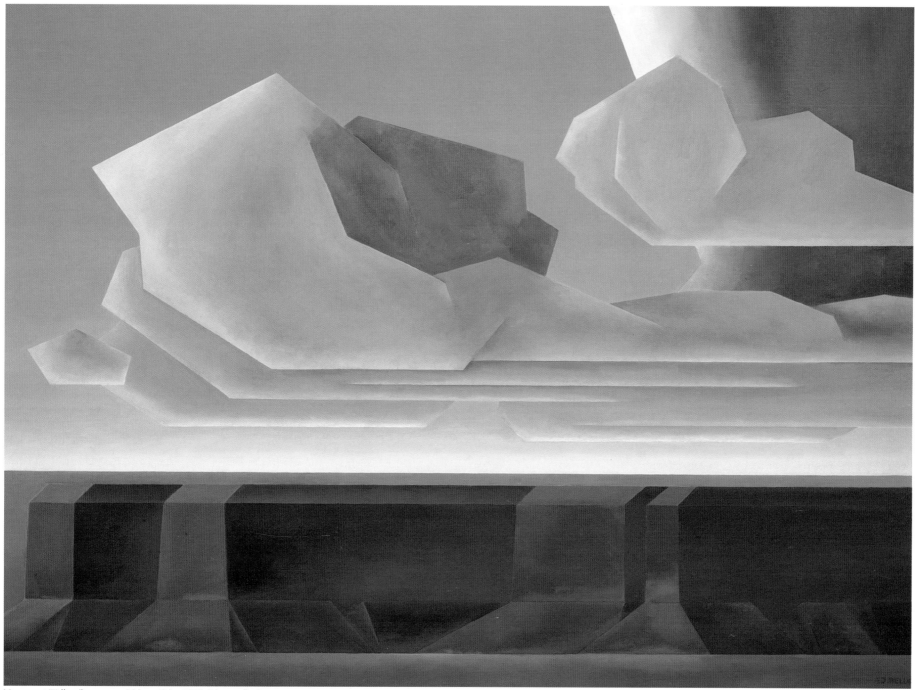

Monument Walls, *oil on canvas, 36 in. x 48 in., 1979. Private collection.*

Dark Clouds Over Lake Powell, *oil on canvas, 30 in. x 40 in., 1981. Private collection.*

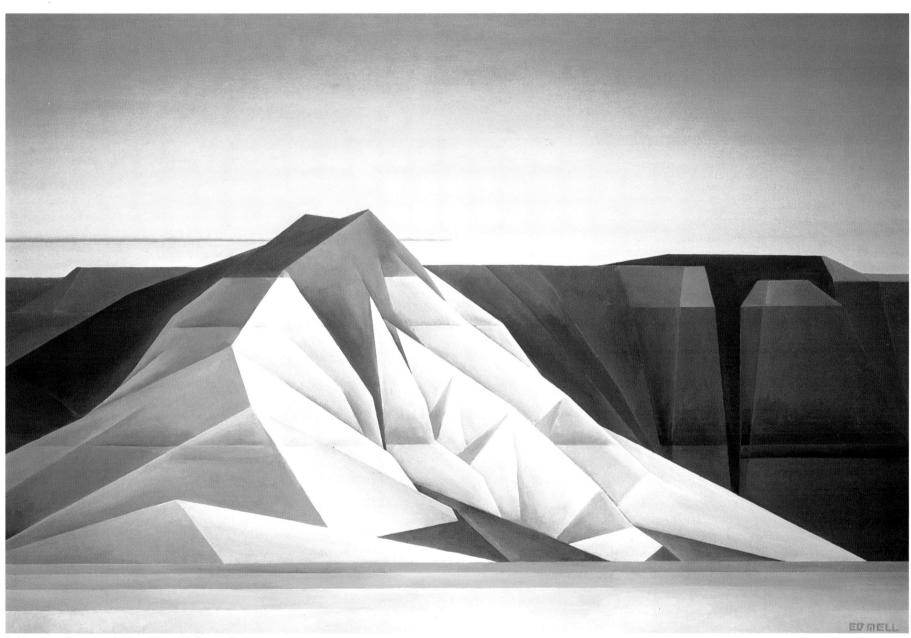

Red into Gray, *oil on canvas, 31 in. x 48 in., 1979. Private collection.*

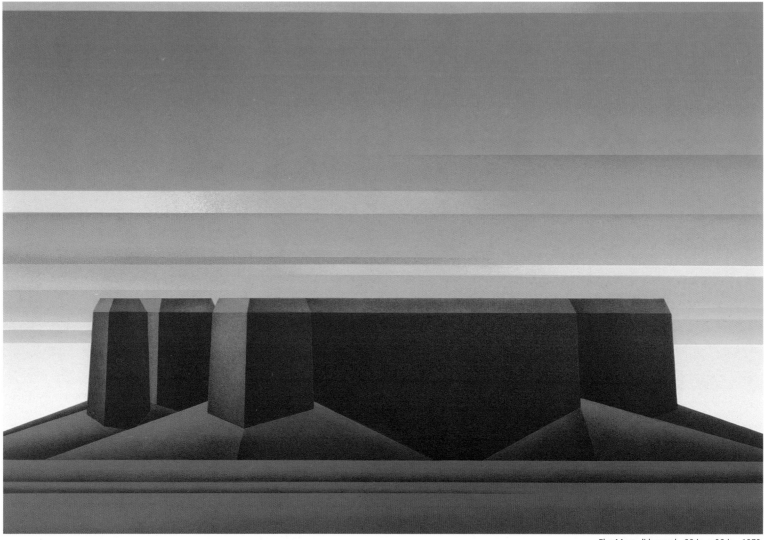

Flat Mesa, *lithograph, 22 in. x 30 in., 1979.*

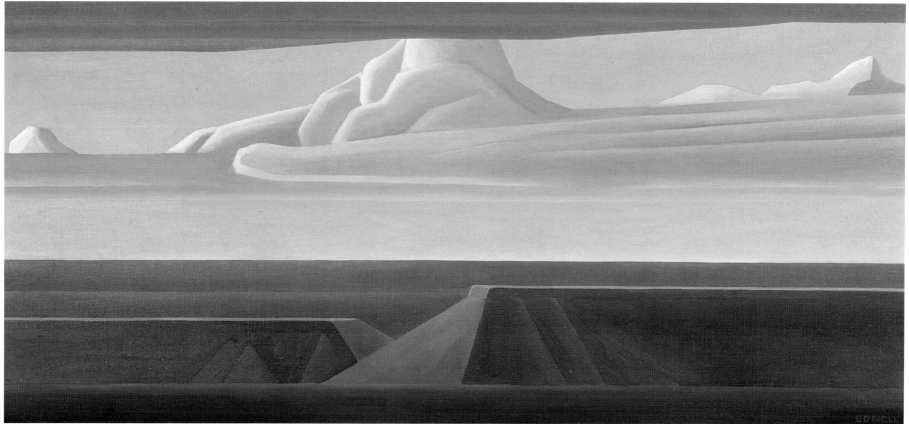

Dusk, *oil on linen, 15 in. x 33 in., 1978. Private collection.*

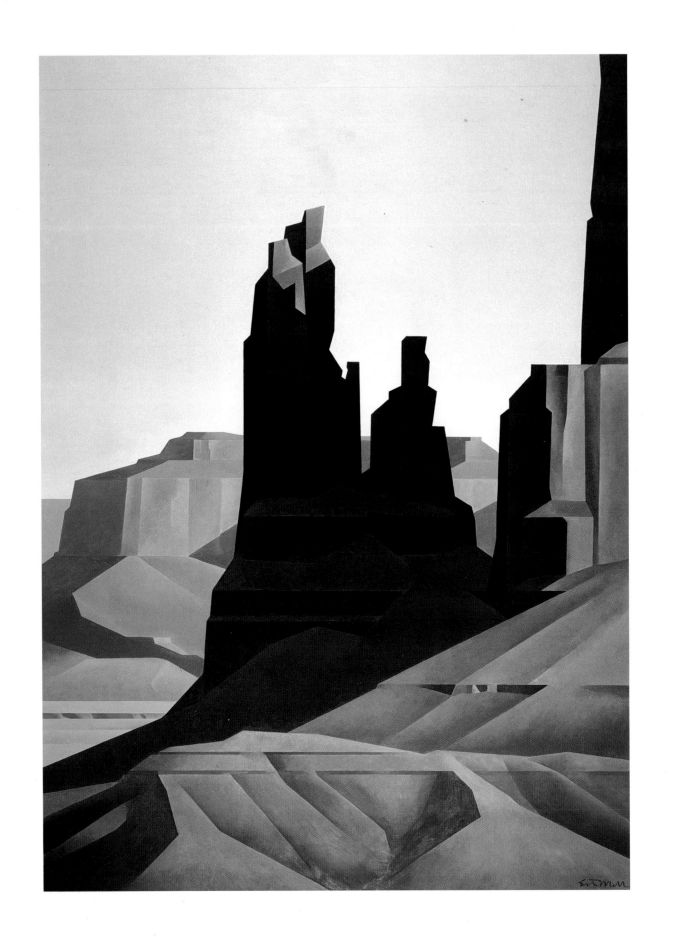

Opposite: Chinle Formation, oil on canvas, 66 in. x 48 in., 1982. Private collection.

In the spring of 1980, Mell's landscape painting took a new direction. Jerry Foster, news reporter and pilot for Phoenix's KPNX-TV, was producing a series of special programs for the station's evening news, using a helicopter as a portable studio. He called the series, which focused on the Colorado Plateau, *Sky 12 Country.* Foster is possessed of supreme, even arrogant confidence from flying helicopters, first honed on missions in Vietnam, then from numerous rescues throughout Arizona, often under extremely hazardous conditions. In recognition of Foster's abilities, he was awarded aviation's highest award, the Harmon Trophy, in 1982.

When painting a sunset or extraordinary rock configuration, I view it with an eye toward design integrity. I am an idealist attempting to elevate the power of the original vision by reducing it to its architectural elements. — *Ed Mell*

Mell had met Foster in 1979 through a mutual friend, photographer Tom Gerczynski, and began to drop hints about how he would like to accompany Foster on a helicopter trip. In turn, Foster was intrigued with Mell's art, "pleasing to the eye," he recalls, but needing "elevation," since he knew Mell had so far only viewed the plateau's landscapes from ground level.

"There were two things that Mell needed then, to see a new perspective and to toughen up," Foster recollects. "I thought he needed to be more forceful."

One day in late April 1980, Foster called Mell and said, "Pack your bags, we are going on a four-day trip to northern Arizona. You have a seat." Mell still recalls walking onto the television station's roof on May 1, startled by the small Hughes 500E helicopter. He was a little unnerved at first, particularly when Foster described the helicopter as "a little pod with ten thousand moving parts, and which can kill you if something goes wrong."

On that first aerial voyage, Foster flew Mell to Sedona, then on to Flagstaff to refuel. A second helicopter, piloted by Dr. Andrew Laird, a Phoenix orthopedic surgeon, accompanied them. Foster always insisted another helicopter fly with him on extended trips to the Colorado Plateau, for video photography and in case of an emergency. After they refueled, the group flew to the top of the San Francisco Peaks, landing on Mt. Humphreys, at 12,794 feet the highest point in Arizona. The Navajos

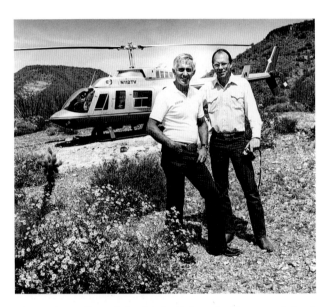

consider it one of their Four Sacred Mountains, "adorned with abalone" when snow covers it in the winter. The Hopi call the summit "Cloud House," where they believe spiritual beings called kachinas live for part of their lives. Even in May, considerable snow remained on the peak where the two helicopters touched down. Mell still retains the thrill of standing on the top of Arizona, with views stretching to infinity.

From the top of the mountain, Mell could see northeast to the Painted Desert along the valley of the Little Colorado River, and, further on, Black Mesa, nearly seventy-five miles away. To the north were the Kaibab Plateau and the Grand Canyon, and eastward, over one hundred miles distant, the ghostly bulk of Navajo Mountain loomed. To the southeast rose the White Mountains and out to the west some forty-five miles lay Bill Williams Mountain.

After they had admired the views and Mell took photographs, Foster and Laird flew their helicopters east to a small trading post for lunch. The proprietor, impressed with the mode of transportation that landed them on the field next to the post, remarked, "Sure like the way you boys dropped in here." Foster and Laird then went on to the Grand Canyon, their destination Havasu Falls. When they finished hovering above the falls for camera shots, they flew on to the Grand Canyon airport to refuel. Then the two helicopters followed Marble Canyon above the water to Glen Canyon Dam and Lake Powell, where they landed at Page. That evening they probed the canyons and buttes around Lake Powell while Mell photographed the sunset and the views that unfolded from landings on solitary rock formations. The next two days were spent exploring Monument Valley and the slickrock wilderness of Navajo Mountain. Finally, Foster and Laird dashed back to Phoenix.

For Mell, this trip and subsequent flights introduced him to vantage points in places where

> **I feel like a proud father when I see Mell posters around the country. Once, we were in Juarez, Mexico, and gone to dinner at, of all places, the Montana Steak House. There on the wall as we walked in were two of Mell's posters.** —*Jerry Foster*

humans had literally never stood before. Foster enjoyed flying up to an isolated rock spire, putting the skids on the top, then ordering Mell, "OK, now get out." When the skids hit the rock, Mell would jump out, and Foster would fly away briefly, and sometimes out of sight. Mell wondered how he would ever get down if Foster failed to return.

The thrill of flying in the helicopter translated into new perspectives for Mell's landscape paintings. There was drama, certainly, but also a scale unimagined by earthbound travelers on the plateau's terrain. "The grand dimension of it all began to be immediately reflected in my work," Mell observes. His studio became the vast sweep of the Colorado Plateau; the easel, the front seat of a helicopter. The best way to view this country is to fly over, hover above, or land on top of it, as Mell learned, for new landscapes were unveiled, sharp and clear. With the helicopter, you not only saw the front of a rock form, but could explore the sides, the back, and finally, perch on it like a bird. This was indeed "standing up country," as geographer C. Gregory Crampton once proclaimed, with as much country vertical as there was lying down.

"It was an aerial voyage that shaped, and continues to shape, a new visual perception of the plateau from top to bottom," Mell says.

As he would do on subsequent helicopter flights, Mell took nearly one thousand photographs on this trip. He used two motor-driven cameras, equipped with wide-angle and telephoto lenses. Flying in the helicopter gave him immediate reference, as the varied landscape forms flashed by the ship's Plexiglas windows. The helicopter became a painter's tool, granting him visual access to places that had no approach from the ground. Peaks, mesas, buttes, and canyons Mell thought had been overdone by other painters suddenly assumed new dimensions from the air. Visualization in his art became an emotional and creative response to a perspective unobtainable from the ground.

Upon his return from helicopter flights, photographs took on greater significance, as Mell

Sometimes a shadow or a line in the drawing offered the first suggestion of how I could bring out the power in a particular formation. —*Ed Mell*

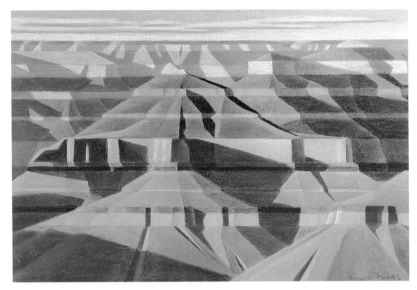 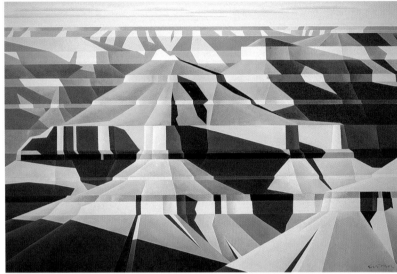

Left: South Rim, Grand Canyon *study, pastel,*
14 1/2 in. x 22 in., 1981. Private collection.

Right: South Rim, Grand Canyon, *oil on canvas,*
48 in. x 72 in., 1981. Private collection.

reviewed the slides for inspiration. The photographic reference library—and there would be thousands of slides eventually—influenced his landscape painting. They became a library of revelation, and the slides an extended sketchbook. As he explains, "They were viewed over and over, then I selected several for evocative forms and color." Behind their selection lay a question: How could Mell translate the experiences, and his reflection on them, into dramatic structures on the canvas?

Several photographs would be selected for their visual ideas, such as cloud formations, or a particularly provocative landform. To this day, he avoids the entrapment of using a single photograph by fusing a number of slides together into his vision of a panoramic scene. After choosing the photographs to be used, he would make a quick pastel drawing and progress to a larger one, on which the landscape outlines could be organized in a coherent fashion. As the drawing accumulated more specific information, Mell would refine the forms even further, with horizontal planes emphasized over perspective planes. He would then place tracing paper over the pastel sketch and outline the landscape edges with crisp lines. Next, this line drawing would be projected onto a gessoed canvas. Then Mell would draw the landscape contours on the canvas as straight edges. The final step would be to apply the colors. Mell used Windsor and Newton brand oil pigments, thinned with a poppy seed oil. This made the oils more fluid and endowed his canvases with a natural sheen.

He simplified his paintings to their bare-bones essentials, then honed them further into imaginative, selective fragments of the plateau's complex landscapes. The images looked like specific places,

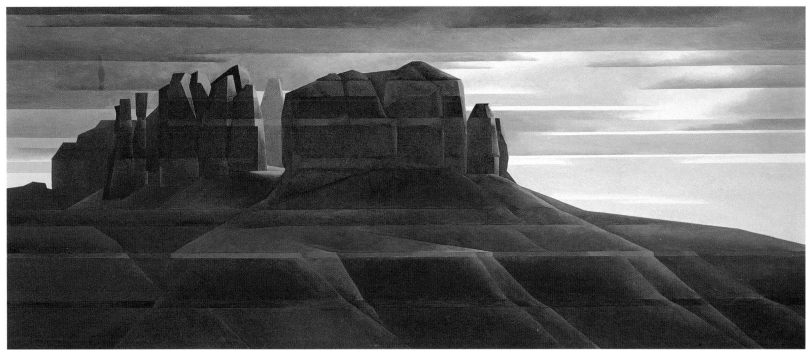

Sedona Forms, oil on canvas,
24 in. x 54 in., 1980. Private collection.

but they are not profiles of the plateau's formations any earthbound traveler would see. They are designed, and Mell's interest in the foundations of modern art led him to see landscapes this way.

"If anything, my landscapes then looked like they could be built," Mell explains. "Sometimes I describe them as architectonic, where images were refined to flat planes or structural forms by using straight lines and adapting special design elements to them."

Mell tried to push the drama further on a canvas than in reality. As the impact of the Colorado Plateau's spacious landscapes engaged his imagination, Mell's paintings in the 1980s expanded in size, prompted by his recognition of the importance of large scale. Often the paintings were five by six feet or larger. Some eventually achieved almost mural status, ranging up to twelve feet across.

I push the coloration and intensify the plateau's ruddy, fugitive colors in a search for effective combinations to make a painting more powerful. — *Ed Mell*

One of the first paintings he created from the initial helicopter trip with Foster was *Sedona Forms*, a view of one of the region's blocky, pink-tinged buttes soaring against the horizon. But it was the flight around Monument Valley that became one of Mell's cherished memories. From the helicopter he might sometimes

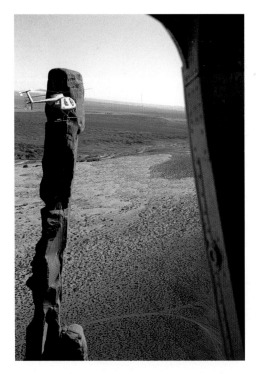

Monument Valley, 1982.

see the monoliths throw sunset shadows nearly thirty-five miles long across the sagebrush- and chamisa-dotted plain. The colors of Monument Valley, he discovered, changed from one moment to the next, and offered varied visual perceptions of the landscape. Monument Valley's perpendicular, castle-like buttes and spires, the eroded remnants of Navajo sandstone, looked like architecture to Mell. Scattered about the valley, they seemed a silent city of stone. It is a monumental landscape, a place of arrested motion, and not an intimate one.

Mell would watch the other helicopter "become a speck of dust," he remembers, as it flew around the landmarks of Monument Valley. One of the formations, Three Sisters, did not seem especially large until they hovered close to it. Foster explored around the front, the sides, the rear, and then flew between the spires. Mell found himself overwhelmed by the scale.

"I was hanging in space looking at Three Sisters," Mell says. "There is an excitement in seeing such formations from the helicopter that you cannot begin to imagine from the ground, no matter how spectacular they look from below."

A painting he did after that experience, *Three Sisters in Shadow,* captured the adrenaline rush of this new perspective, the eroded, chiseled forms of this famous landmark outlined against the sky. With the helicopter's mobility, Mell was able to see behind the spires and create the painting from a different angle. As Mell envisions it, the presence of Three Sisters on canvas is eternal, their story one of continued creation.

This horizon-to-horizon drama, the indescribable fantasy of the plateau, is a bright, looming memory that somehow finds its way into a painting. — *Ed Mell*

These interpretations came as the helicopter wafted, circled, and landed on the lithic landscape. These horizontal and vertical worlds were embedded in paintings such as *Pillar, Monument Valley* (page 60) and *Noon* (page 59). Their sheer-sided, angular forms presented on canvas possess an architectural quality set against the horizontal panorama of

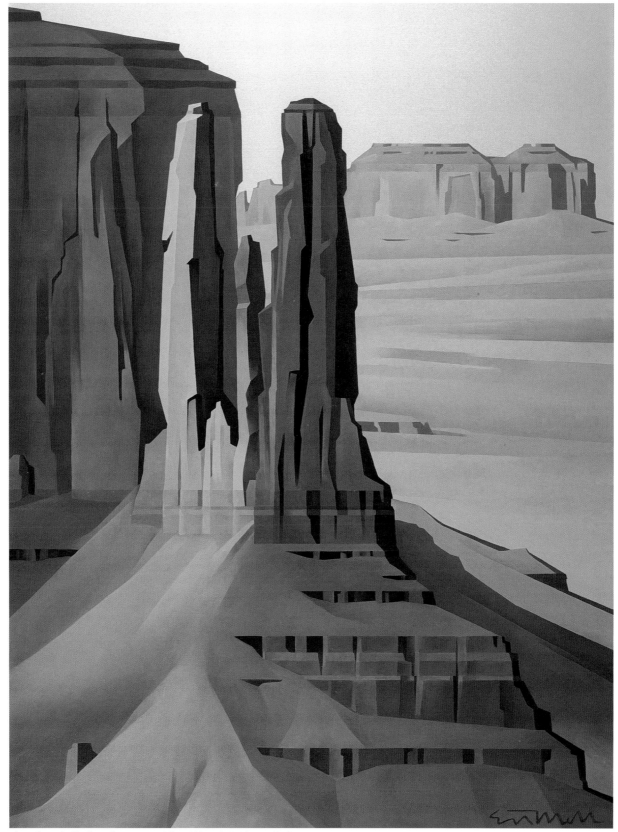

Three Sisters in Shadow, *oil on canvas, 48 in. x 36 in., 1982. Private collection.*

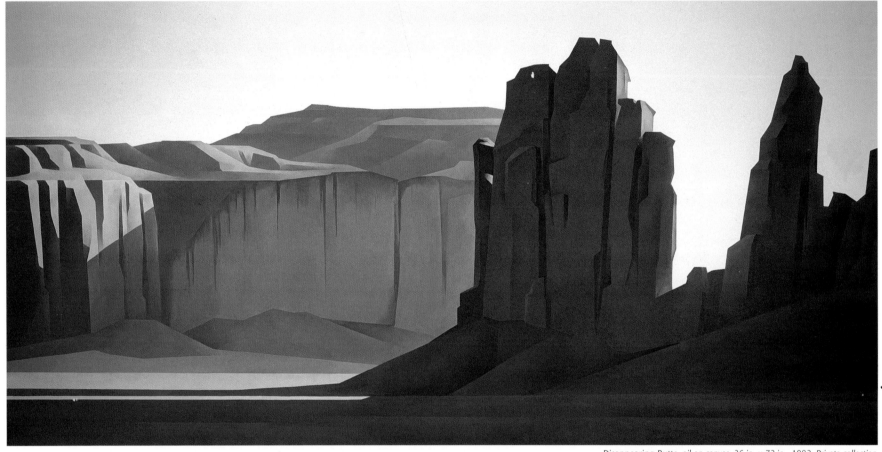

Disappearing Butte, *oil on canvas, 36 in. x 72 in., 1982. Private collection.*

Lake Powell, *oil on canvas, 20 in. x 32 in., 1980.*
Private collection.

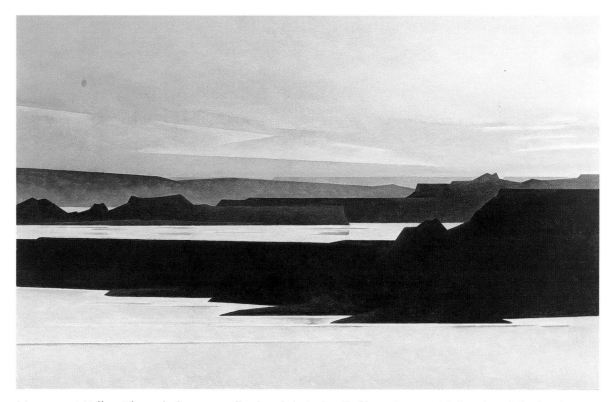

Monument Valley. The paintings are edited and their details filtered out as Mell reduced the land-scape contours to barest essentials. The result is an art of constructed topography done in paint, and the impression one of immensity. To accomplish that effect, Mell placed the main formations in shadow, which heightens their enigmatic presence.

Still another painting, *Disappearing Butte,* suggests an optical mirage, in which the formation in the foreground blocks part of a far-off mesa to create an illusion for the viewer.

The Lake Powell region emerged as another of Mell's areas for inspiration. Formed when Glen Canyon Dam was completed in 1964, Lake Powell stretches nearly two hundred miles from Page, Arizona, to near Hite, Utah. The azure-blue water of the lake confronts the predominant sunburnt redness of Navajo sandstone to create impressive color contrasts. A labyrinth of cliffs, mesas, buttes, canyons, and arroyos sur-rounds the lake's edge, their corrugated shapes revealed under the clear, dry light.

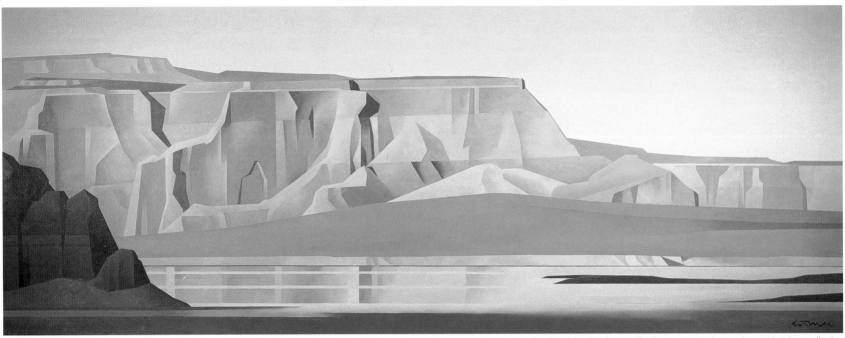

Antelope Island, Lake Powell, *oil on canvas, 36 in. x 96 in., 1982. Private collection.*

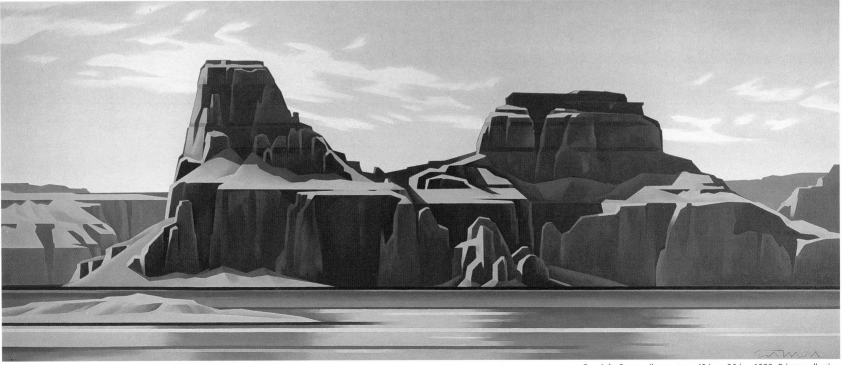

Gunsight Butte, *oil on canvas, 40 in. x 96 in., 1985. Private collection.*

Golden Light on Grand Canyon, *oil on canvas,*
36 in. x 36 in., 1983. Private collection.

Mell is enthralled with the variety of subjects he sees at Lake Powell. Some of his earliest reactions to the lake include his first painting there, *Lake Powell* (page 49), an image that shows abstract skies and hues of red reflected on the lake's surface. Other paintings, such as *Lake Powell Cloud Drift* (page 62), present scenes at the end of day as clouds turn dramatic and dark from a disappearing sun. *Boundary Butte* (page 65) is an interpretation of Mell's thoughts about the massive forms and cloud formations that define the lake's essence, a coherent image with magnitude and balance. This was his first attempt at a nocturnal painting. Another place he remembered from the vantage point of the helicopter seat appeared in *Book Cliffs* (page 62), where the Green River cuts through the high cliff walls to emerge near its junction with the Colorado River.

Chinle Formation (page 40) presents a view of multi-colored formations, composed of shales, sandstones, and limestones, whose eroded forms can be seen anywhere in this country. When *Southwest Art* did an article on Mell in September 1982, *Chinle Formation* was reproduced as the cover. *Mesa's Skies* (page 63) integrates the sense of permanence of rock and sky, their forms reduced to volume, lines, and planes, with a feel for atmospheric conditions and the drama of a far horizon. In 1982, Mell converted this painting into his first poster.

Mell discovered his experiences around the Grand Canyon presented a special challenge for his creative expression as a painter. This great, mile-deep abyss is composed of multiple landscapes and fractured distances, where the perception of depth, profiles, space, and color is never the same from hour to hour or day to day. Using photographs he has taken from his airy perch on the various helicopter flights over and through the canyon, Mell painted such canvases as *Golden Light on Grand Canyon; South Rim, Grand Canyon* (page 44); and *Canyon Storm* (page 64).

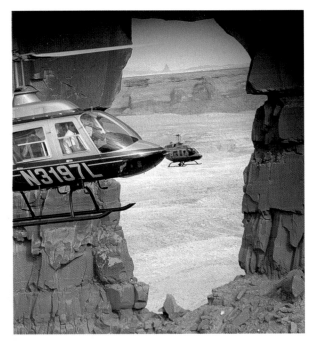

Round Rock, near Chinle, Arizona, 1985.

The paintings do not just hint at the chronological layering of Grand Canyon's geologic formations—such as the Kaibab limestone and Coconino sandstone near the rim, and the massive band of Redwall limestone about midway down—they virtually shout. The horizontal layers are conspicuous through Mell's use of strong horizontal lines and vivid color. In *Canyon Storm*, Mell has portrayed the effects of the canyon shrouded in fog, the result of clouds that billow up from the super-heated depths below after rain or snow falls.

To the north of the Grand Canyon lies the bold escarpment of multihued formations called the Vermilion Cliffs, which wind back and forth across the Utah-Arizona boundary for nearly one hundred and fifty miles. In *Vermilion Cliffs,* Mell has not merely replicated, but intensified their colorful geological formations, like layers of a cake, along with distance and light that define their existence.

While Mell had successful exhibits of his work at the Harris Gallery in Houston, Art Resources in Denver, and at the Marilyn Butler Gallery in Scottsdale, he wanted to secure gallery representation that would support his desire for a long-term, productive relationship. In 1981, he approached Suzanne Brown, who had established a contemporary art gallery on Scottsdale's Main Street. She had come west with her husband in the 1950s while he worked on a law case. They stopped in Phoenix and never left. Brown began to sell art out of her station wagon in the early 1960s, and started her gallery in the 1970s. Intrigued by Mell's new helicopter-inspired landscape paintings, she agreed to represent him. Within three months of their agreement, Brown scheduled a successful solo exhibition of Mell's landscape paintings. Since then she has given him a spring exhibition every year.

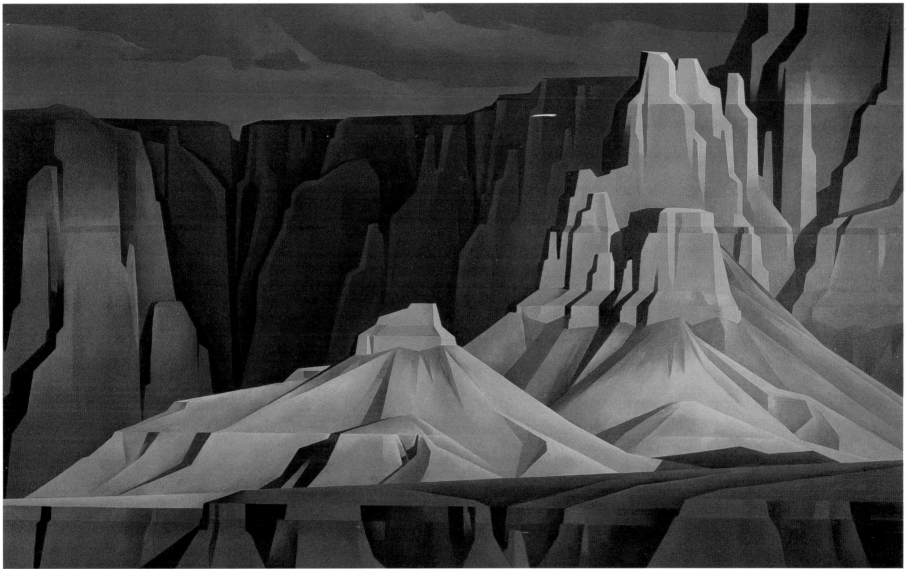

Vermilion Cliffs, *oil on canvas, 48 in. x 78 in., 1982. Private collection.*

Mell's other long-time gallery representation is Dewey Galleries (formerly Dewey-Kofron Galleries) in Santa Fe. Ray Dewey encountered Mell's landscape paintings in an issue of *Southwest Art* and could not shake them from his thoughts. They were, in Dewey's perception, powerful and dramatic images. He finally called Mell sometime in the early 1980s and asked to represent him in Santa Fe. At present, Dewey and his partner, Nat Owings, carry Mell's work at Owings-Dewey Fine Art.

Mell exhibited his landscape paintings at the Arizona Invitational, held at the Scottsdale Center for the Arts, and in Artists of Arizona, held at the Center of Modern Art in Guadalajara, Mexico, in 1982, while the Long Beach Museum of Art gave him a one-person exhibition in 1983. Further recognition arrived when *American Artist* did stories on the theme of American landscape painting in their February 1984 issue, and used one of Mell's paintings for the cover. In July 1985, *Arizona Highways* profiled him in an article and reproduced one of his paintings for that month's cover.

Mell continued to take helicopter trips with Foster. Short excursions were made to Wickenburg, Roosevelt Lake, the Superstition Mountains, and the Verde Valley. Another trip occurred in 1982, when Mell accompanied Foster to Navajo Mountain and around the remote canyons that surround Inscription House Ruins in Neetsin Canyon, northeast of Red Lake. An additional helicopter voyage took place later that year, when Foster invited Mell to join him on a trip with Senator Barry Goldwater to Navajo Mountain. Foster picked up Goldwater and Stan Jones, an authority on the region, at Page, flew them first to Monument Valley, then on to Navajo Mountain. The Navajo called the mountain Not-is-ahn, "Hiding Place of the Enemies," from a small band that had escaped Kit Carson's punitive expedition in 1863. Clarence E. Dutton, a government explorer, first saw the mountain in the late 1870s from the Utah plateaus and chronicled it in *Geology of the High Plateaus of Utah:*

> **When I first saw the red rocks of Sedona many years ago, I thought no artist could ever capture on canvas what I felt nature could do so well. But Mell had gone beyond that, not by imitation, but by discovering his own style and endowing it with life.** — *Suzanne Brown*

Far to the southeastward, upon the horizon, rises a gigantic dome of wonderfully symmetric and simple form. It is the Navajo Mountain. Conceive a segment of a sphere cut off by a plane through the seventieth parallel of latitude and you have its form exactly. From whatsoever quarter it is viewed, it always presents the same profile. It is quite solitary, without even a foothill for society, and its very loneliness is impressive.

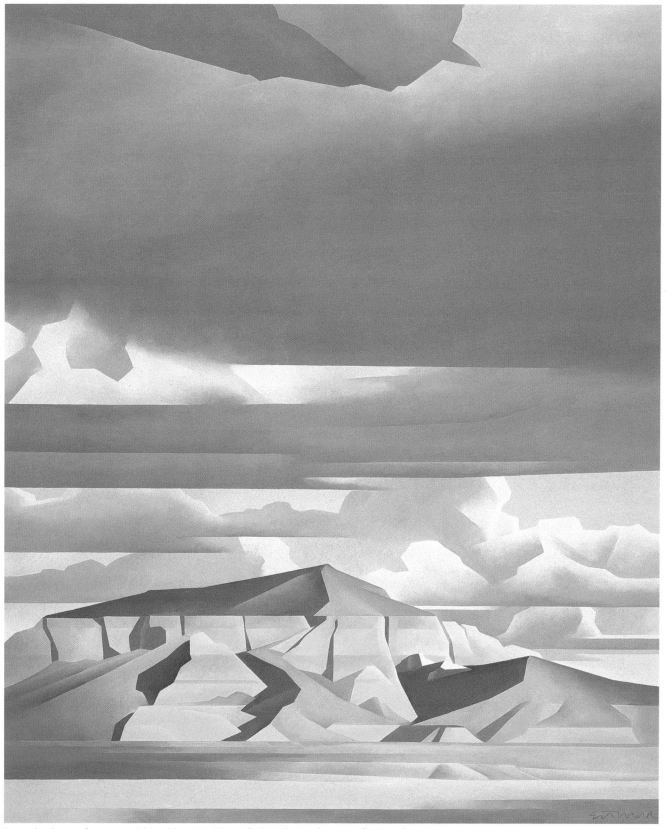

Reservation Storm, *oil on canvas, 48 in. x 40 in., 1982. Private collection. (Photograph courtesy of Frank Croft Fine Art.)*

Grand Falls, Little Colorado River, 1980.

Goldwater had managed the family's remote Rainbow Lodge and Trading Post high on the shoulder of Navajo Mountain for some years. Besides conducting trading post activities for local Navajo residents, the lodge arranged pack trips to Rainbow Bridge. The post burned in 1951, and Goldwater had never returned. Mell recalled that Goldwater was emotional as he got out of the helicopter and walked over to the stone foundation of the post. Later, Mell did a painting, *Reservation Storm* (page 55), his recollection of Navajo Mountain's massive, rounded bulk posed against the dramatic curtain of a summer storm.

Afterwards they flew west to the flat-topped, white-walled sandstone expanse of White Mesa, which stands alone on top of the Kaibito Plateau. On White Mesa's edge is White Mesa Arch, a magnificent natural stone arch which resembles a flying buttress. Another arch located on the mesa is Margaret's Arch, named after Goldwater's first wife (although it was later renamed). Mell says he thought hovering above both of the arches in the helicopter was like viewing a lunar-like landscape from a little silver spaceship.

Perhaps the most productive trip for Mell, and, as it turned out, one of the last extensive ones with Foster, occurred in the late summer of 1985. Foster, who arranged for two other helicopters to accompany him, planned a five-day expedition that would take them to northeast Arizona, and part of northwest New Mexico, then traverse the Lake Powell region, including Navajo Mountain and Rainbow Bridge, and conclude at the Little Colorado River where it flows into the Colorado.

On an August day, marked by intermittent rain squalls, the group left Phoenix for Winslow, then from there flew across the open terrain of the Navajo Reservation to Chinle. Foster had traded in the Hughes helicopter and was using a new Bell Jet Ranger, which had more room, was faster, and could fly farther. That night the group stayed at the Thunderbird Lodge, then departed early the next morning. After Foster and the other helicopter pilots flirted with Round Rock, north of Chinle, the flotilla flew northeast into an almost unknown region of buttes, canyons, and natural arches.

Mell was impressed with this rugged land carved from red-orange Wingate sandstone. Smooth, alcove-indented cliffs, square-shouldered buttes, and mesas dot this area, which is called Redrock Valley from the fiery sandstone color of the earth. Spires isolated by retreating cliffs, and a half-dozen or so natural arches, windows in stone, are found eroded into spurs of sandstone. One of them, Royal Arch, which Foster tried to poke the helicopter nose through, rivals Rainbow Bridge in height. Ancient cliff dwellings could be seen in Alcove Canyon and Hasbidito Valley. Besides Royal Arch, the group discovered a natural arch that apparently lacked a name. Everywhere Mell and the others looked, there was no sign of human habitation, except for the Anasazi ruins or an abandoned Navajo hogan. One member of the party stated he saw more in a half-day of flying than twenty years of hiking in the area.

From Redrock Valley, the group flew east to the double-spired form of Shiprock, its dark volcanic mass thrust upright, alone above the sagebrush plain, like a ship under sail. Shiprock is a sacred place to the Navajo, and in their legends they call it Winged Rock, after the petrified remains of Rock Monster. After the helicopters landed at the Farmington airport to refuel, they headed west toward Monument Valley over a landscape of dramatic flat-topped mesas, buttes, and twisted canyons. In Monument Valley, the helicopters were dwarfed by the colossal, vertical-sided, isolated buttes and pinnacles, some nearly a thousand feet high. Mell took dozens of photographs, as Foster's helicopter flew above and along the sides of the spectacular formations.

Mell breaks down the landscape to barest essentials. His palette is extremely sensitive, and he works with the structure of the landscape. He tells the story of the Southwest, and tells it well. — *Ray Dewey*

After Monument Valley, they flew over Piute Mesa to the solitary dome of Navajo Mountain. Still perhaps the least explored part of the Navajo Reservation, Navajo Mountain and the colorful, broken terrain of the Rainbow Plateau are carved by numerous deep gorges and box canyons. As the helicopters prowled the nameless canyons that radiated out from the mountain, they could see north to the towers of Monument Valley, and further on, the Henry Mountains in Utah. To the west rose the Vermilion Cliffs, and the tangle of canyons at the junction of the Little Colorado River and the Colorado River. Southwest the San Francisco Peaks stood on the horizon, while to the south and southeast Black Mesa brooded on the skyline.

Then they flew north to Lake Powell, hovered above Rainbow Bridge for photographs, and afterwards followed the lake until they veered south to pass over the Kaibito Plateau. Mell asked Foster to visit White Mesa Arch again, where the helicopters landed to explore the magnificent landmark.

Foster flew his craft through the arch several times, the rotor blades inches from rock. "It was like flying through the earth," Foster recalls.

That afternoon they landed at Page, where the helicopters were refueled. After dinner, Mell wanted to photograph the sunset around Lake Powell, so the helicopters lifted off from the airport and flew over the lake, searching for a place to land that had dramatic views. They found it at Gunsight Butte, a large monolith that rises nearly a thousand feet out of Lake Powell's shore. There was just enough space for the three helicopters to land on top. Foster's helicopter teetered on the edge of the butte so far that the skids protruded over and the craft rocked back and forth in the wind. All around, dark clouds muttered with thunder, and lightning flashed nearby.

As Mell and the station's photographer took pictures and Foster recorded narration, the group heard a buzzing sound. A blue light started to flicker along the edges of the helicopter's tail rotors Then a sudden realization hit: With all that metal clustered on top, Gunsight Butte had turned into a giant lightning rod. Both Mell and Bryan Neumeister, Foster's cameraman, yelled, "Let's get out of here!" Everyone piled into the helicopters and made a hasty exit. That evening at Wahweap Lodge, the participants told stories about the episode on Gunsight Butte that reached mythic proportions.

The next morning, the helicopters departed Page, dropped like stones over the rim past Glen Canyon Dam, then flew down Marble Canyon. The helicopters picked their way above the Colorado River, like dragonflies flying in single file, until they reached the mouth of the Little Colorado River— an activity that is now prohibited by National Park authorities. Foster and the other two pilots flew up the river for a mile or two, before finally finding a narrow sandbar to set their craft down on. Unless roiled into a chocolate-red color by storm runoff, the lower part of the Little Colorado River flows a brilliant but milky opaque turquoise, the result of mineral accumulations deposited into the river from Blue Springs upstream. Several members of the group, including Foster and Mell, went for a brief swim in the cold water, while others admired the dramatic rock formations on the canyon walls. Finally, the helicopters lifted off, corkscrewed up to clear the canyon rim, and returned to Phoenix.

A year or so later, Foster retired from flying. Recently, he has resumed his career, and now is a newscaster and helicopter pilot for Phoenix's NewsChannel 3 television station. The legacy of Foster and his helicopter made a difference not only in Mell's reference material, but in his first-hand comprehension for the scale of the Colorado Plateau.

"I still use slides from the helicopter junkets, and could paint the rest of my life from the images obtained on those trips," Mell reflects.

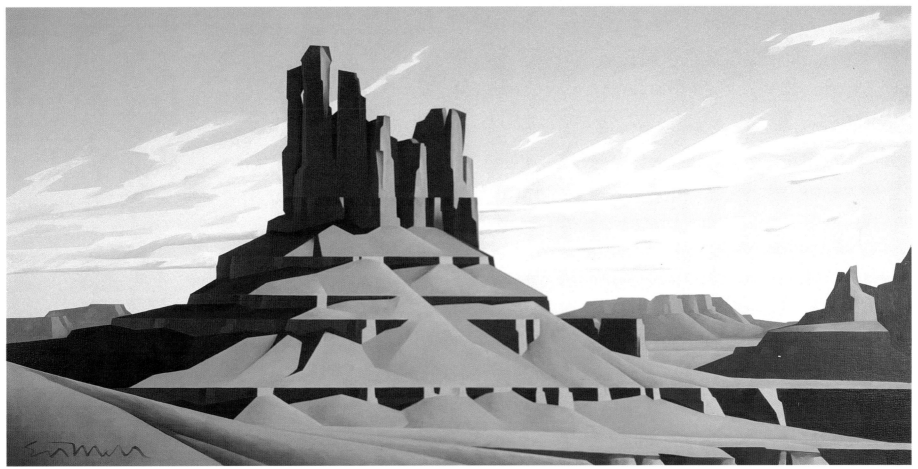

Noon, *oil on canvas, 24 in. x 48 in., 1985. Private collection.*

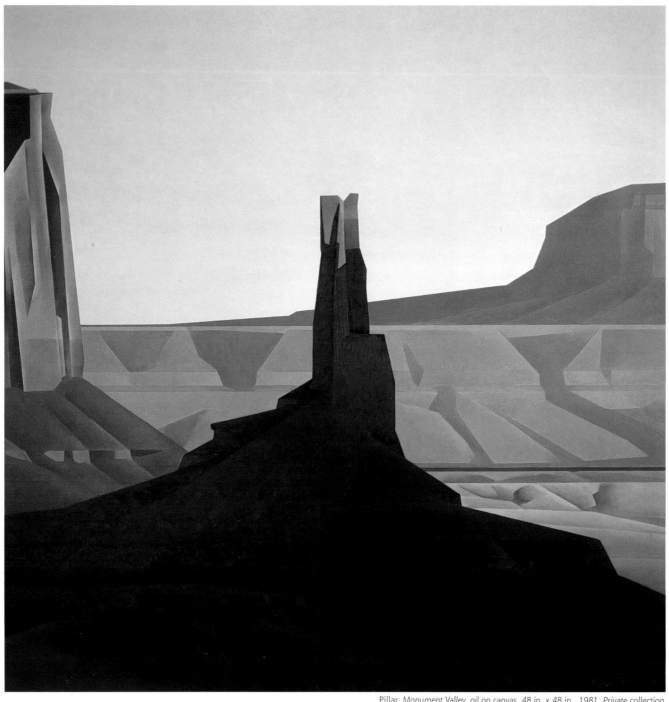

Pillar, *Monument Valley, oil on canvas, 48 in. x 48 in., 1981. Private collection.*

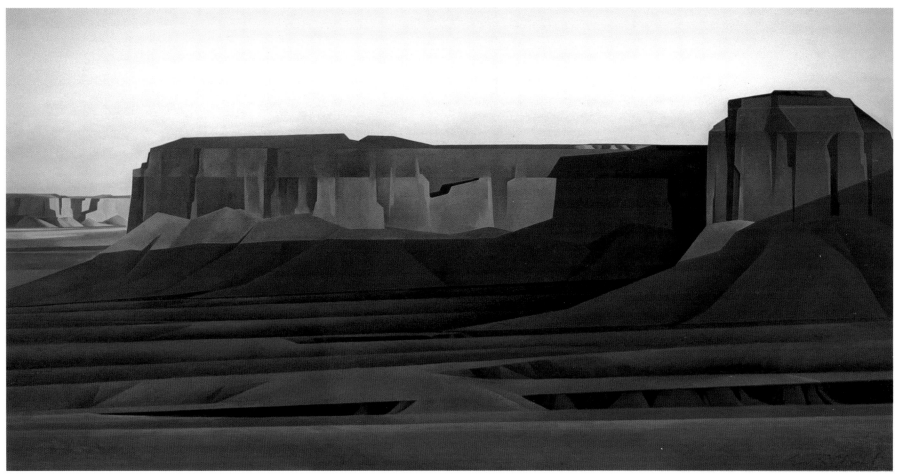

Train Rock, *oil on canvas, 36 in. x 72 in., 1980. Private collection.*

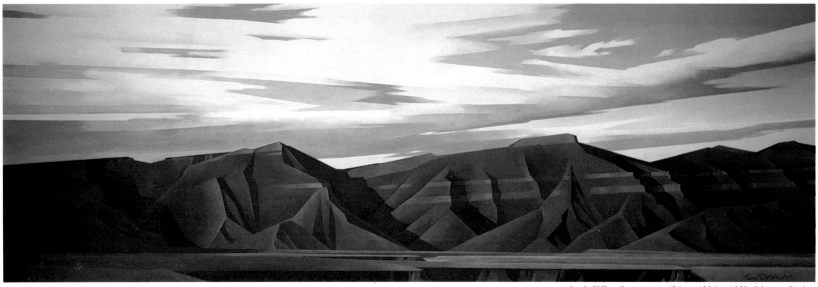

Lake Powell Cloud Drift, *oil on canvas, 30 in. x 96 in., 1982. Private collection.*

Book Cliffs, *oil on canvas, 40 in. x 120 in., 1983. Private collection.*

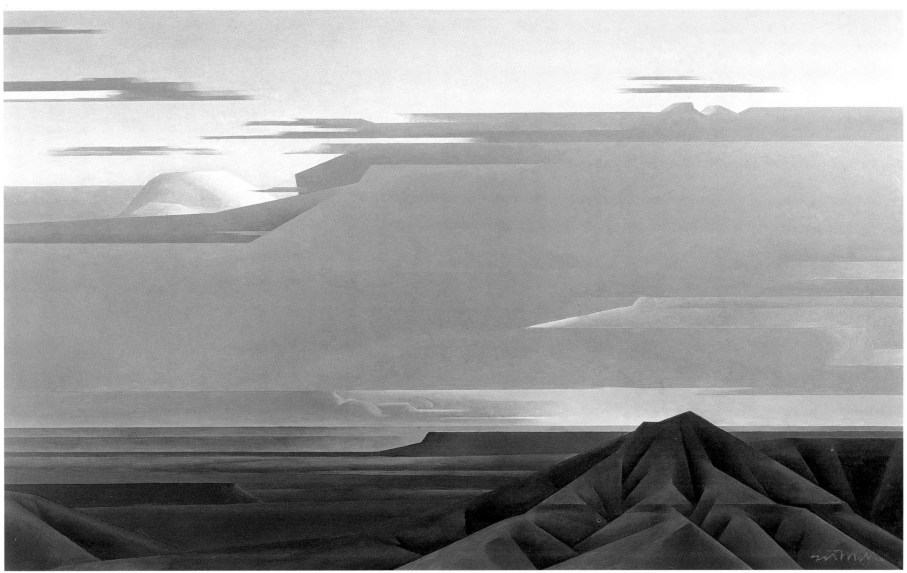

Mesa's Skies, *oil on canvas, 24 in. x 40 in., 1981. Artist's collection.*

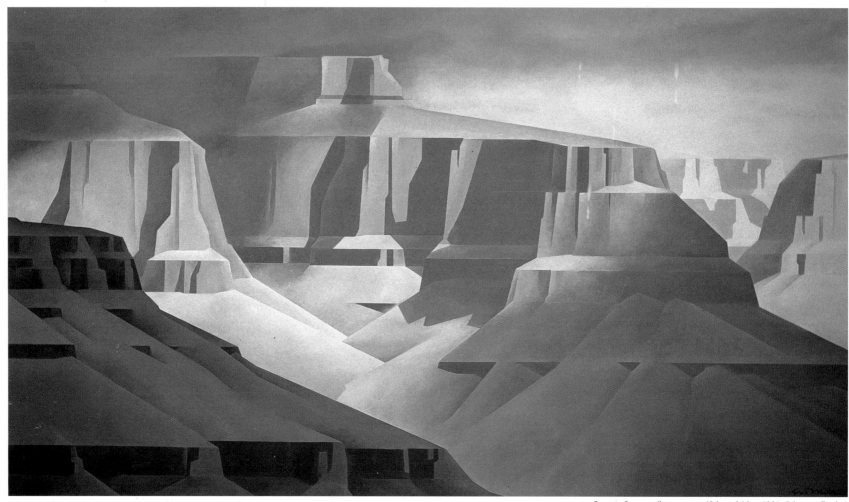

Canyon Storm, *oil on canvas, 48 in. x 84 in., 1981. Private collection.*

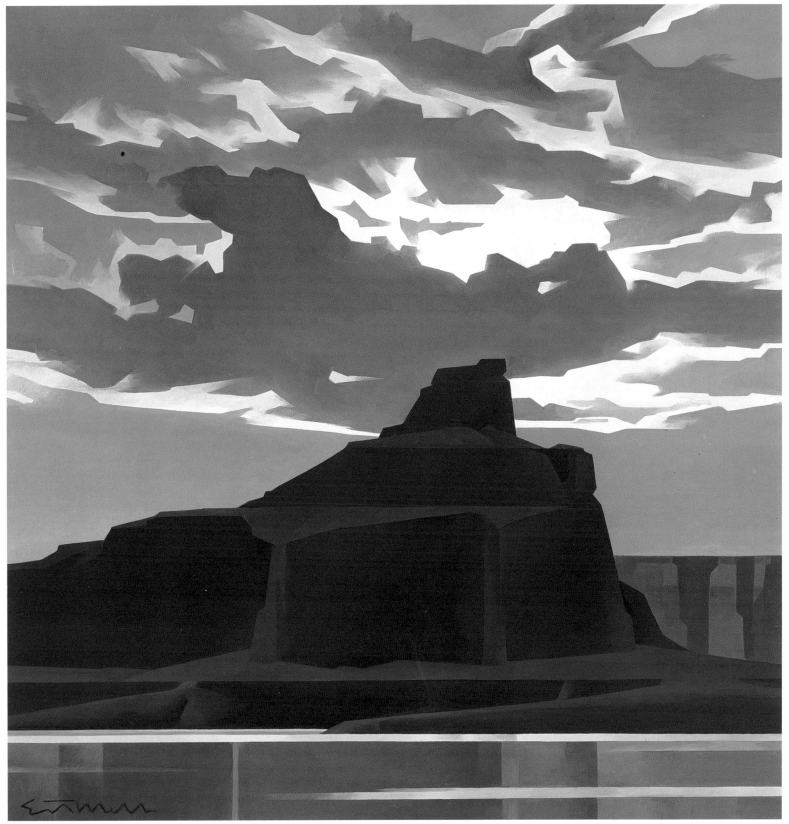

Boundary Butte, *oil on canvas, 30 in. x 30 in., 1984. Artist's collection.*

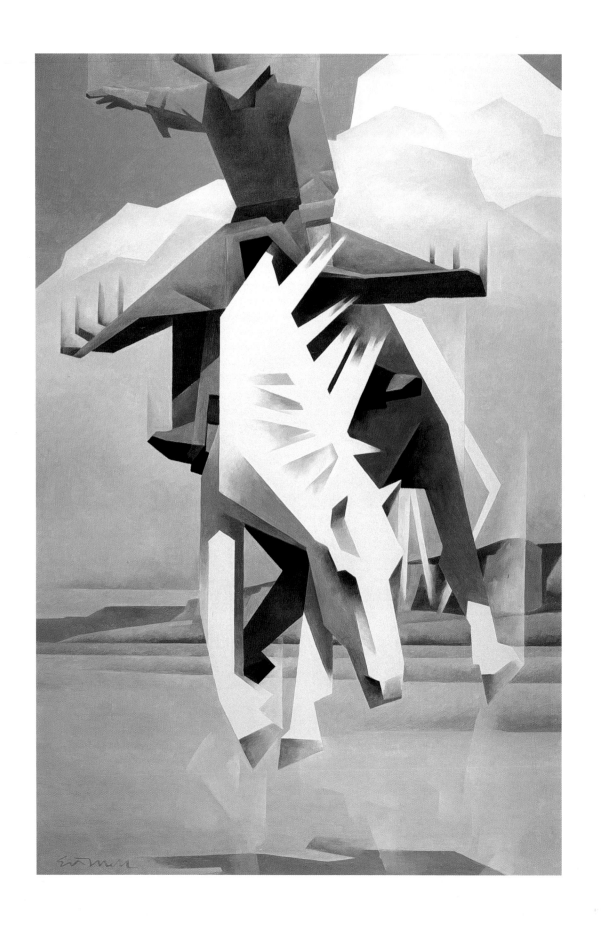

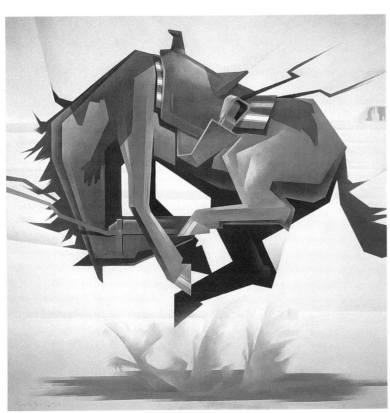

Just a Shadow of What He Used to Be, *oil on canvas, 54 in. x 54 in., 1983. Collection of Elizabeth Young.*

Opposite: This Palomino Ain't No Pal of Mine, oil on canvas, 36 in. x 24 in., 1982. Collection of Patti Valdez and Michael Collier.

At certain times Mell could feel his interest in landscape painting wane, and as he has done throughout his career, in 1981 he turned to other subjects to reinvigorate the art. He continued to paint landscapes, but now identified a different arena for subject matter: cowboys, horses, and that American icon, longhorn cattle.

Prompted by his sense of humor and his interest in traditional Western art, Mell considers these images an antidote, a flip side to his serious landscape paintings. Part of that stimulus comes from Mell's admiration for Alonzo "Lon" Megargee (1883–1960), an Arizona artist noted for wit and irony in his paintings, block prints, and lithographs. Mell collects Megargee's work; his home and studio are decorated with examples of his art. Megargee is best known for his painting *Last Drop from His Stetson*, a cowboy offering his horse water from his Stetson hat, used by Stetson and widely reproduced. Another one of Megargee's paintings, *Gone Are the Days,* hangs in Mell's Phoenix home. It portrays a perplexed cowboy in the Prohibition era paused in front of a saloon that advertises milk, soda pop, and ice cream.

Mell experimented with pastel sketches in an attempt to capture the energy of rodeo riders and bucking broncos. From the pastel drawings, he painted canvases of their angular figures set against austere landscapes. His first paintings in what might be termed the Old West figurative series included *This Palomino Ain't No Pal of Mine, Headin' Fer Dirt* (page 68), and *Just a Shadow of What He Used to Be.* Cowboys are joined temporarily, it seems, to bucking broncos, the animals and riders portrayed with planes and sharp points. Their images appear to cut through the canvas, jumping out with force and power. They also possess the visual irony of pop art.

Another painting, *Square Shooter* (page 69), shows a square-jawed gunfighter, eyes squinted, two pistols ready in his hands. The painting is done with cubist angles and straight lines. It could be Tom Mix or

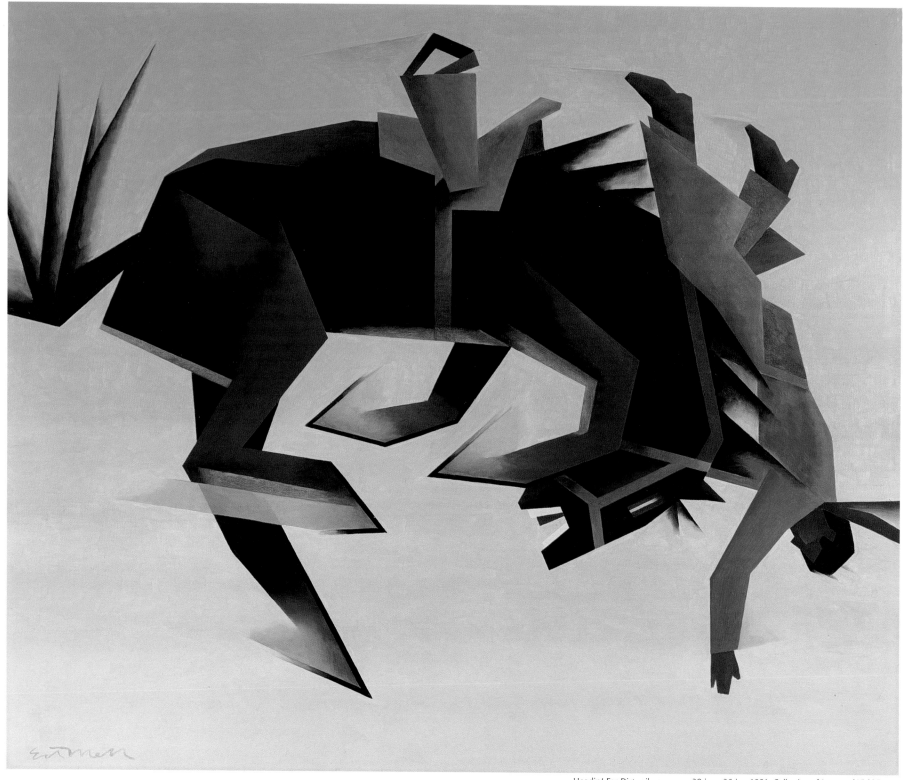

Headin' Fer Dirt, *oil on canvas, 30 in. x 36 in., 1981. Collection of Jerry and Vicki Foster.*

Square Shooter, *oil on canvas, 42 in. x 34 in., 1988. Collection of Arnold Schwarzenegger.*

a steely-eyed William S. Hart. Actor Arnold Schwarzenegger was in Santa Fe in the summer of 1988, filming the movie *Twins* with Danny DeVito, when he saw the painting displayed in a window at Dewey Galleries. Perhaps he sensed some similarity in profile, for he purchased the painting for his Los Angeles office.

Another Old West image that Mell admired was longhorn cattle. One of his friends kept some longhorns on a ranch in Chino Valley, north of Prescott. One day, Mell went there to take photographs of the cattle out on the open range. As he started to photograph the animals, a farmer in a nearby field began to plow the dry earth with a tractor. A strong wind rippled the dust through the longhorn herd. At first, Mell thought this would disrupt his photography, but then he saw something else. Later, he made a pastel drawing, and from that painted *Longhorn Duststorm* (page 77). The colors of the longhorns are obscured by the blowing dust but their shapes remained outlined, while light filtered through the dust plays upon their gray forms.

"It was something new and fresh, Mell says, "that dusty kind of look I have always admired in Old West paintings."

In a similar fashion, *Movin' the Herd* (page 80) captures a cattle drive. A cowboy hazes a group of longhorns along a trail at the end of a desert day, as the fading sun backlights a cumulus cloud and faraway mountain range.

He can bend the anatomy of a horse and rider so far, yet you can still tell what kind of horse and rider they are. Mell finds and splits the point between realism and abstraction. *—Bob Boze Bell*

The gaunt, powerful, angular shapes of longhorns attracted Mell, and he saw them worthy of formal portraiture. The early cowboys in the Southwest described the longhorn steer as tall, bony, coarse-haired, flat-sided, thin-flanked, three-fifths horn and hooves, and the rest, hair. In *Southern Arizona Longhorn* (frontispiece), Mell presents this impression of a longhorn, but adds more, as if it were sculpted from the land itself. The animal appears like a statue in the landscape: colossal, grandiose, and, as befits a longhorn steer, supremely confident. Likewise, *Cordes Longhorn* (page 76) and *Movin' Closer* (page 70) are individual portraits of three longhorns, each with a different longhorn personality. Their colors are varied earth tones; their stance speaks of self assurance.

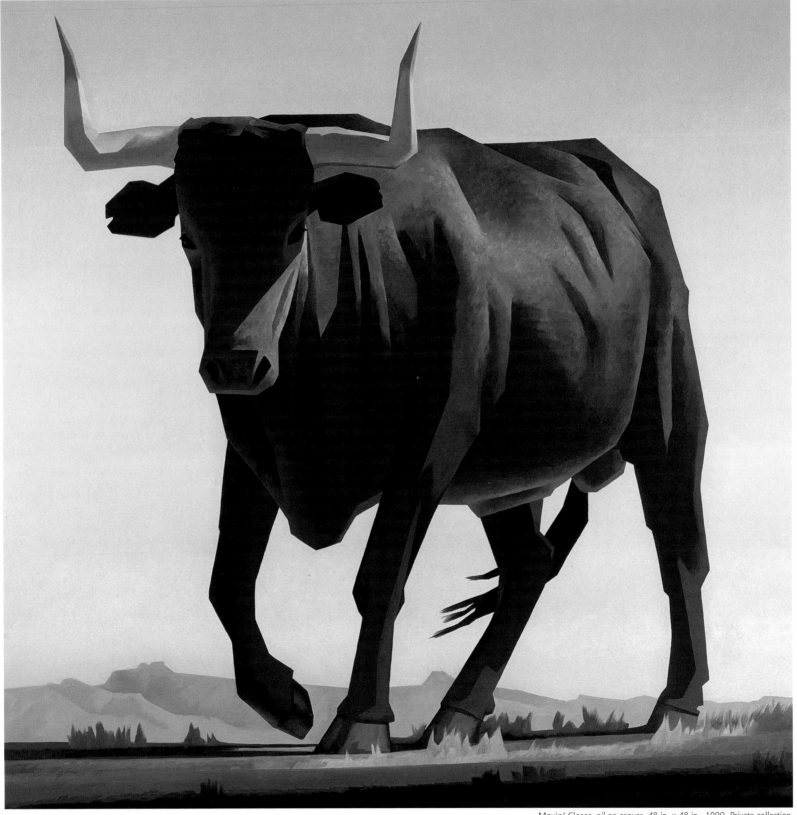

Movin' Closer, *oil on canvas, 48 in. x 48 in., 1990. Private collection.*

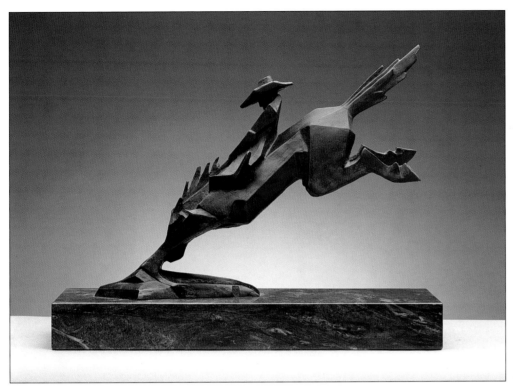

Diggin' In, *bronze, 11 in. x 14 1/2 in., x 4 in., 1985.*
(Photograph by Dan Vermillion.)

Other, varied images attracted his eye. In *Dusk Branding* (page 80), Mell has captured the feel of cowboy culture. Three cowboys, their forms hunched over a steer they are about to brand, are designed with sharp angles and planes. *Desert Vultures* (page 83) portrays two birds clustered on a cactus, their dark forms sinister against the dwindling light. Still another painting, *Zanjero* (page 82), connects a spade to the hand of a field-worker set against the backdrop of irrigated fields. The painting reflects strict economy, emphasized by strong lines, with the feel of an emblem suggestive of hard, backbreaking work.

Interested and adept in other mediums, Mell bought some plasticine clay one day in 1985. As he watched television with his two sons over the next several evenings, he molded and sculpted the clay into a form. As in his cowboy and longhorn paintings, Mell wanted to express nostalgia in the three-dimensional sculpture that emerged. Soon he had created *Diggin' In*, a thirteen-inch-high figure. Pleased with the results, he had the sculpture formed in bronze at the D'Ambrosi Arizona Bronze Foundry in Tempe, then issued it in a limited edition of thirty casts. The sculpture seems to move through kinetic energy, with the angular shapes of the cowboy and horse done in almost monochromatic dark gray and blue-green colors. Mell brought his painting style, with its emphasis on design and stylization, over to sculpture, giving it speed and energy.

"I think it conveys a little of the craziness of riding a bucking bronco," Mell says of *Diggin' In*. "I like to deal with that insanity, and insanity is abstract to begin with. I was also eager to give a contemporary feel to a subject matter and a medium that are traditional."

When the *Diggin' In* sculptures were released to Suzanne Brown Galleries and Dewey Galleries, they quickly sold out. Mell then developed another limited edition bronze, *Rearin Back,* again done in an edition of thirty pieces. That was followed by *Two Horses* in 1990. In 1993, he did a bronze of a longhorn, which he titled *Toro del Yermo*.

One of his sculptures, though, became larger than life. The City of Scottsdale announced an open competition in 1991 for a public sculpture destined for the intersection of Marshall Way and Main

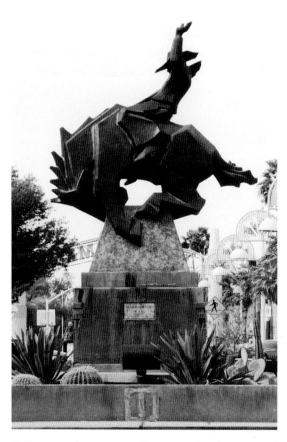

Street in the heart of the city's art district. A committee formed by the Scottsdale Cultural Council selected one of nine entries, a design by Luis Jimenez of a wild bull-and-rider fiberglass sculpture finished with bright, glossy jet-aircraft colors. However, the Jimenez piece was considered too avant-garde for tradition-oriented Scottsdale. A local petition effort was even undertaken to reverse the selection. The competition was reopened the next year and this time attracted over a hundred entrants, among them Mell, who had not entered the first time.

Mell first made a small, hand-worked wax maquette, a model of the sculpture he envisioned, and entered it in the competition. The Scottsdale Cultural Committee selected his design from the entries and awarded him a seventy-eight thousand dollar commission. He called the sculpture *Jack Knife*, a cowboy attempting to maintain connection with a rearing horse. Their intertwined forms are fragmented into a mass of planes reminiscent of the 1930s streamlined style.

Mell refined and adjusted the proportions of the small clay model into first a one-foot version, then into a two-foot sculpture. "With clay, you can add and subtract," Mell says. "Besides, the clay models are like my studies for paintings." As Mell worked on the sculpture, he consulted with architect John Douglas about the sculpture's base, and with landscape architect Nancy Wagner. Then Mell spent several months in the creation of a life-size clay. Under the design specifications the ultimate goal was a heroic eight-foot-tall sculpture. The sculpture was then molded into fifty sections, which were cast in molten bronze by Arizona Bronze Foundry artisans. They then reassembled the sections and finished the work. In early December 1993, a year from when Mell started creating it, the massive sculpture was lifted onto the six-foot base and installed.

Jack Knife, bronze, 8 1/2 ft. x 7 ft. x 3 3/4 ft. on a 6-ft. base, 1993. Located at the intersection of Marshall Way and Main Street in downtown Scottsdale.

Jack Knife has a reverence for the Old West. It is not traditional, but yet it has a traditional theme. The angularity accelerates the power and energy of the rider and horse, more than accurate depiction. — *Ed Mell*

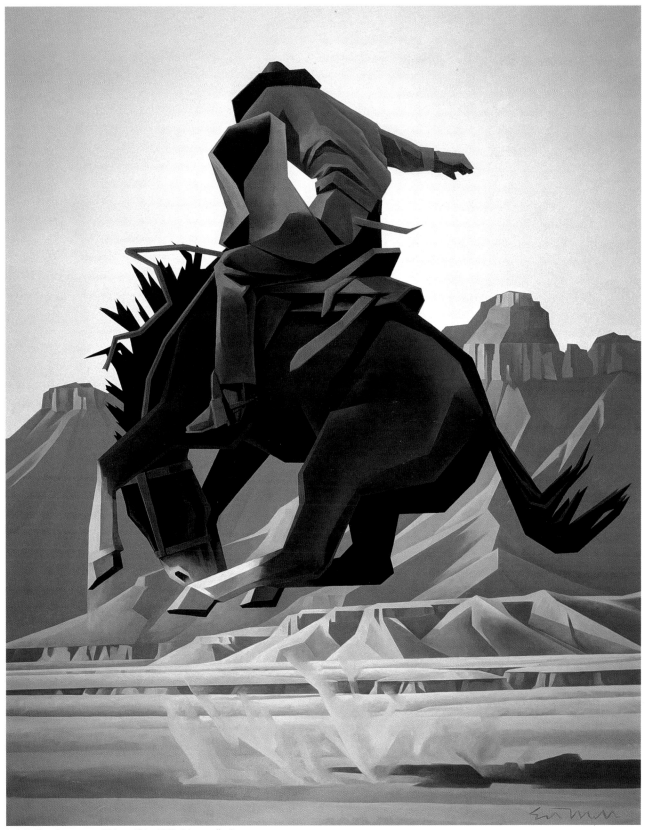

Jack Knife, *oil on canvas, 60 in. x 48 in.,1985. Private collection.*

"Ed Mell speaks to the region more than anyone else," says Marc D'Ambrosi of the Arizona Bronze Foundry. "Mell's rendering of *Jack Knife* appeals to both the supporters of contemporary art and people who prefer more Western. He melds the two sides well."

Besides creating the cowboy and longhorn paintings and the sculpture, Mell utilized his designer background in other ways. In 1991, he painted a canvas for the Copperstate 1000, an annual four-day antique car rally sponsored by the Phoenix Art Museum, in response to a request from museum director James Ballinger. As the name implies, each year a thousand-mile route takes rally participants through various regions of Arizona. The painting, an image of an automobile on a desert highway, was reproduced as a poster, and the painting itself was auctioned off to the highest bidder by the event's promoters as a fundraising venture. Mell, who had acquired a pristine 1962 Corvette by then, and who has never lost his love for vintage cars, entered the rally. He now paints an image each year for the event, which the sponsors reproduce as a poster. Mell also enjoys driving in the rally.

> **I want to play with Western stereotypes in a contemporary manner. It is a good release for me from landscape painting, which is my serious side.** —*Ed Mell*

The images interweave the fantasy presence of automobiles with the Southwestern landscape. One painting, for instance, *Braking the Mesa,* the poster for the 1994 rally, depicts an automobile, its blurred shape reminiscent of the old streamlined design that emphasized speed, roaring along a convoluted highway. Mell designed the clouds above to mirror some of the vehicle's physical features, with louvres and exhaust pipes subtly integrated into the cloud shapes.

Mell's paintings of cowboys, longhorns, and automobiles, along with his sculpture, while not in the mainstream of his art, are nevertheless an important support for his landscape painting. His landscapes are strengthened when he returns to them by these attempts to remain fresh and vital. Perhaps this narrative work—or storytelling—is a form of artistic therapy, or more appropriately, experimentation. Most of the figures are set against a landscape. Mell has tried to interweave the landscape with a human rather than a sublime scale. On the surface, the paintings reflect pop art themes, yet Mell has managed an approach in which he believes the painting itself should be beautiful, rather than what the painting refers to.

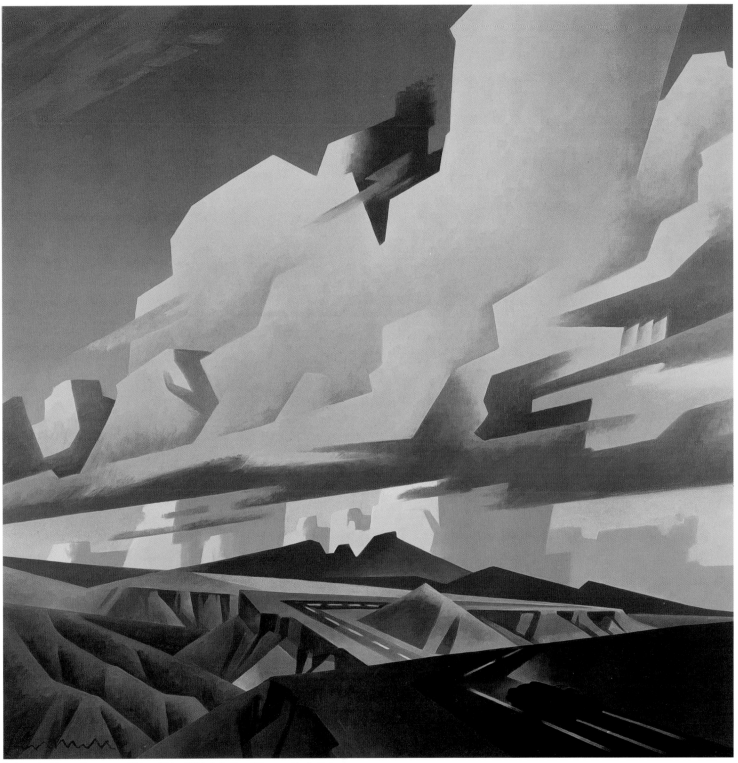

Braking the Mesa, *oil on canvas, 36 in. x 36 in., 1994. Collection of Bruce and Leslie Male.*

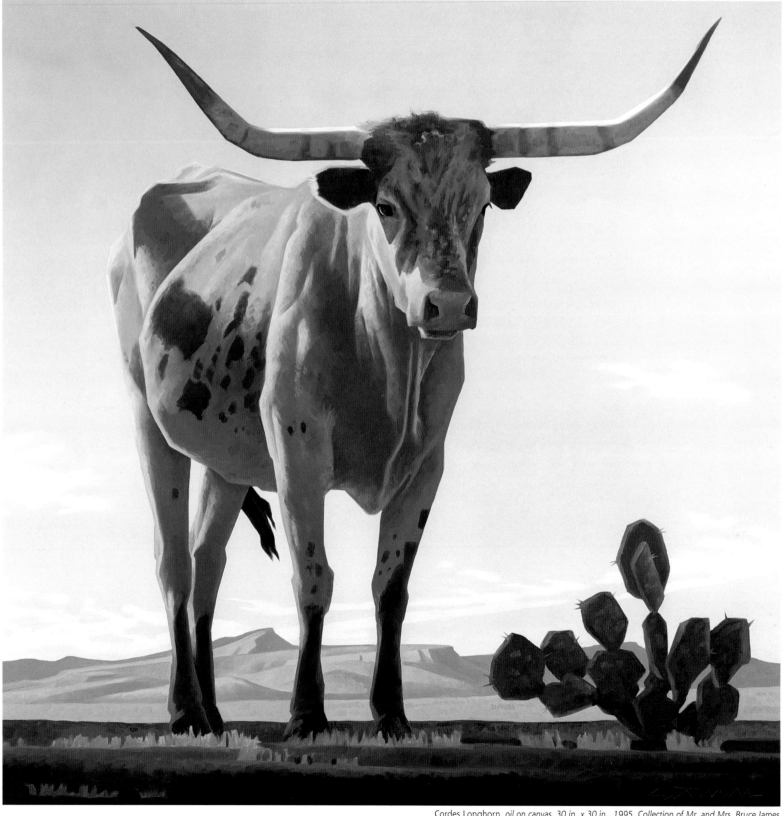

Cordes Longhorn, oil on canvas, 30 in. x 30 in., 1995. Collection of Mr. and Mrs. Bruce James.

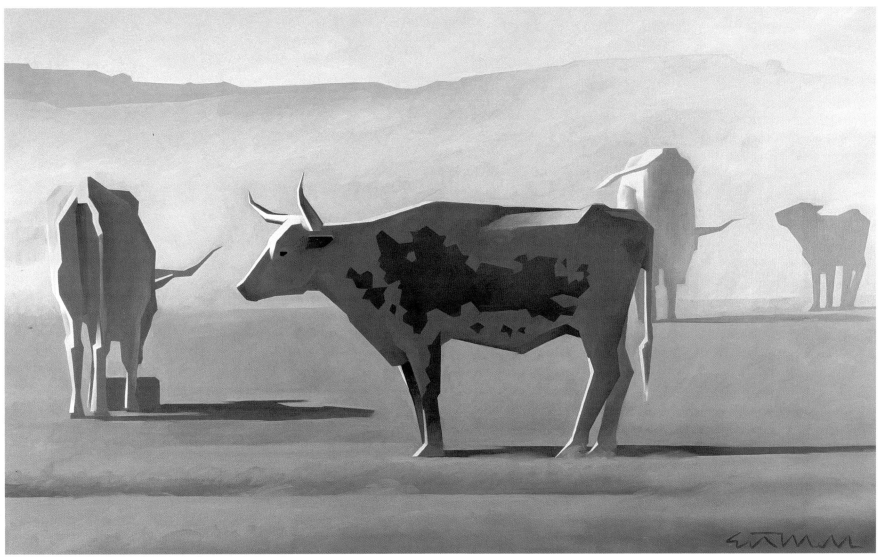

Longhorn Duststorm, *oil on canvas, 24 in. x 40 in., 1988. Private collection.*

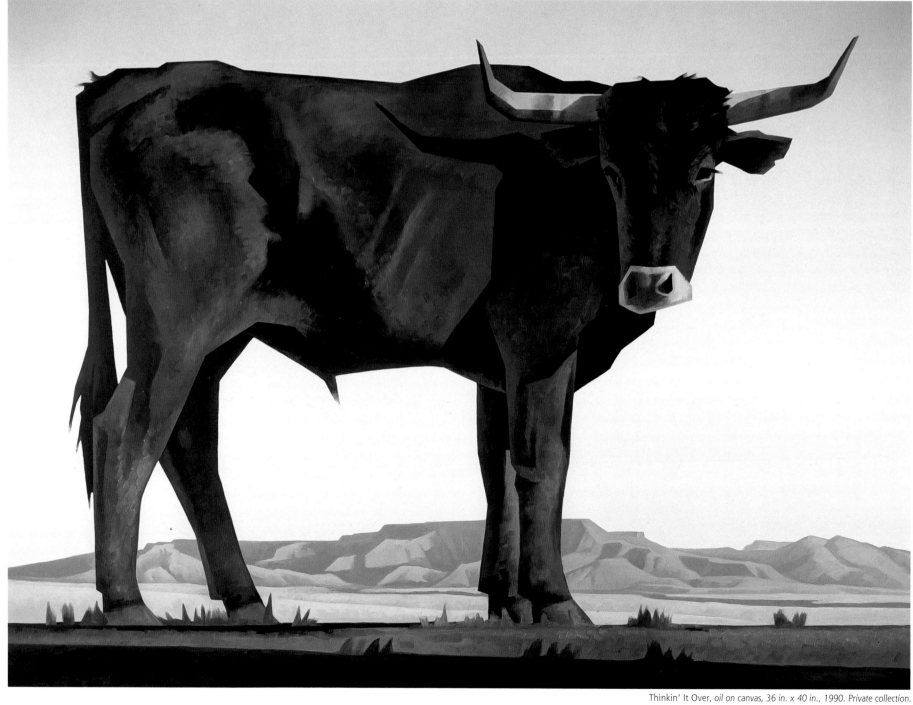

Thinkin' It Over, *oil on canvas, 36 in. x 40 in., 1990. Private collection.*

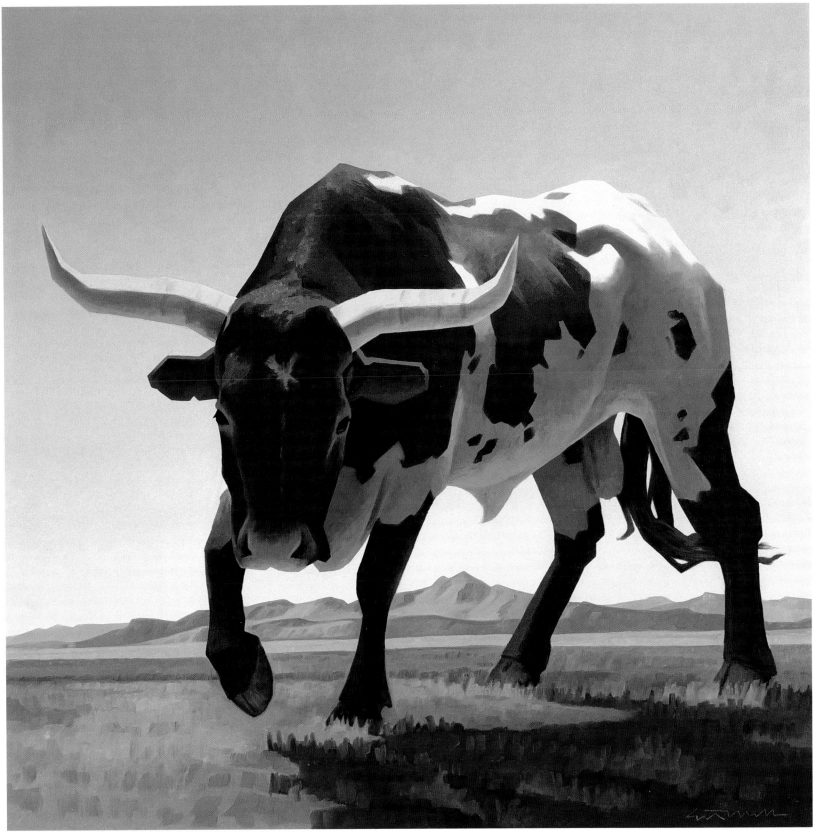

On the Move, *oil on linen, 30 in. x 30 in., 1995. Private collection.*

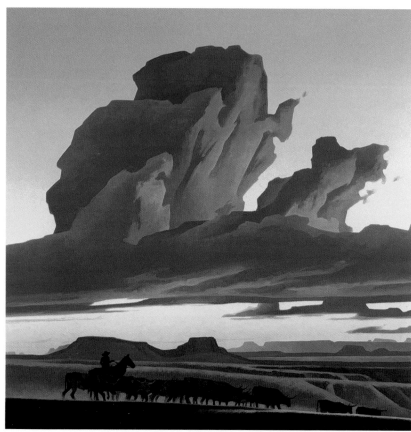

Movin' the Herd, *oil on canvas, 60 in. x 60 in., 1993. Collection of Richard B. Burnham.*

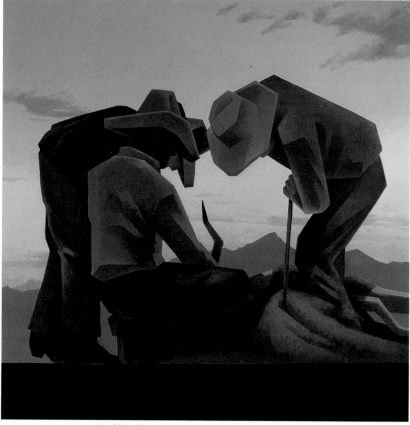

Dusk Branding, *oil on canvas, 38 in. x 38 in., 1993. Collection of Edward J. Martori.*

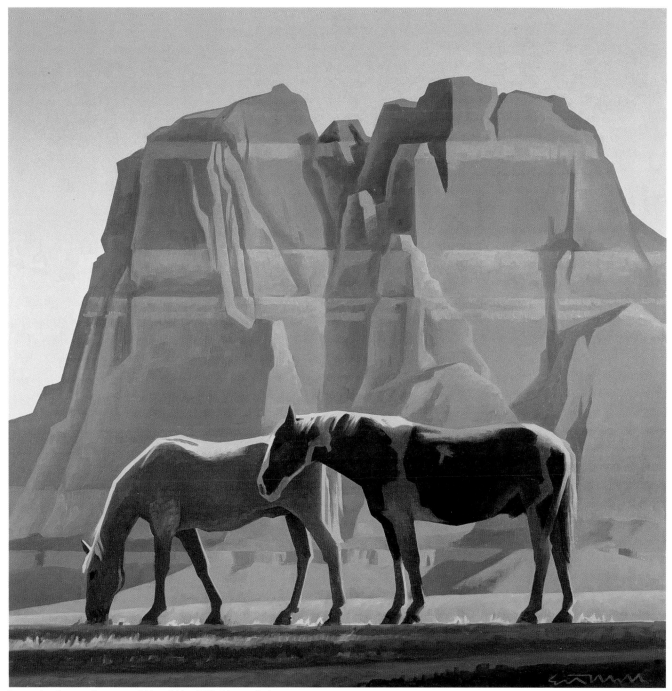

Reservation Horses, *oil on canvas, 24 in. x 24 in., 1993. Private collection.*

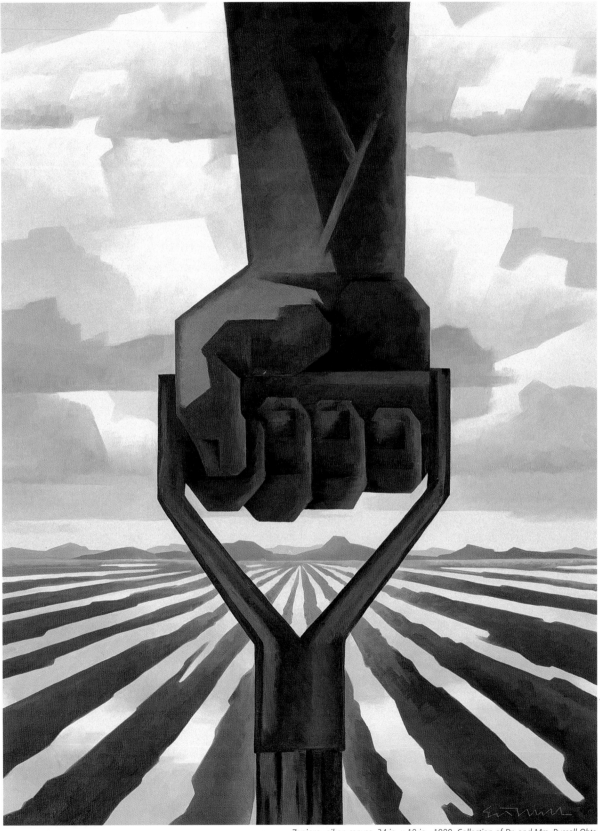

Zanjero, oil on canvas, 24 in. x 18 in., 1989. Collection of Dr. and Mrs. Russell Ohta.

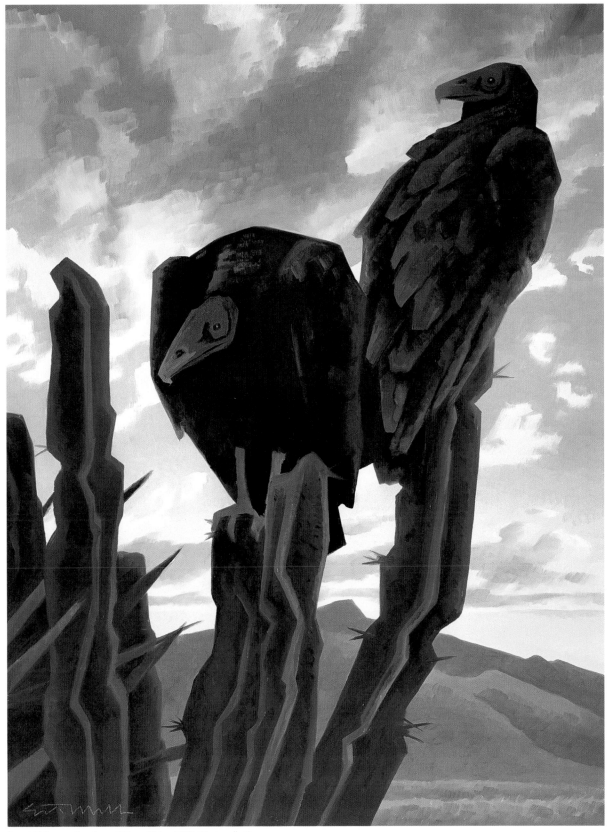

Desert Vultures, *oil on linen, 24 in. x 18 in., 1990. Private collection.*

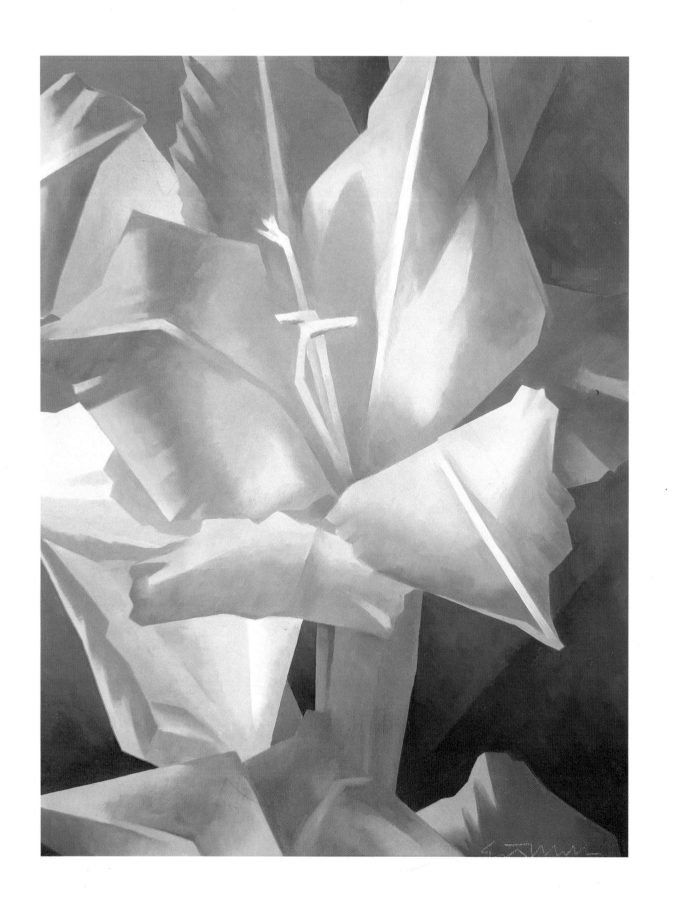

Opposite: Pink Gladiolas, oil on canvas, 24 in. x 18 in., 1988.
Private collection.

Sometimes the passion for painting landscapes subsided, and Mell, no matter how much he tried, could not force the paint to say what he wanted it to say. He had turned to other subjects before—cowboys, cattle—and to the medium of sculpture. But in 1988, he identified an entirely different topic: flowers.

Mell was attracted to the flowers' forms, or maybe their colors, but cannot remember what prompted him to paint them. One day he decided to experiment and purchased a potted plant from a local nursery. He equipped one of his cameras with a macro lens, photographed the petals on the plant from various angles, then painted an oil of the flower, which he titled *Pink Gladiolas.* Like in his landscape paintings, he experimented with the flowers' forms and their colors.

He continued to paint landscapes, but flowers now began to assume a larger role in his subject matter. Mell did not venture far in search of dramatic flower subjects: they were found behind the alley that ran by the studio, or next to the building, or along a nearby road. As he does for landscape paintings, Mell draws on the camera initially to help describe the flowers for a study. These images, with the camera's assistance, are painted with regard to the flowers' singular beauty and personality.

> **At first I thought his flowers were just a diversion, but I was wrong, for he has taken flower painting to a new height. Where Georgia O'Keeffe favored a delicate, sensual approach to her flower works, Mell's are masculine, forceful, almost like steel.** —*Bob Boze Bell*

Still other flowers—petunias, hollyhocks, and carnations—emerged as portraits, selected for their shapes and colors. *Pink Carnation* (page 92) is based on Mell's perception of the flower petals' fluidity. They are natural objects recreated into almost plastic form, executed in Mell's tight, meticulous style, and in large scale. With *Two Petunias* (page 91), Mell has discovered another kind of truth, where these flowers emanate a powerful life force of their own. Their colors are bold and dramatic, and with enhanced scale, the flowers' presence seems more solidly tangible and persuasive than in reality.

Still another plant, and one he would paint frequently, was close at hand. Several species of cactuses grow around his studio, and Mell, attracted by their flowers, assertive colors, and shapes, began to

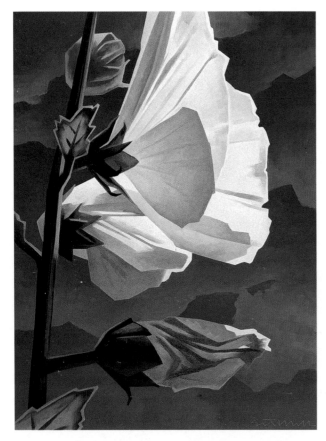

Pink Hollyhocks, *oil on linen, 20 in. x 15 in., 1993. Collection of Dr. and Mrs. Charles Taggart.*

study them closely. He would photograph the cactus flowers in various stages of bloom, from the tight, compact bud to the final stage as the petals embraced the light. In *White Cactus Bud* (page 95), Mell painted the still-compact flower in the first stage of unfolding. Set against a dark background, the regal flower is ready to emerge. He isolated the petals, as he has in all of his flower paintings, so that they dominate the composition. The reduction of the image to crucial lines and colors heightens the clarity of the painting.

Mell carried the life process of the cactus flower further when he painted *Regal Cactus Bloom*, *Crimson Cactus Bloom* (page 94), and *Blooming Beaver Tail Cactus* (page 93). In these paintings, the flowers have unfolded. When we look at them we are startled into noticing the bold, almost confrontational flower forms that crowd and fill the frames. Mell has made an attempt to venture beyond the facts that define the flowers' appearance, and look more closely to discover principles that dictate their designs. At other times, Mell experimented with an angular, expressive approach, as in *Crimson Edges* (page 95), where the real forms of the flowers were reconstructed into more abstract images.

One painting in particular celebrates a unique desert plant. The night-blooming cactus is a cryptic plant that hides in the shade of desert trees, shrubs, or convenient buildings. They bloom only for three or four nights a year, but the flowers emerge as magnificent silky-white forms in the shape of trumpets. One morning as Mell was arriving at his studio, he spotted one of the cactuses huddled next to the building. Struck by the intensity of the blooms, he snapped off a few flowers, then photographed them outside in the sunlight.

Flowers have such an intensity of color to them. I think I brought some of that back to my landscape painting. —*Ed Mell*

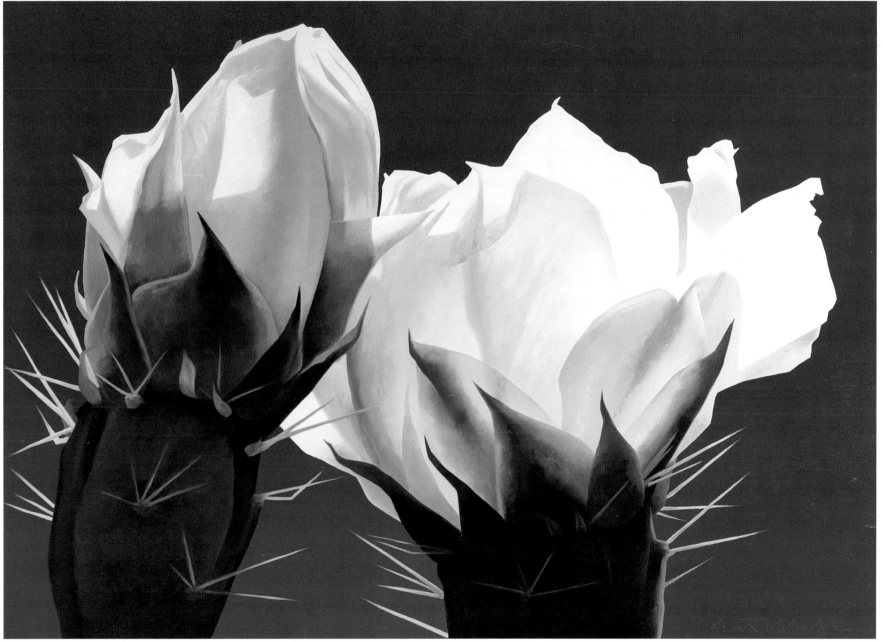

Regal Cactus Bloom, *oil on canvas, 32 in. x 44 in., 1996. Collection of Mr. and Mrs. Abraham Friedman.*

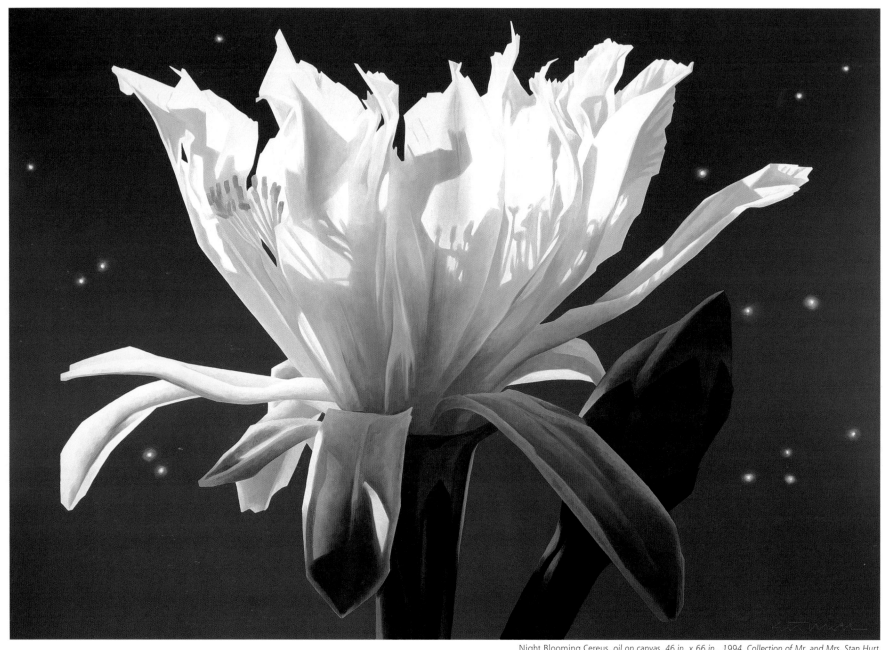

Night Blooming Cereus, oil on canvas, 46 in. x 66 in., 1994. Collection of Mr. and Mrs. Stan Hurt.

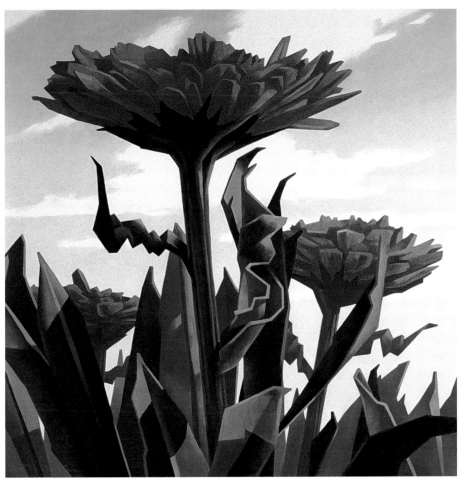

In the Garden, *oil on canvas, 32 in. x 32 in., 1990.*
Private collection.

Mell applied landscape principles to flowers and it worked.
He has created a new visual vocabulary. —*Bill Schenck*

The result was *Night Blooming Cereus*. The flower is enlarged and magnified until it has become, it seems, a landscape. Actually, the term *flowerscape* might be more appropriate for an image that has assumed grander scale, with the sense of a powerful force of its own. The paint that shimmers upon the canvas accentuates the contours of the flowers against the background of the crystal-clear, star-dotted desert night that has provoked their bloom.

As Mell gained confidence with his flower paintings, they began to exhibit the character of his landscape work: monumental, and endowed with an immensity not unlike the plateau's landforms. The simplified symbols of his flowers stand only for themselves, yet by virtue of his designs, the paintings are both intimate and panoramic.

"His flower paintings have a sense of volume and of light," says fellow Arizona artist Bill Schenck.

The flower that has become one of his favorites is the rose. Roses are different, he says, with their elegant curves and luminosity so apparent as light strikes the petals. When Mell started a painting, he first took photographs of the roses' transparency, positioning them so that light filtered through their petals. In *White Rose* (page 98) and *American Beauty* (page 99), among others, he painted compositions where the sinuosity of the flowers' stems and petals are dominant elements, presented against what appears as boundless space. These paintings are simplified and stylized, not literal, as Mell endowed them with an inner vitality. Without the loss of delicacy and presence, Mell infused the paintings with a strong design, a tension between representation and abstraction. In the designs, he took the curves of the flowers and expanded them, increasing their fluorescence.

Mell's handling of *Violet Rose* (page 100) and *Open Rose* (page 101) emphasizes the organic curves of the petals, which turn and twist, and the stems of the plants. Stirred by the rose's diaphanous colors, Mell posed the flower against a teal-blue background, letting the delicate pink shades of the petals burst forth. The rose appears grander, more flagrant than in real life. The chrysanthemums in *In the Garden*, which Mell

designed so that the viewer looks upward at them, seem like abstract spires set on a vast landscape, their forms hard like colored metal, radiant under the Southwestern light. In both of these works, as in his other flower paintings, Mell shaped the petals and leaves so that the eye is drawn to the center of the composition.

Invariably, Mell's flower paintings are compared to those of Georgia O'Keeffe. Critics have emphasized the feminine imagery and symbolic aspects of O'Keeffe's flower works, but as someone once remarked about them, they are and are not flowers. Both Mell and O'Keeffe have enormously enlarged their flowers to transform them into not only new spatial dimensions, but a different kind of visual perception. Their flowers are translated into microscopic visions, worlds unto themselves. But the intent of Mell's art and O'Keeffe's art is different. O'Keeffe painted her flowers vertically, in most cases, with three-quarter views downward, whereas Mell's flowers are usually, although not always, executed in a horizontal format. He looked carefully at his landscape painting and translated his techniques successfully to flower painting. While Mell is primarily interested in the visual design and impact of his flowers, O'Keeffe endowed her work with mysticism, and probed their identity as specific, perhaps sensual, things.

> **I asked my friend Erma Bombeck to come over to the gallery and look at one of Mell's flower paintings. She replied she hated flower paintings, but she came anyway. She fell in love with the painting as soon as she saw it, and purchased it immediately**. —*Suzanne Brown*

Mell turned to flower painting in order to cleanse his sight, so that he might return to landscapes with renewed vigor and insight. Like he saw the plateau's landscapes, he conceived images of flowers, which were not only created by light, but constructed by it. In turn, he has taken that luminosity of flowers and translated it back into his landscape painting. Besides, Mell has found, through utilization of different angles of vision, he could uncover new forms in flower subjects. He moved his viewpoint closer to the objects, and was thus able to break through their outline to reveal a different, more abstract quality.

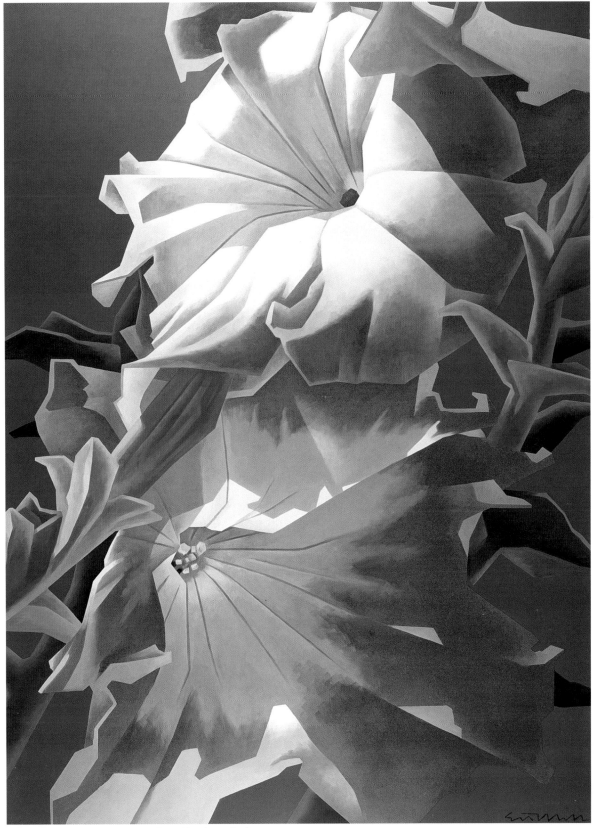

Two Petunias, *oil on canvas, 54 in. x 36 in., 1990. Private collection.*

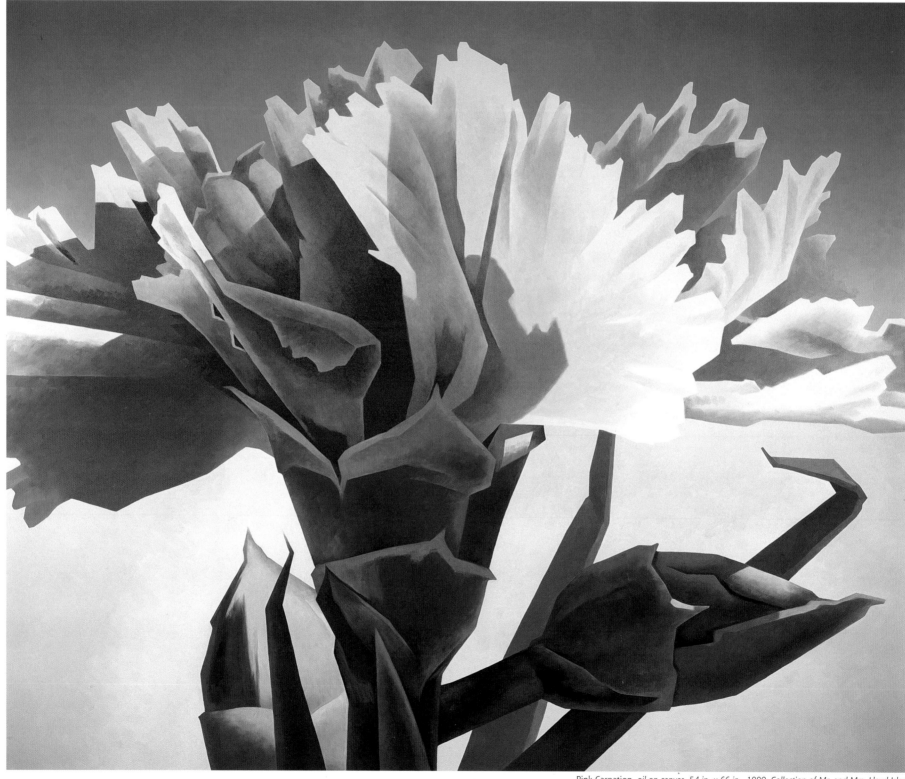

Pink Carnation, *oil on canvas, 54 in. x 66 in., 1990. Collection of Mr. and Mrs. Lloyd Isler.*

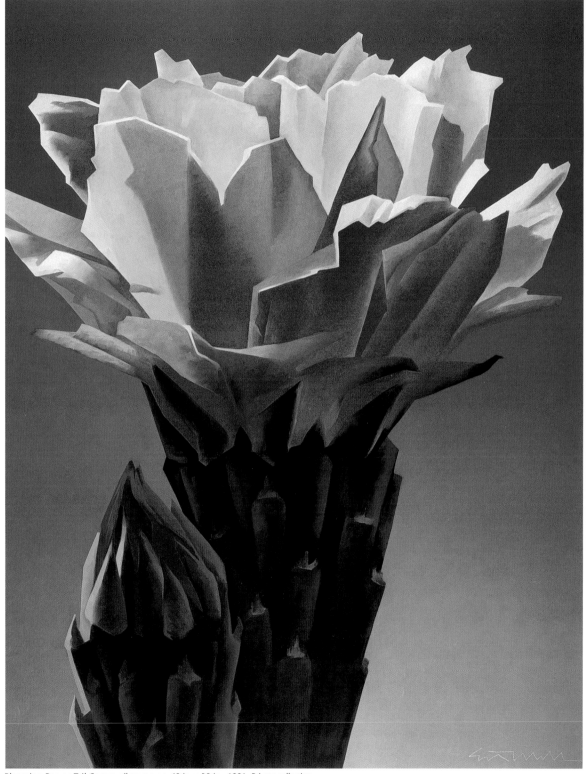

Blooming Beaver Tail Cactus, *oil on canvas, 40 in. x 32 in., 1991. Private collection.*

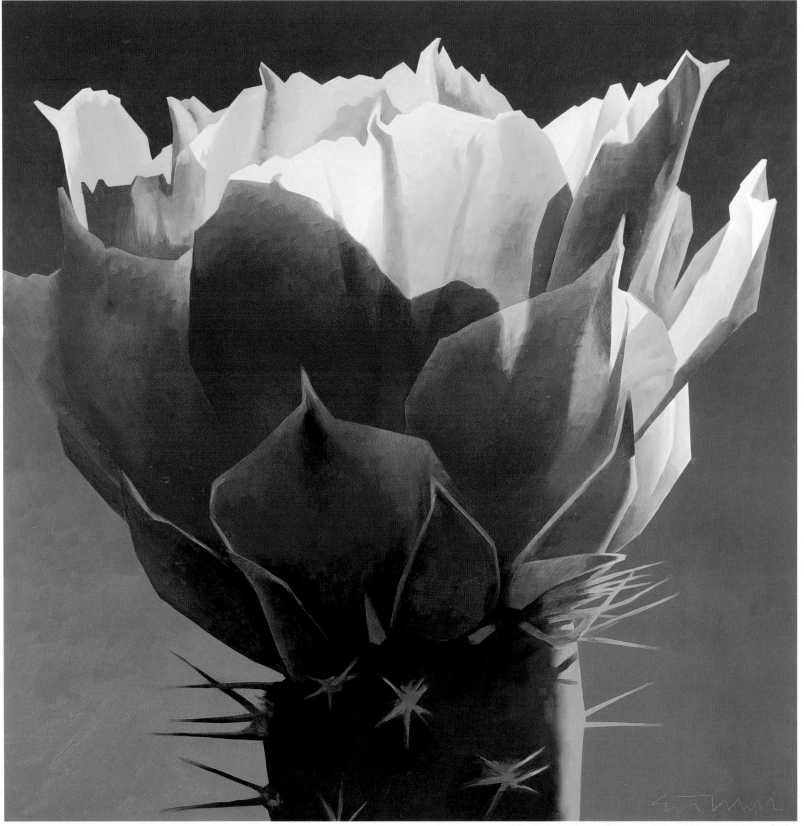

Crimson Cactus Bloom, *oil on canvas, 32 in. x 32 in., 1992. Private collection.*

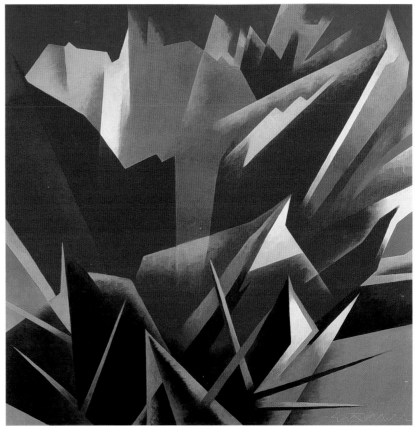

Crimson Edges, *oil on canvas, 32 in. x 32 in., 1993. Private collection.*

White Cactus Bud, *oil on canvas, 40 in. x 30 in., 1989. Private collection.*

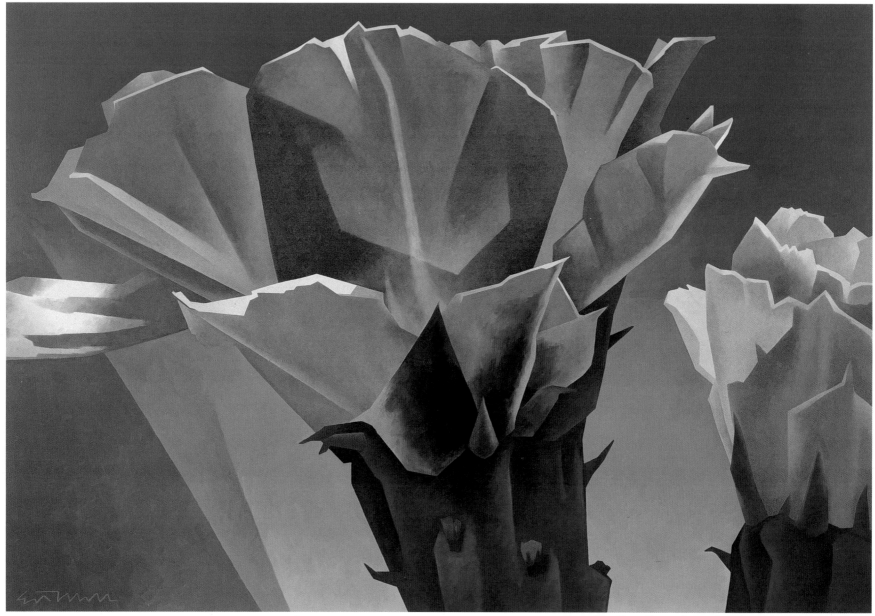

Open Cactus Bloom, *oil on canvas, 66 in. x 96 in., 1990. Private collection.*

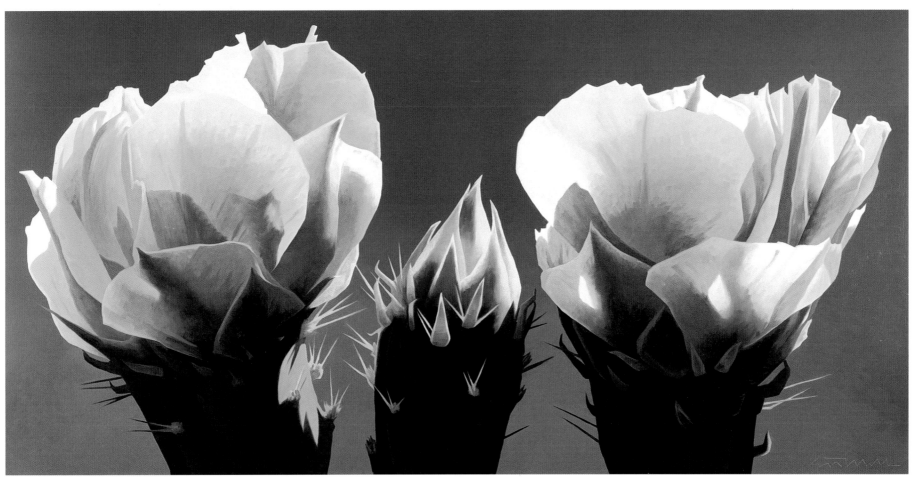

Phases of Bloom, *oil on canvas, 30 in. x 60 in., 1996. Private collection.*

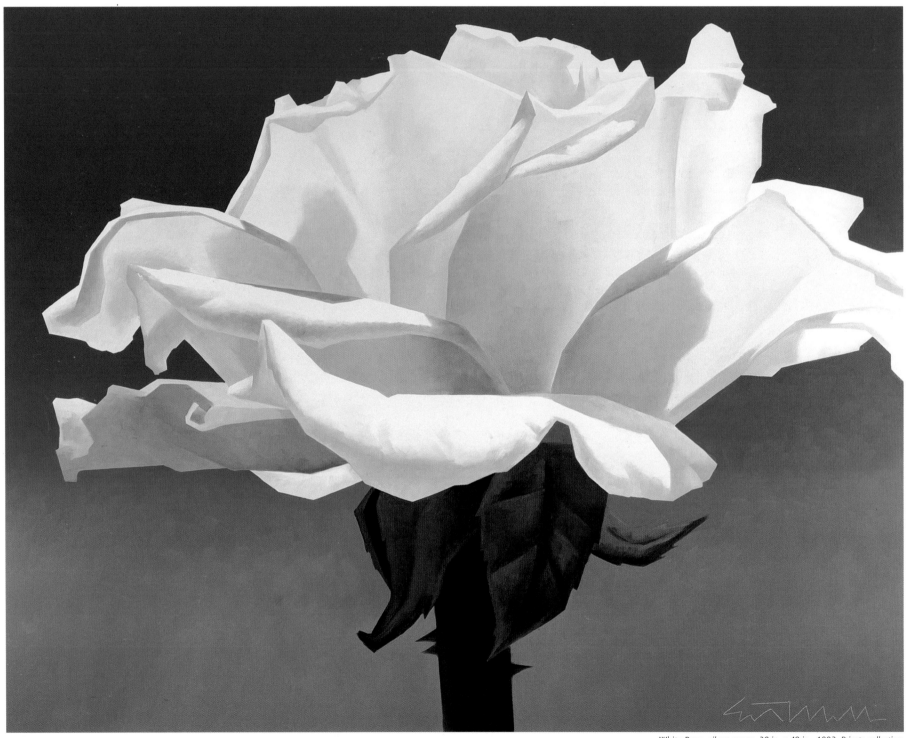

White Rose, oil on canvas, 30 in. x 40 in., 1992. Private collection.

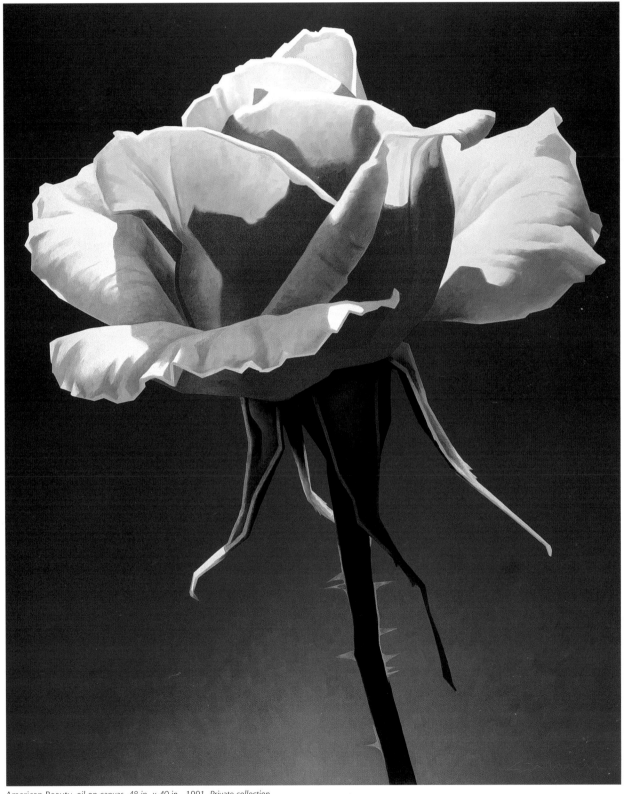

American Beauty, *oil on canvas, 48 in. x 40 in., 1991. Private collection.*

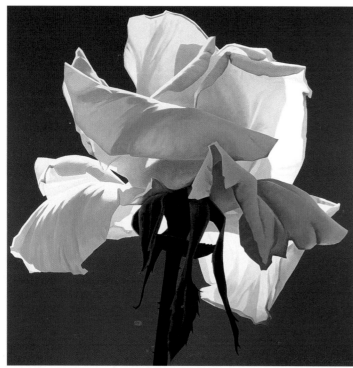

Violet Rose, *oil on canvas, 36 in. x 36 in., 1996. Collection of Faith Sussman and Richard Corton.*

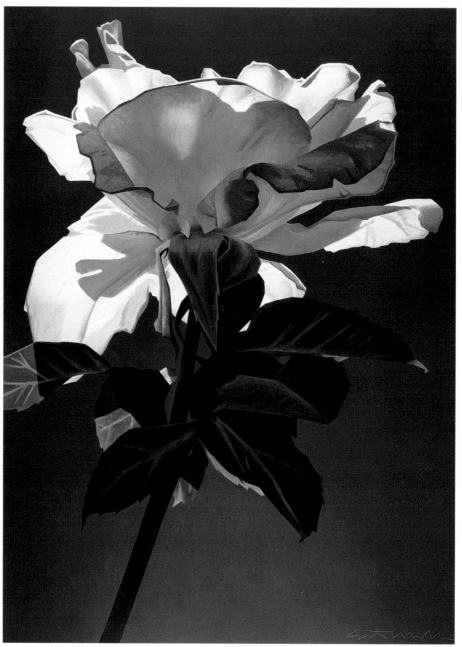

Rosa Triste, *oil on canvas, 48 in., x 36 in., 1995. Collection of Dr. and Mrs. Charles Taggart.*

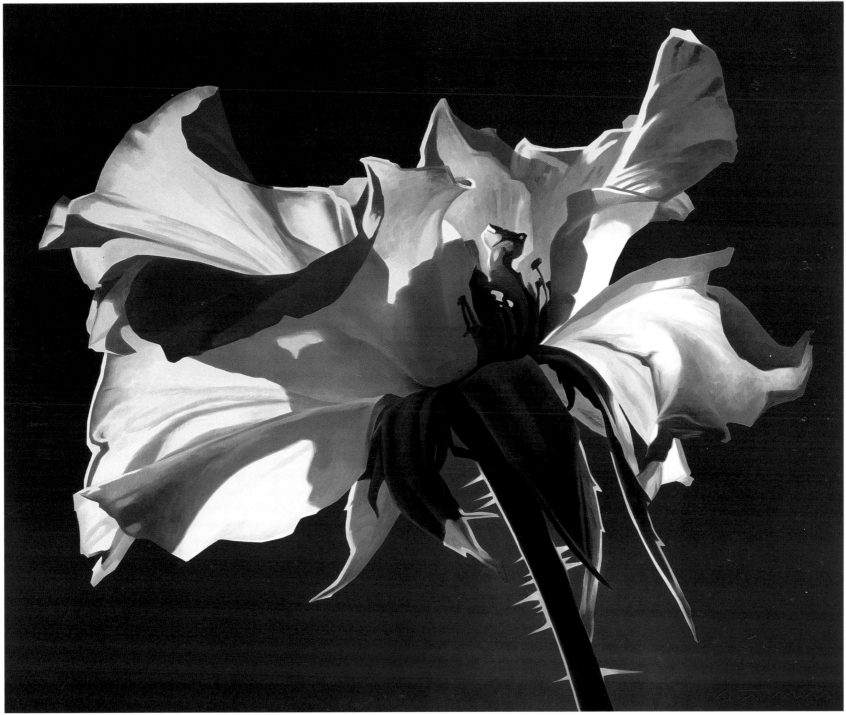

Open Rose, *oil on linen, 48 in. x 36 in., 1995. Private collection.*

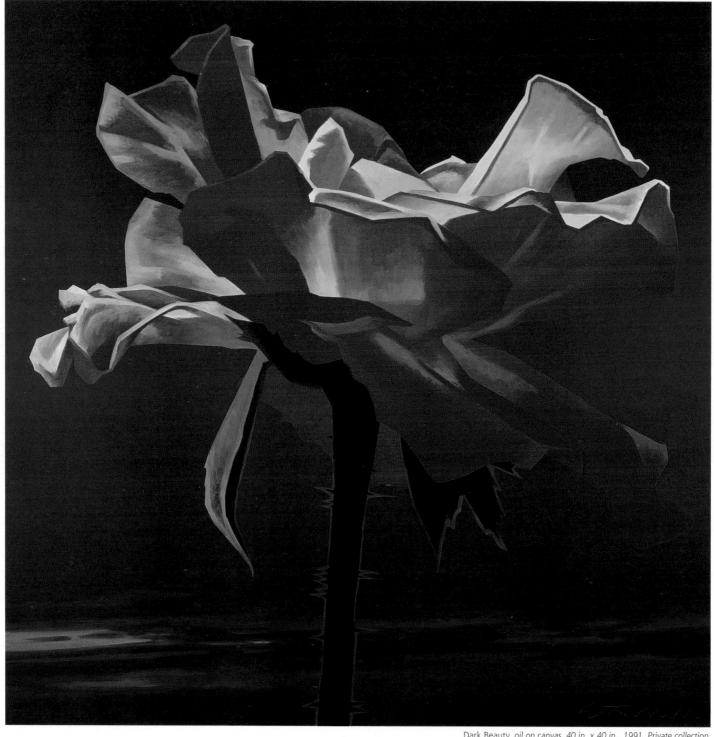

Dark Beauty, oil on canvas, 40 in. x 40 in., 1991. Private collection.

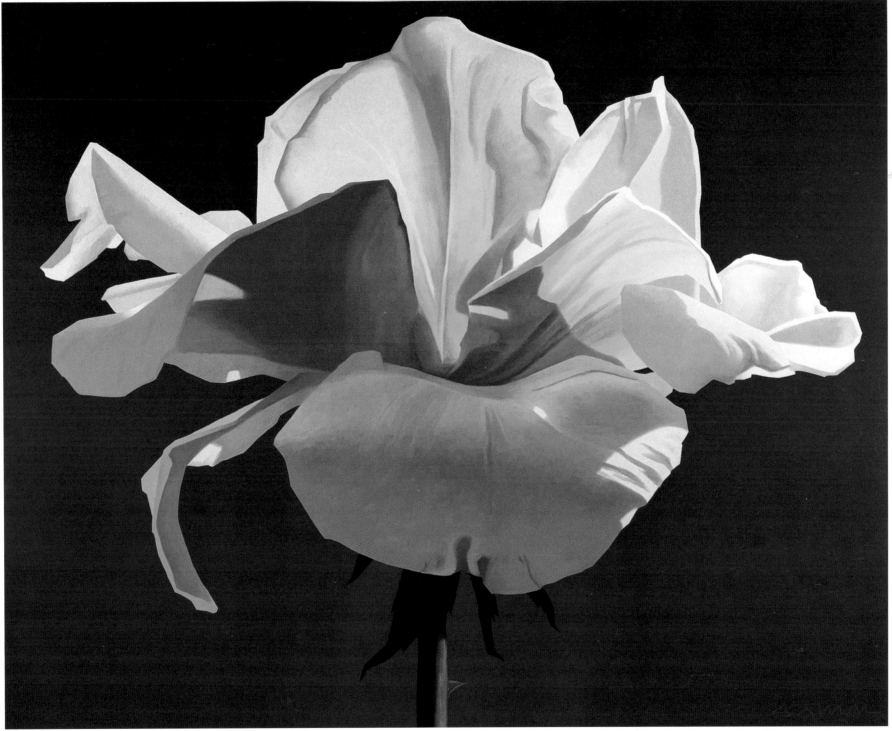

Fire Rose, oil on canvas, 44 in. x 54 in., 1995. Collection of Craig and Barbara Barrett.

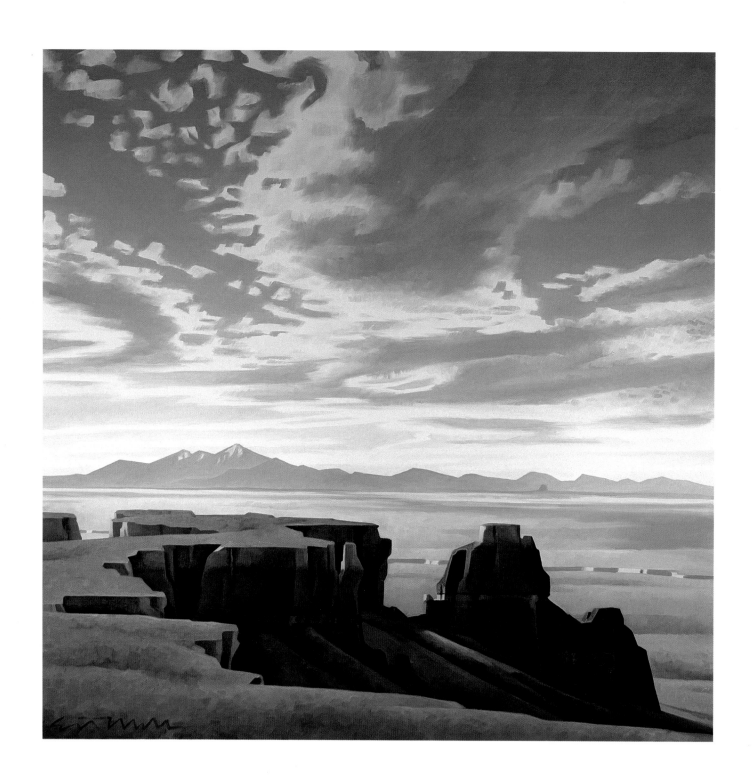

Opposite: View from Red Ridge, oil on canvas, 34 in. x 34 in., 1990. Collection of Dr. and Mrs. Charles Taggart.

Even as he explored figurative work, flower painting, and sculpture, Mell never strayed far from landscape painting. By the late 1980s, his landscape art had softened as he relied less on pre-conceived design and more on intuition. He developed an optimistic vision, more assured, and one in which he says he hoped viewers could get lost. His style became less self-conscious, freer, and more spontaneous, as he started to relax hard edges and angles. Where before landforms were singular elements in his paintings, now clouds began to assume a dominant place.

"I became aware of his landscape paintings by 1980," Bill Schenk says. "As I looked at them, I thought he could handle paint, but there was no clear vision. By 1988, Mell had come a long way. His paintings used more saturated color, were more naturalistic, and his landscape forms and clouds sophisticated and dramatic."

Mell has discovered, as had Maynard Dixon before him, that clouds are the roof of the land. Skies and clouds, rather than the earth, govern his recent landscape paintings. Most of his visits to the Colorado Plateau take place in summer. He knows the summer monsoons begin in July, when the empty sky begins to fill with slender high vapors that twist above the expectant land. By August, thick cumulus clouds gather in large, heaped masses, and march daily over the horizon in silent ranks from the Gulf of California. In the afternoons, they merge and build into thunderheads, dark and threatening violence as rain squalls arrive in short bursts. They cast abstract shadows over the landscape, with long veils of rain that drift downward. By evening, movement has slowed or ceased, and the clouds hang quietly, suspended over the earth as the departing sun illuminates mesas, buttes, and canyons with radiant light, like the heart of a furnace that has started to cool.

There is something about the sky that is magical. You can get lost in it. *—Ed Mell*

As Mell discovered the power of cloud worlds, his paintings absorbed the vision of what he learned. In *Sweeping Clouds at Dusk* (page 125) and *Eye of the Storm* (page 107), Mell has defined the dramatic march of rain clouds over the land. Often, as the clouds drift overhead, they trail virga, or "ghost rains,"

ragged streamers that usually evaporate before they reach the ground. At other times, downpours might be swift and heavy, what the Navajo call "male rains." By early the next morning, cloud fragments would float above the land, calm and harmonious, as in *Morning After the Rain* (page 131) or *Clearing Storm, Lake Powell* (page 120). When the U.S. Department of State searched for examples of American landscape art for exhibition in overseas locations, they selected *Eye of the Storm* to hang in our embassy in Moscow.

Mell has come to recognize there is a world mirrored above the earth—one of pantheistic light, skies, and clouds. In Willa Cather's book *Death Comes For the Archbishop*, the protagonist, Father Latour, is overwhelmed by the Southwestern sky and the clouds that inhabit it.

> One thing which struck at once was that every mesa is duplicated by a cloud mesa, like a reflection, which lay motionless above it or moved slowly up from behind it. . . . Sometimes they were flat terraces, ledges of vapour; sometimes they were dome-shaped, or fantastic, like the tops of silvery pagodas, rising one above another, as if an oriental city lay directly behind the rock. Whether they were dark and full of violence, or soft and white with luxurious idleness, they powerfully affected the world beneath them. The desert, the mountains and mesas, were continually reformed and recoloured by the cloud shadows. The whole country seemed fluid to the eye under this constant change of accent, this ever-varying distribution of light.

In other paintings, like *Towering Clouds, Lake Powell* (page 123) and *High Clouds* (page 124), he captures the visual poetry of quiet clouds, their formations evocative of the melancholy near the end of a desert day. The clouds have exhausted their moisture, and are starting to drift apart. Shadows creep over the earth. There is a hush upon the landscape, the cryptic silence joined to a paradise of cloud and sky.

Sometimes Mell did not travel far to discover the mood of clouds. Near his home in Scottsdale is Squaw Peak. There one evening he saw formations and light that intrigued him, and he managed to take some photographs. He painted *Squaw Peak at Sunset* (page 108), a canvas with interplay of light and shadow in the foreground, and departing clouds layered above.

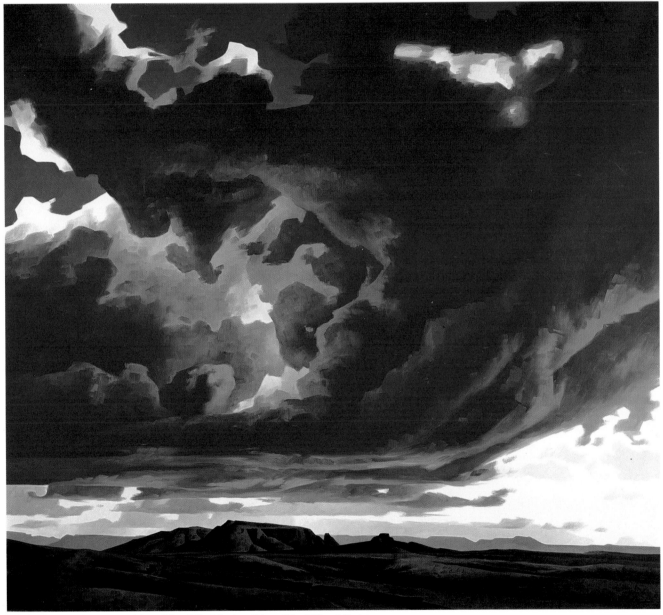

Eye of the Storm, oil on canvas, 42 in. x 48 in., 1991. Collection of Mr. and Mrs. William C. Blackstone.

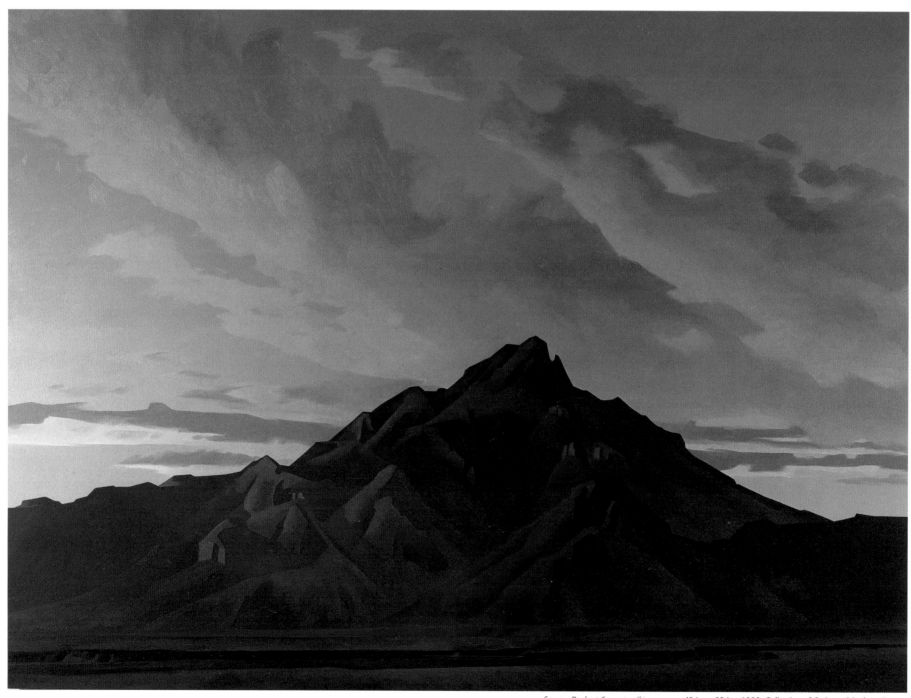

Squaw Peak at Sunset, oil on canvas, 40 in. x 62 in., 1988. Collection of Craig and Barbara Barrett.

As an idea starts to form in Mell's mind, he begins to think about a painting. Perhaps it is something—a photograph, or maybe a specific experience—that he remembers from years ago. He gathers his slides together and reviews them for color, landscape contours, and cloud shapes, searching for inspiration. Most importantly, Mell probes for ideas in the landscape that conform to his painting ideas. Sometimes he comes across an image he painted years ago, and he wants to paint it again with a new perspective. From several slides he might commence with a rough design sketched in pencil, then continue to develop it further with an oil study.

Mell switched from pastel to oil studies when he realized that he had been inadvertently translating the softness of pastel into his paintings. The study might take from two to four days to finish. It charts the growth of an idea and becomes a diagram of his visual thinking. As such, studies serve as a bridge between the photographs and the final painting. They are, in effect, dress rehearsals for the finished work. From the start of his painting career, Mell has always favored a horizontal format for his canvases, reinforcing the interplay he establishes between sky and earth.

An average day at the studio begins between eight and nine in the morning, and the size of a painting dictates how long Mell spends there. The development of a canvas that has spacious skies usually means long periods of painting, sometimes up to twelve hours. During Phoenix's hot summers Mell is forced to paint longer hours since the heat can shorten the drying time of oils. A larger canvas might take anywhere from five days to two weeks for completion. A studio composition of the Grand Canyon, with its complex design, could take twice as long, compared to another painting with significant areas of sky and open spaces.

The clouds in Mell's paintings make a complete landscape view. His language of clouds almost seems connected to what Native American mythology about afterlife refers to as "cloud people." —*Ray Dewey*

When he starts a painting, he works on it until it is finished, and he only does one at a time. He paints quickly, putting as much paint down on a canvas as he can, adjusting color and form while the paint is still wet. Mell commences to paint the cloud formations first, blocks out their shapes, then adds in the color, attentive to light and volume, as in *Towards the End of Dusk* (pages 110 and 111). As always, he is concerned with the impact of space. Usually the cloud formations are massed vertically on the canvas, which sets up a tension between the vertical and the horizontal that invigorates and strengthens the

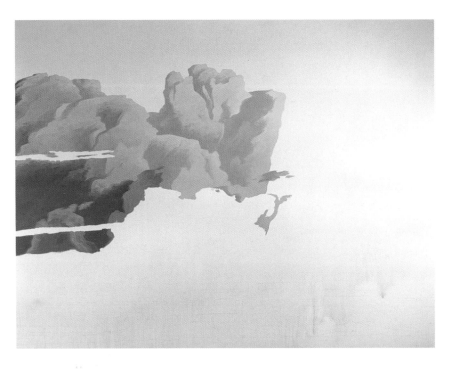
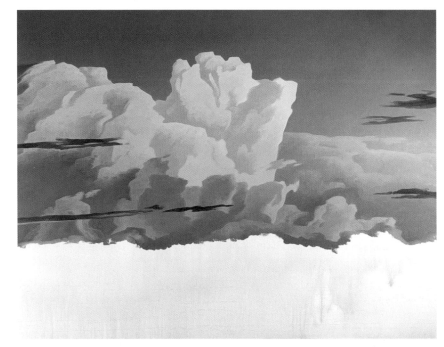
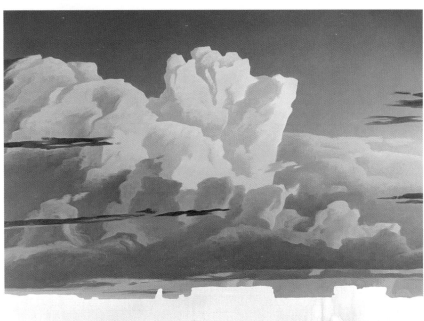
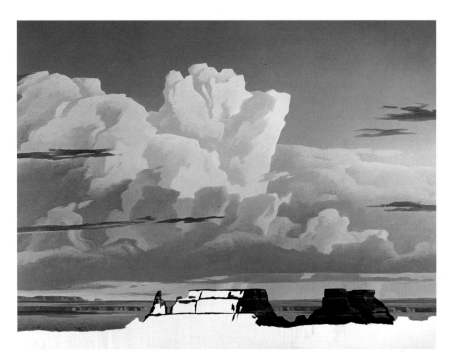

A painting in progress: Towards the End of Dusk at four different stages of the process, and completed, opposite.

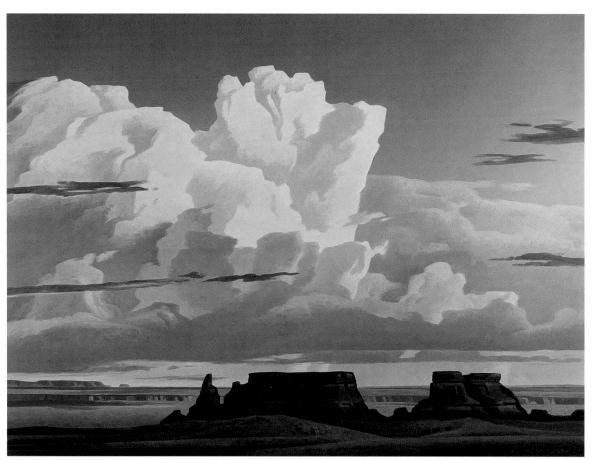

Towards the End of Dusk, *oil on canvas, 36 in. x 48 in.,*
1995. Private collection.

composition. The clouds are finished before he proceeds to paint in the landforms. Mell feels the light casted from the sky dictates the sense of light on the landscape forms.

"He has a great eye but works against the grain from every rule learned at art school," Bob Boze Bell says. "In art school, you were taught to work on every part of the painting at once. You should be able to stop a painting at any time, and it would look finished. But Mell will do the entire sky, all around, down to the horizon. Mell breaks every rule by doing segments, so that the painting looks blocked out."

As little as five or up to fifteen different colors are used, and he strives to maintain a consistent color balance throughout a canvas. Vegetation patterns are shown as color gradations, rather than actual forms. That intensive, exaggerated color scale Mell favored in early paintings has been replaced by richer hues. In some of his recent paintings, the colors are almost monochromatic. Mell now uses Grumbacher brushes and Windsor and Newton oils. He favors such colors as Mars orange and red, and other earthtones. As in his early painting efforts, he never uses colors as pure pigments straight out of the tube, and he mixes them, which he believes improves their effect for a painting. In addition, he creates his own brown and black color pigments.

One of the special places that inspires Mell's work is the Moenkopi Plateau and the Painted Desert, southwest of the Hopi mesas. The Painted Desert begins north of Cameron, sweeps southeast in a crescent-shaped arc to beyond Petrified Forest National Park and follows the course of the Little Colorado River for most of its length. The area is named for its austere landscape and rainbow shades

of gray, green, pink, red, orange, brown, and blue. The Navajo call the Painted Desert *halchíítah*, or "amidst the colors." Harold S. Colton, founder of the Museum of Northern Arizona, wrote in his 1932 guidebook to the region, *Days in the Painted Desert and the San Francisco Mountains*, that it is "a beauty of things at once near and far, real and unreal, definite and hazy with distance: it is a beauty of an earth close at hand and the beauty of a far off land that never was, a land made out of distance and desire."

To the northeast rises the Moenkopi Plateau tablelands, a region composed of shale and sandstone. One of the least-known sections of the Navajo Reservation, the landscape is marked by ascending terraces. It is an erosion-lovers' paradise, with cliffs, knobs, buttes, mesas, spires, and pillars scattered over the terrain. The Moenkopi Plateau drains into the Little Colorado River through deep gashes cut into the terrace steps, canyons six hundred to eight hundred feet deep, whose sides are formed of gray, green, pink, and white strata of singular beauty.

Near Leupp, along the Little Colorado River, Mell chanced upon some rock formations that looked almost like stone gargoyles or goblins. He painted *Desert Tower* and *Leupp Road Formation,* their shapes formed into a sculpture by centuries of wind and blowing sand. Elsewhere on the Moenkopi Plateau, he discovered boundless vistas and formations of unparalleled splendor. Inspired by what he had seen, Mell created *Moenkopi Plateau* (page 125), a large canvas that encompasses the patterns of distance, light, and aggressive solitude that define this part of the Colorado Plateau.

One place on the Moenkopi Plateau that Mell returns to whenever possible is Coal Mine Canyon. He first encountered the canyon when he worked on the Hopi Reservation, then again on a

Leupp Road Formation,
oil on linen, 16 in. x 22 in., 1989.
Collection of Daniel and Linda Sharaby.

Mell's real genius is how he has specifically looked at light and how it affects the plateau country. There is never a misplaced value. —*Bill Schenck*

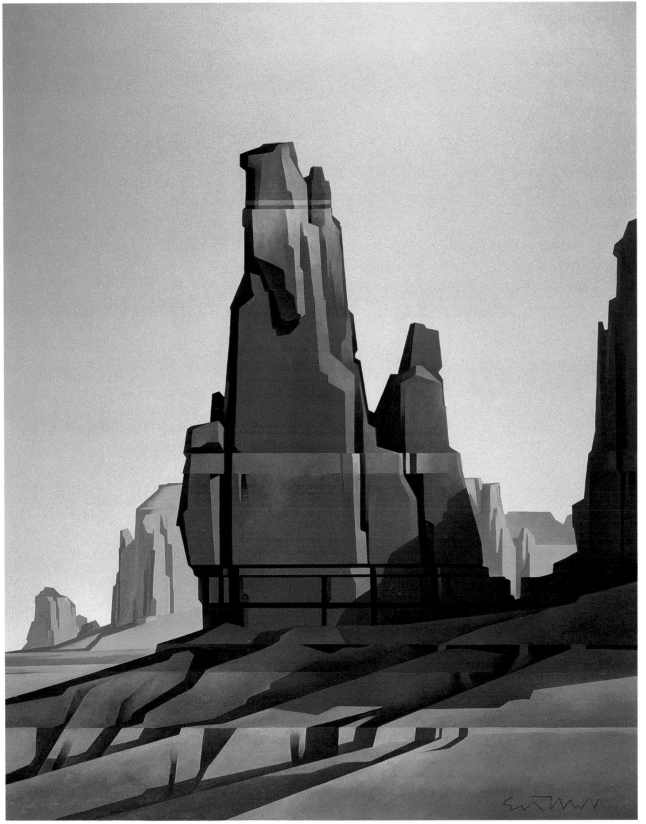

Desert Tower, *oil on canvas, 60 in. x 48 in., 1988. Private collection.*

quick helicopter tour with Jerry Foster. One memorable visit occurred in 1990 when Royal Norman, a meteorologist and newscaster at KTVK-TV 3 in Phoenix, approached Mell in late 1989 with a provocative proposal. Norman wanted to do a story on the process, from start to finish, of Mell envisioning and creating a painting. Norman recalls, as he admits rather awkardly, that he asked Mell, "Would you be opposed to going on a helicopter trip to a place of your choice?" Mell shot back, "Sounds great." Where did he want to go? Coal Mine Canyon.

Mell, of course, had been there before, but Norman had never heard of the place. On a brisk January day in 1990, Mell, Norman, pilot Jerry Clifton, and a station cameraman climbed into a helicopter in Phoenix after Norman's noon show and departed for the Colorado Plateau. They fought headwinds until Winslow, where they landed to refuel. There was a large amount of cloud cover, but the skies began to clear as they left. As they approached Coal Mine Canyon in the late afternoon, the landscape below them sparkled in bright light.

Coal Mine Canyon is lined with spectral spires, eroded fins, and mushroom-shaped rocks that perch precariously on eroded sandstone pinnacles. Within the canyon is a coal vein that has been used for generations by the Hopi and Navajo, visible as a black band just below the rim of the five-hundred-foot walls, separating earthen-red and light gray layers of Mancos shale from the Dakota and Entrada sandstone. The canyon lies about halfway between Tuba City and Hotevilla,

The canvas is like a theater, where it can make a dramatic statement about what I have experienced in the helicopter. —*Ed Mell*

entering Moenkopi Wash just east of the small Hopi village of Moenkopi. Harold Colton, one of the first to explore the area, considered Coal Mine Canyon as fine as, if not finer than, Bryce Canyon in southern Utah.

Mell asked Clifton to fly into Ha-Ho-No-Geh Canyon, a tributary of Coal Mine Canyon, where they landed. Snow still lay in shadowed areas, late afternoon light bounced dark shadows off the canyon walls, and a few cirrus clouds drifted lazily overhead. The helicopter lifted off to film some fly-by shots while Mell and Norman hiked around the canyon. Afterwards, Clifton landed and picked them up, then touched down on the canyon's rim at several places so that Mell could take pictures. Finally, as the light began to erode and evening descended, they left Coal Mine Canyon and flew to Flagstaff, then on to Phoenix. En route, they paused briefly at Ward Terrace, east of Cameron, a

Afternoon Shadows, Coal Mine Canyon, *oil on canvas, 54 in. x 72 in., 1990. Private collection.*

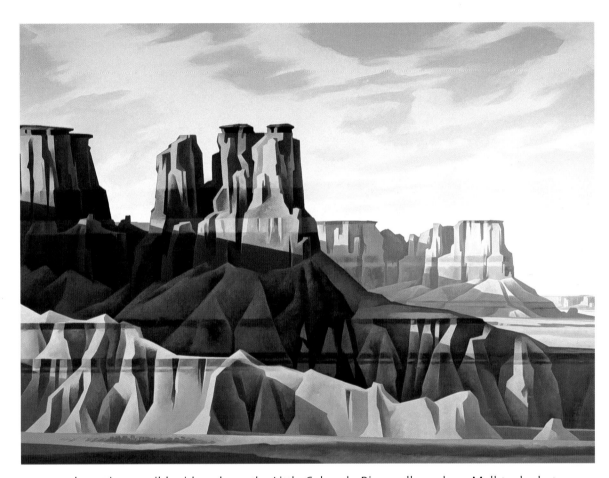

remote, almost inaccessible ridge above the Little Colorado River valley, where Mell took photographs of the impressive views.

At the studio afterwards, Mell reviewed and selected slides from the trip, then initiated some oil studies, precursors to final paintings. Norman asked Mell to select one of the studies so that the journey of creation from conception to final painting could be documented on videotape. Mell had started a small oil sketch, then intended to paint a larger canvas, which he titled *Afternoon Shadows, Coal Mine Canyon.* They filmed Mell as he worked on the study, again about halfway through the actual painting, and at the conclusion, when the painting was completed.

"The energy of Mell's painting overwhelmed me," says Norman. "The drama, grandeur, and beauty of the landscape jumped out at me. As a meteorologist, I notice that Mell's clouds capture

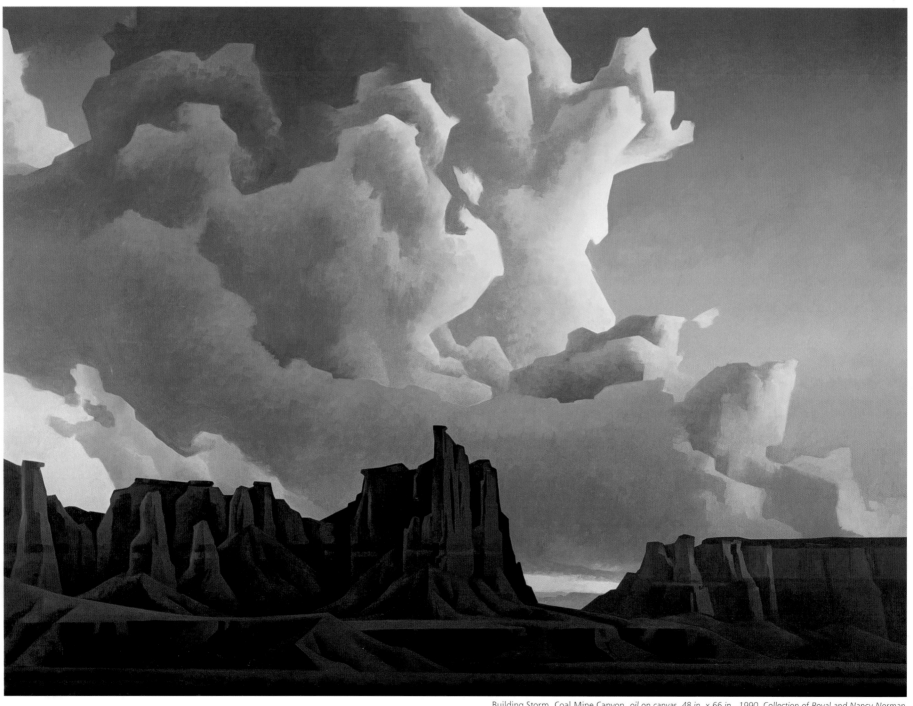

Building Storm, Coal Mine Canyon, *oil on canvas, 48 in. x 66 in., 1990. Collection of Royal and Nancy Norman.*

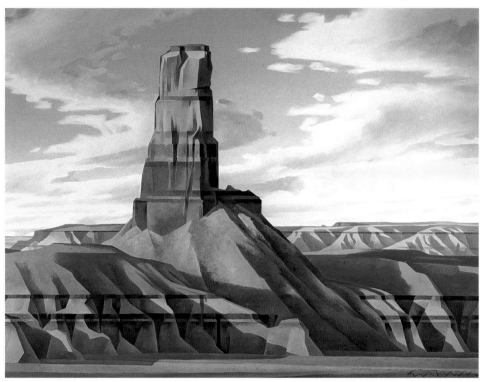

Tower of Coal Mine Canyon,
oil on canvas, 36 in. x 48 in., 1991.
Collection of Linda and David Sheppard.

energy, and they seem to reach for the sky, trying to take a hunk out of it."

In another one of Mell's paintings, *Building Storm, Coal Mine Canyon,* the sun has eased lower in the sky, prompting colors on the cliff walls to emerge as if they were set on fire. The layered rocks are prominent in the painting, and, along with the vertical forms, invoke a powerful, sculptured sense of the canyon. The transient clouds over the landscape contribute to the drama.

When Robert Knight at the Scottsdale Center For the Arts arranged *The Art of Ed Mell*, a retrospective exhibition in 1990 of Mell's paintings, he included *Building Storm, Coal Mine Canyon,* and a number of other landscape works from Coal Mine Canyon, along with figurative work, sculptures, and flower canvases.

Other paintings that emerged from the Coal Mine Canyon trip during the next year or two include *Snow in Ha-Ho-No-Geh Canyon* (page 126) and *Tower of Coal Mine Canyon.* In them, Mell has revealed the theatrical presence of Coal Mine Canyon, with its loneliness, unique forms and colorful strata. His brief pause at Ward Terrace eventually produced the painting *View From Red Ridge* (page 104), a landscape that reveals the panorama west toward the San Francisco Peaks. The earth shines in the clear air, and the geological shapes of the land are stark and profound under the plateau's light.

Mell adds more to the existing drama by using his imagination in a painting. He has added the feel of melancholy, even pathos, and an enormous quiet. —*Bill Schenck*

While most of Mell's art originates from helicopter trips, there are exceptions. In 1994, part of the Copperstate 1000 route passed by Canyon de Chelly National Monument. Mell hiked down the trail to White House Ruins, drove his Corvette along the rim of the canyon to several overlooks, and took photographs of the red sandstone walls and views that unfolded up and down the canyon. Later, back in the studio, he painted *Remnants of a Storm, Canyon de Chelly* (page 129). The work holds the allure of light at the end of day, as the horizon line break draws the viewer toward the canyon rim, where land and sky are joined seamlessly. Another Canyon de Chelly painting, *Chinle Bend* (page 130), portrays

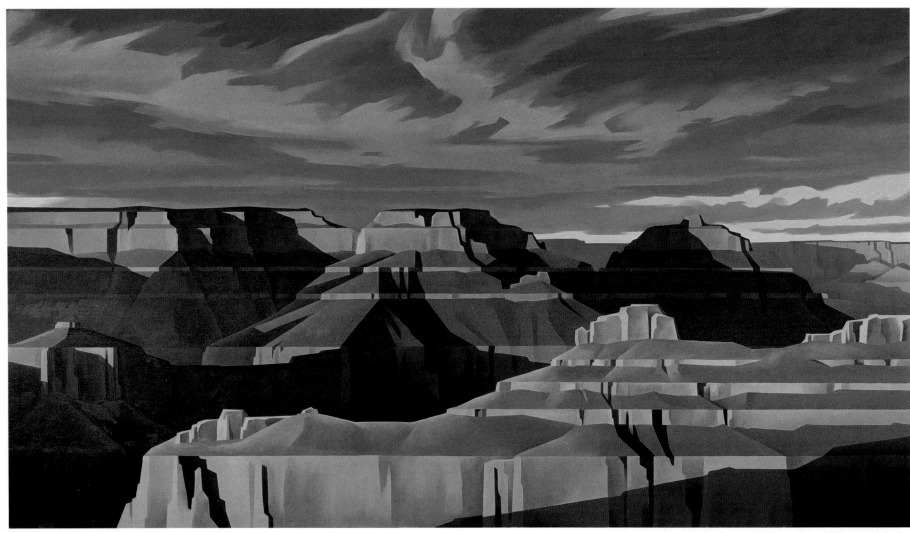

Sunset, Vishnu Temple, *oil on canvas, 40 in. x 72 in., 1987. Private collection.*

the effect of light and of dark clouds hovering over the canyon's ramparts. The canyon's chromatic cliffs embrace the shining stream as it searches for various routes through the sandy wash. The image has a melancholy feel, with gentleness and silence, yet possesses mythic proportions concerned with the imaginative realm of nature.

These and other recent paintings of the Colorado Plateau, along with flower works, were exhibited at the Kolb Studio, a 1904 landmark perched on the edge of the South Rim, in Grand Canyon National Park, during August and September of 1995. The exhibition was sponsored by the National Park Service and the Grand Canyon Association.

In these later landscape paintings, Mell has found the space and thrust that define the plateau—the distance of things faraway. The paintings still have the imprint of his design origins, but they have moved in a steady transition from the conceptual and minimal art of his early period to a more painterly observation of place. Over time, Mell has become a careful observer of skies, and allocates attention to the quality of emphatic light discharged by weather and time and the color it casts on the landscape. These paintings have moved toward a more representational or realistic look, yet have the acute sense that Mell has invented, rather than merely transcribing what he has seen.

Mell's landscape paintings stop people in their tracks when they come into the Suzanne Brown Gallery. They think we have a light behind the canvases. In reality, it is the luminosity that changes in the paintings as the light changes in the gallery. One client who purchased a large seven-by-twelve foot landscape felt it was like bringing the outside in, as if the mountain was in his living room. —*Linda Corderman*

They are structured, and light and color are reordered by Mell on a painting to intensify the landscape space. Above all, he is a conjurer of mood, as he orchestrates shapes and lines, the passages of color, the light on a canvas, and the sense of distance. Ralph Waldo Emerson once declared: "The health of the eye seems to demand a horizon. We are never tired, so long as we can see far enough." Drawn from his interior vision, the landscape paintings of Ed Mell are split into regions along the spine of a far horizon—the sky and attendant clouds, and the plateau's terrain, marked by an endless variety of geological shapes and patterns. The paintings are rooted in specific landscape facts, yet at the same time possess reminders of their conceptual basis and the emotional characteristics of the painter.

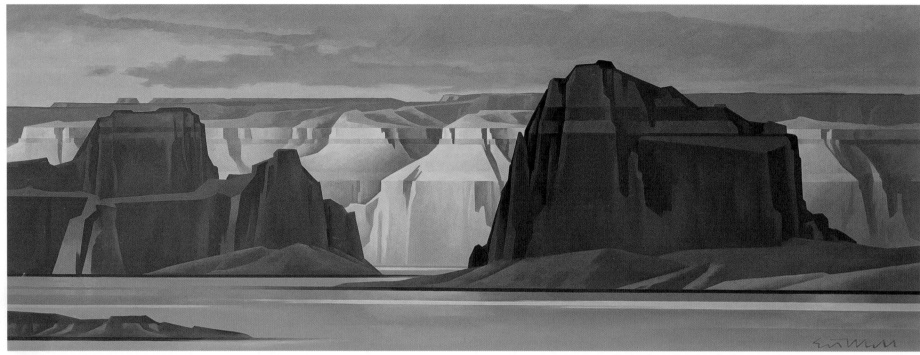

Clearing Storm, Lake Powell, *oil on canvas, 30 in. x 78 in., 1989. Private collection.*

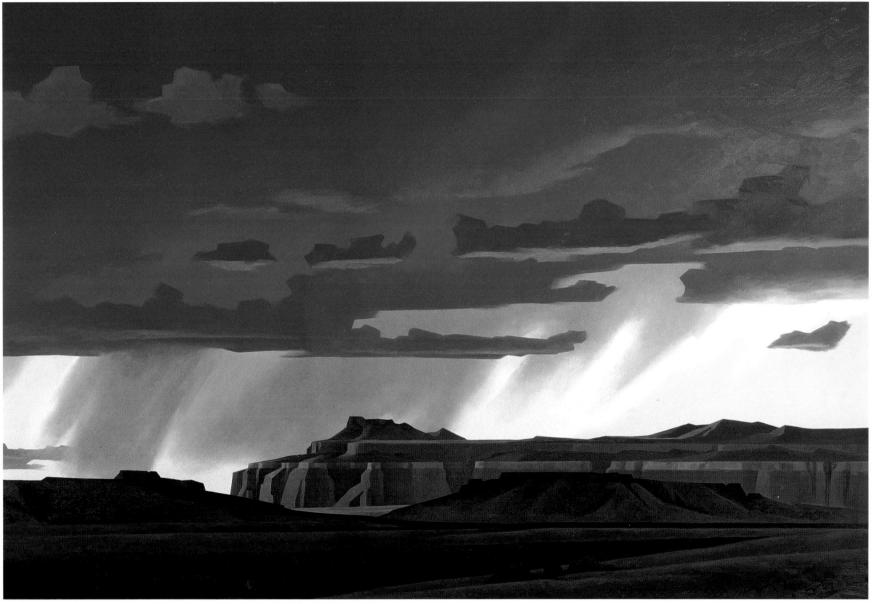

Rain Beyond Long Mesa, *oil on canvas, 40 in. x 60 in., 1988. Collection of Mark and Charlene J. Shoen.*

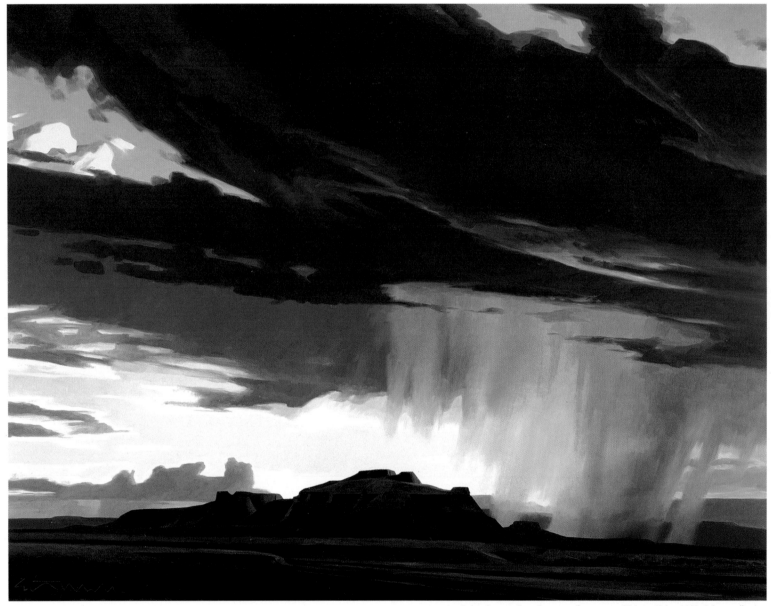

Rainy Season, Four Corners, *oil on canvas, 30 in. x 40 in., 1993. Private collection.*

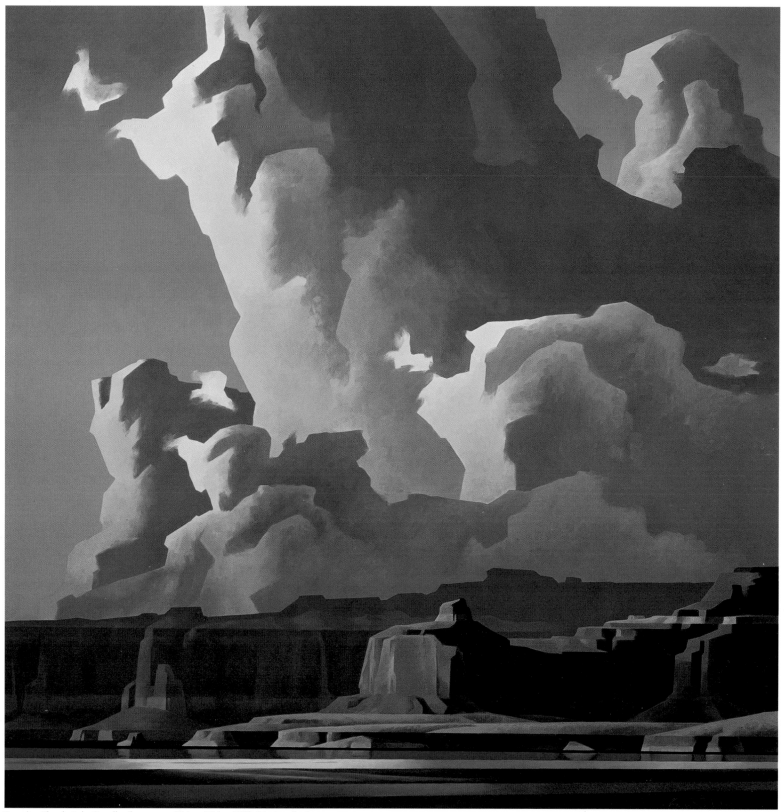

Towering Clouds, Lake Powell, *oil on canvas, 72 in. x 72 in., 1989. Private collection.*

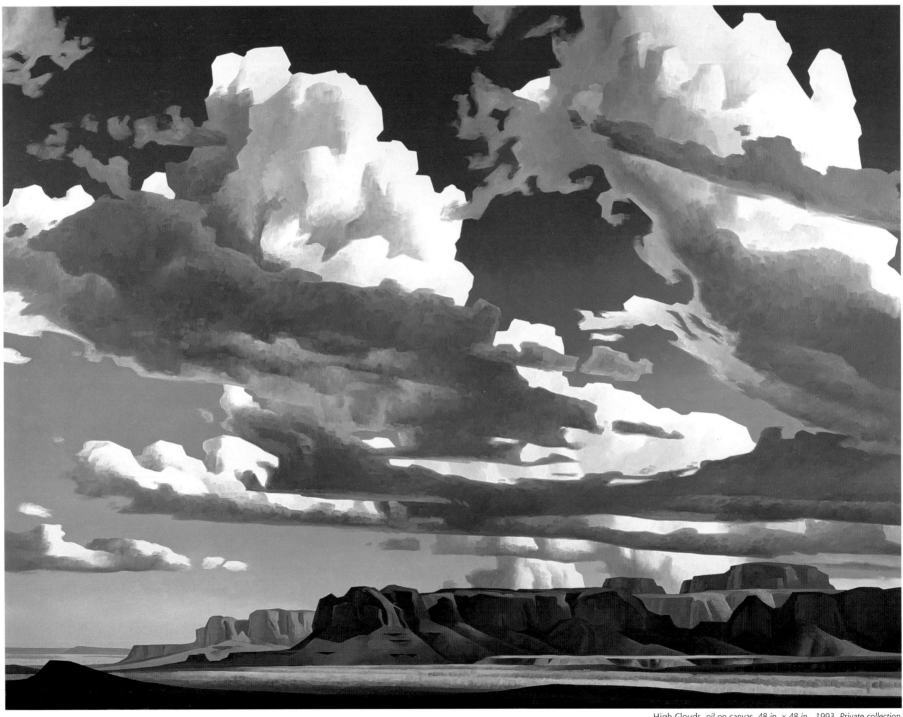

High Clouds, *oil on canvas, 48 in. x 48 in., 1993. Private collection.*

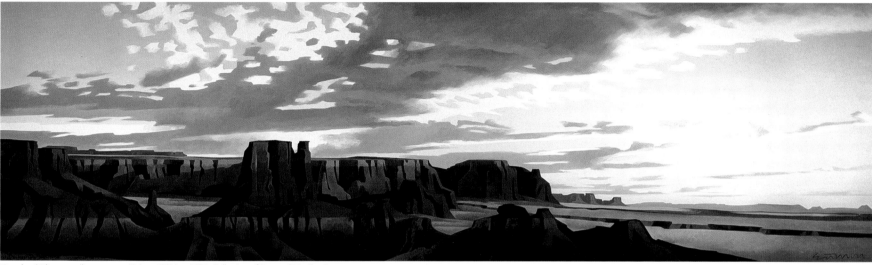

Moenkopi Plateau, *oil on canvas, 40 in. x 138 in., 1991. Collection of Roy and Marilyn Papp.*

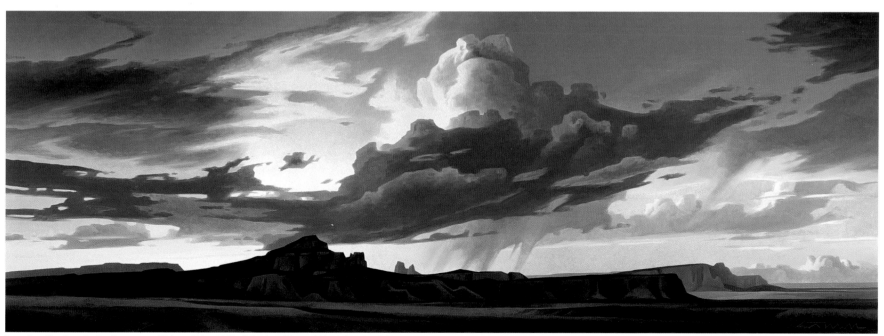

Sweeping Clouds at Dusk, *oil on canvas, 32 in. x 90 in., 1995. Collection of Dr. and Mrs. Robert Sundahl.*

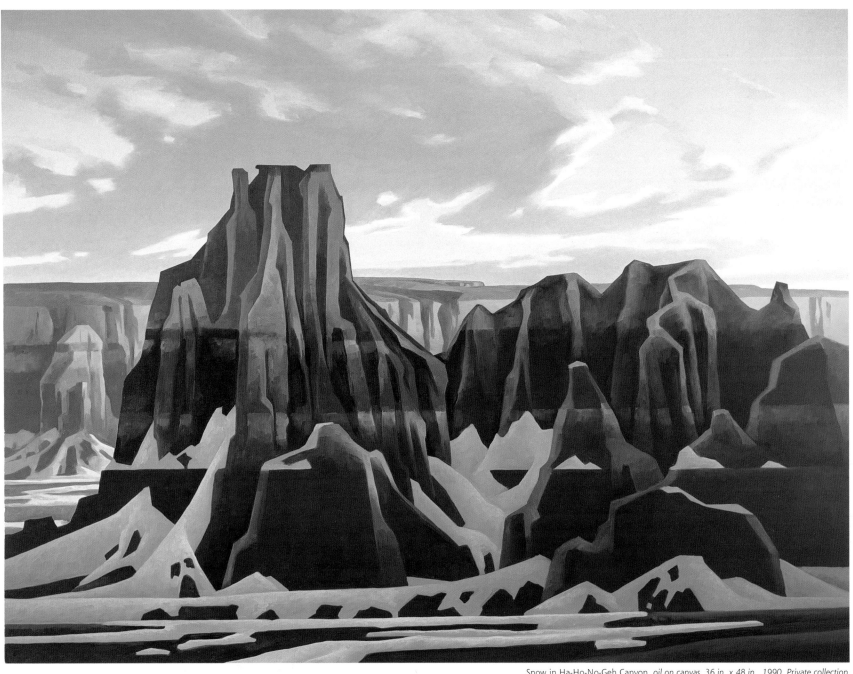

Snow in Ha-Ho-No-Geh Canyon, oil on canvas, 36 in. x 48 in., 1990. Private collection.

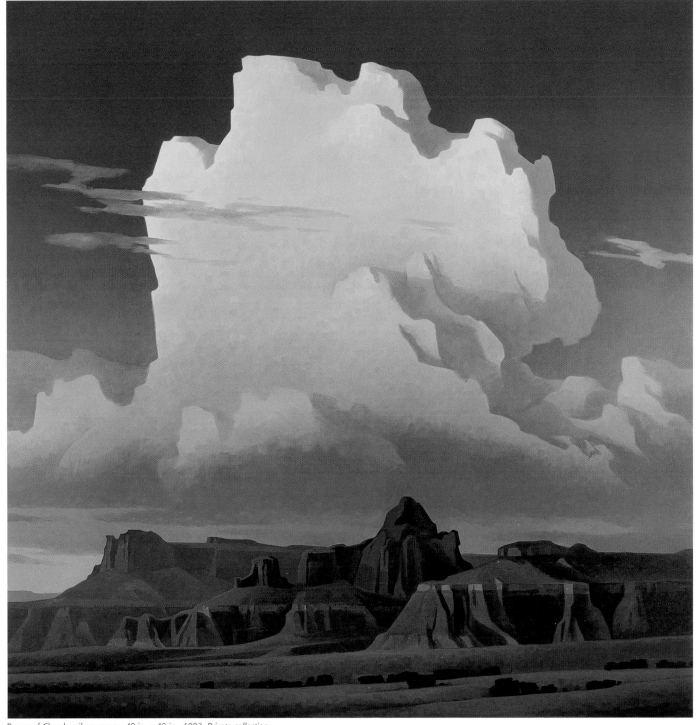

Power of Clouds, *oil on canvas, 48 in. x 48 in., 1993. Private collection.*

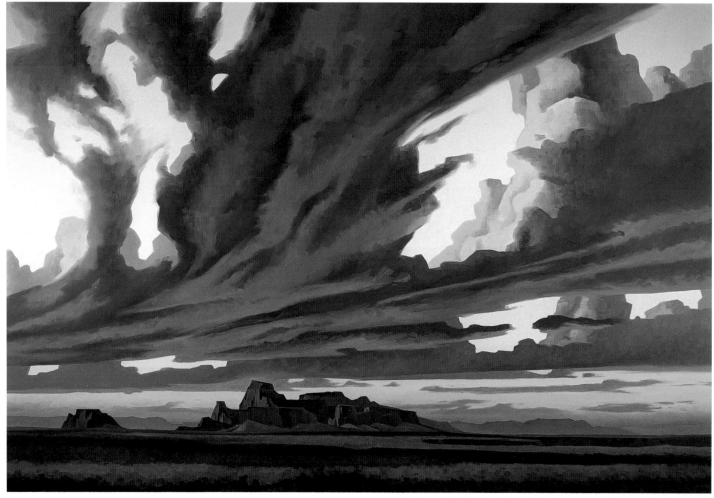

Sweeping Clouds Overhead, oil on canvas, 48 in. x 72 in., 1991. Private collection.

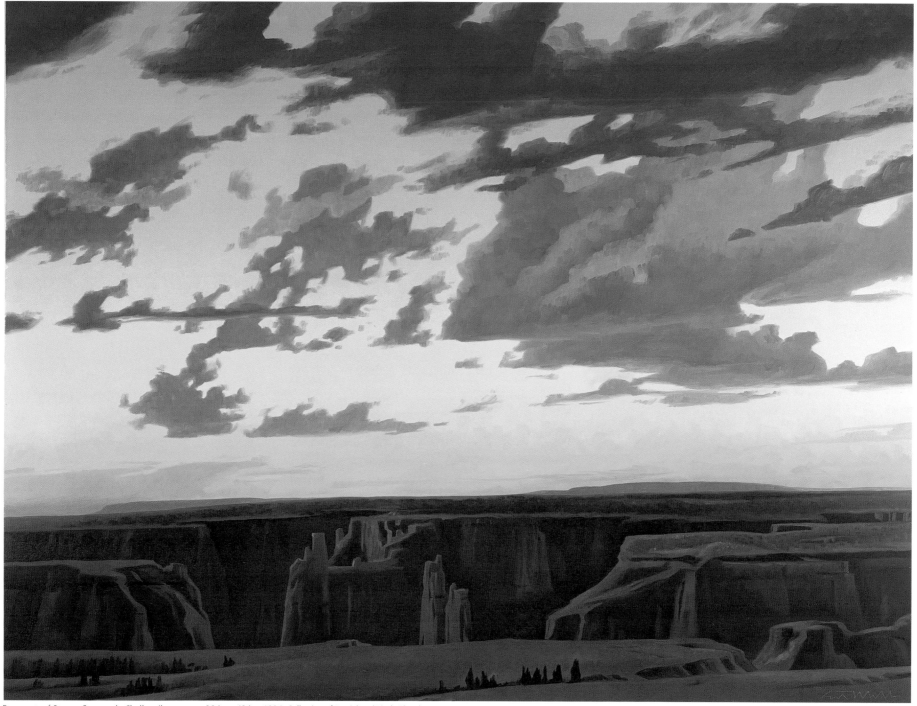

Remnants of Storm, Canyon de Chelly, *oil on canvas, 30 in. x 40 in., 1994. Collection of Daniel and Linda Sharaby.*

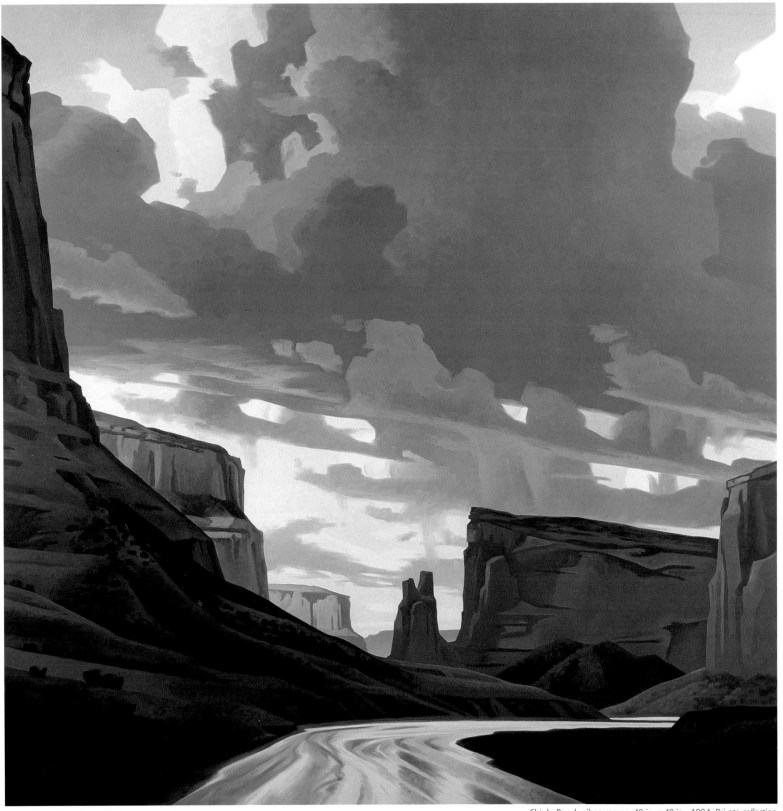

Chinle Bend, *oil on canvas, 48 in. x 48 in., 1994. Private collection.*

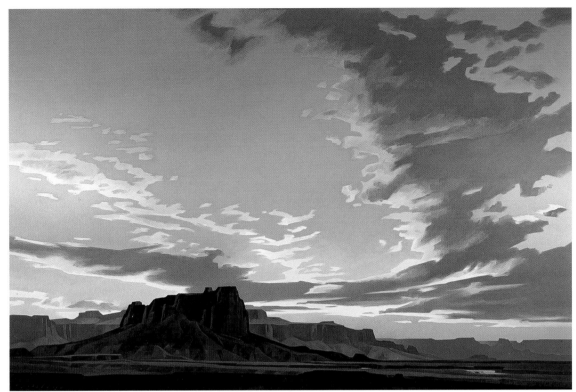

Open Valley Sunset, *oil on canvas, 48 in. x 72 in., 1990. Private collection.*

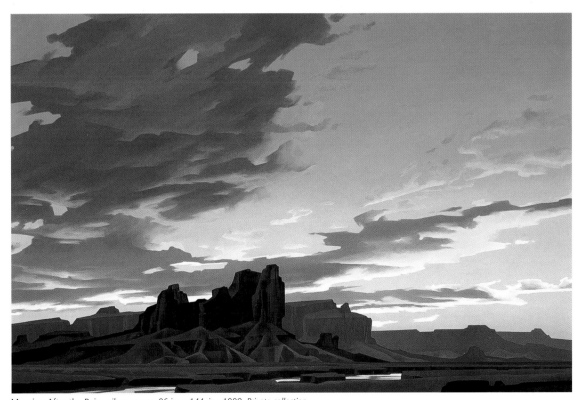

Morning After the Rain, *oil on canvas, 96 in. x 144 in., 1990. Private collection.*

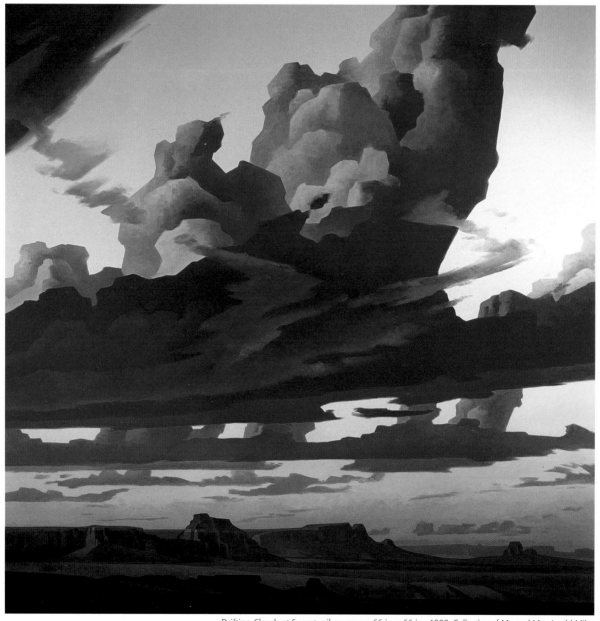

Drifting Clouds at Sunset, *oil on canvas, 66 in. x 66 in., 1990. Collection of Mr. and Mrs. Jerold Miles.*

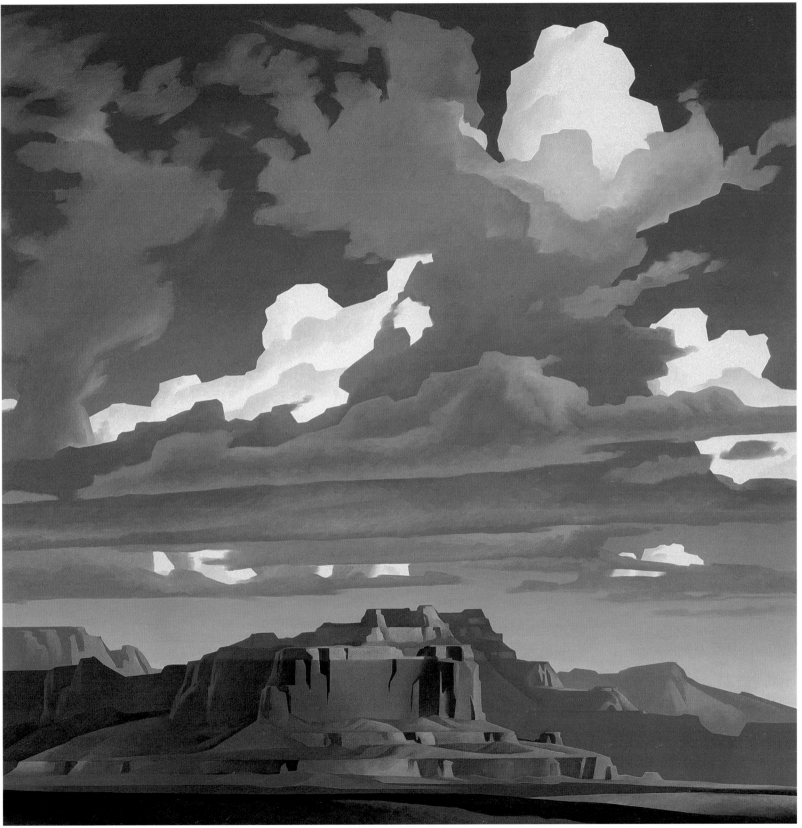

Sweeping Clouds, *oil on canvas, 52 in. x 52 in., 1987. Collection of Phoenix Art Museum.*

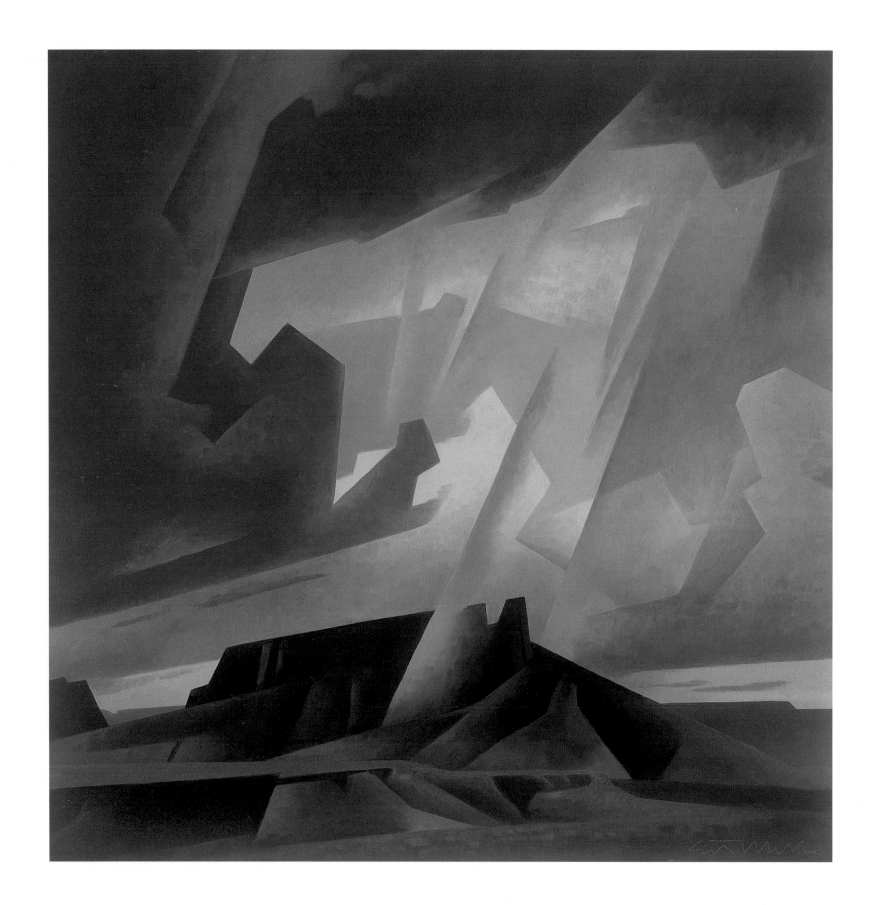

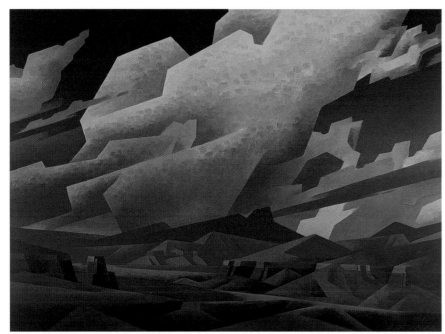

Force of a Storm, *oil on canvas, 30 in. x 40 in., 1995.*
Collection of Dr. and Mrs. Vladimir Kovacevic.

Opposite: Blue Sheets of Rain, *oil on canvas, 30 in. x 30 in.,*
1994. Private collection.

Ed Mell has the confidence and ability to work simultaneously in different styles. Never content to ride one particular style for long, he started to experiment with abstraction in landscape paintings by the early 1990s. He cannot articulate why, he just says that the urge or the vision surfaces, and he must respond. Perhaps he has found his artistic roots in these landscape paintings, with their energy and raw structure. They are, as some like Nat Owings believe, the bedrock of how he sees the land. In fact, Owings, one of Mell's art dealers, says he senses there are two painters inside Mell. One is the designer, the other is one who can evoke the timeless feel of the landscape through his abstract art. The designer traps him when he does his realist painting and does not let him fulfill his destiny. The abstract work, on the other hand, permits Mell's perceptive landscape vision to emerge further.

When Mell decides to paint an abstract landscape—and they are, compared to his realist paintings, infrequent in numbers—he has no idea what it will look like when completed. An idea begins to percolate when he puts a line down on a canvas. He might study a dozen or more slides to prompt a start, but he does not extract anything specific from the images. As Mell proceeds to work on an abstract painting, he lets both form and color invent themselves. Landscape formations and the clouds on a canvas are painted into geometric pieces, but unlike true abstraction, do not dematerialize as he strives for overall unity. In most instances, the images in the paintings move between varying degrees of abstraction and a designed realism.

Landforms and clouds are charged with energy in these paintings. Unlike his more serene, realistic landscapes, Mell infuses abstract works like *Standing Clouds* (page 140) and *Force of a Storm* with the dynamics of movement. His use of lines, planes, and color suggests motion and enhances the scenario of a landscape under varied conditions. In *Marching Blue Mountains* (page 136) and others, he creates an

impression that the clouds and landscape both move in the same direction. The paintings seem vitalized with the energy of the storms. Another work, *Blue Square Cloud,* was inspired by his 1994 visit to Canyon de Chelly. Mell constructed the sunbeams that stream out of the clouds in the painting through use of straight lines, and their design resonates with the angular geometry of the landscape below.

Mell knows also that the Colorado Plateau can conjure up violence, as powerful summer storms ravage the earth. The violent confrontation of an electrical storm with the landscape is shown in *Cloud Lightning* (page 142) and in *Energy of a Storm* (page 138). Jagged streaks of lightning flash downward to menace the earth, their power enhanced by dark clouds that will follow shaking the ground with thunder. In these paintings he has demonstrated the combative movements and tension in nature, which is so much a part of this Western country.

The Grand Canyon region in particular lends itself to abstraction, Mell has found. Already abstracted, the Grand Canyon is stimulated by light and shadow upon a landscape that is never finished. In *Rolling River, Grand Canyon* (page 144), Mell reached out to the edge of his personal vision to discover the geological formations that define the canyon's spirit. Streamers of rain move over the earth in slanted sheets, while an unearthly late afternoon light bathes the corrugated landscape.

Two other paintings, *Open Heavens, Grand Canyon* (page 145) and *Canyon Rain* (page 146), present storm clouds that tower over the canyon, their shapes alive with the premonition of rain. Shafts of reflected light penetrate and illuminate the multi-layered land below in shades of red, orange, apricot, and peach. With these paintings, Mell has reconciled the poetry and geometry of the Grand Canyon.

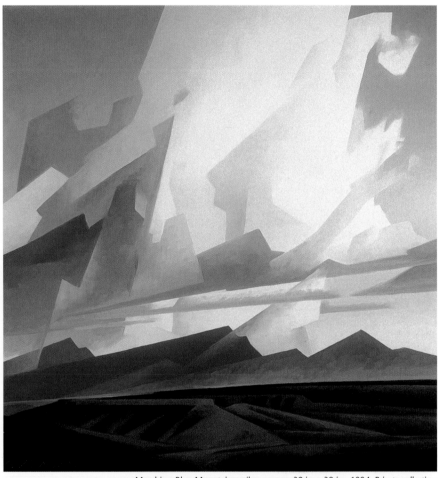

Marching Blue Mountains, *oil on canvas, 30 in. x 30 in., 1994. Private collection.*

Mell has reached a level where he is fluid, and can move from an abstract to a more realistic landscape painting. He can make that decision when to hold the edge or to let it flow. His abstract paintings are more layered, and there is more going on. They are both fluid and abstract at the same time. —*Bob Boze Bell*

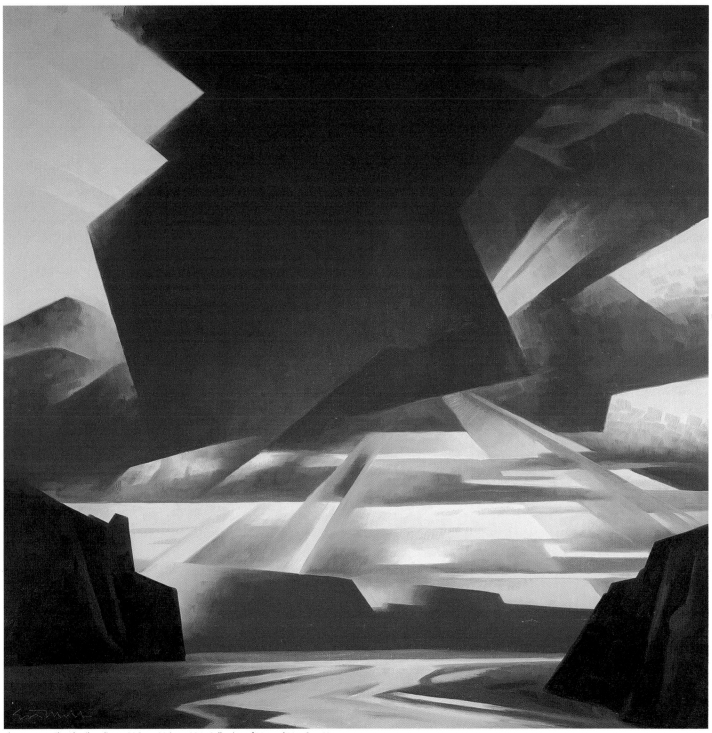

Blue Square Cloud, *oil on linen, 22 in. x 22 in., 1994. Collection of Mr. and Mrs. Stan Hurt.*

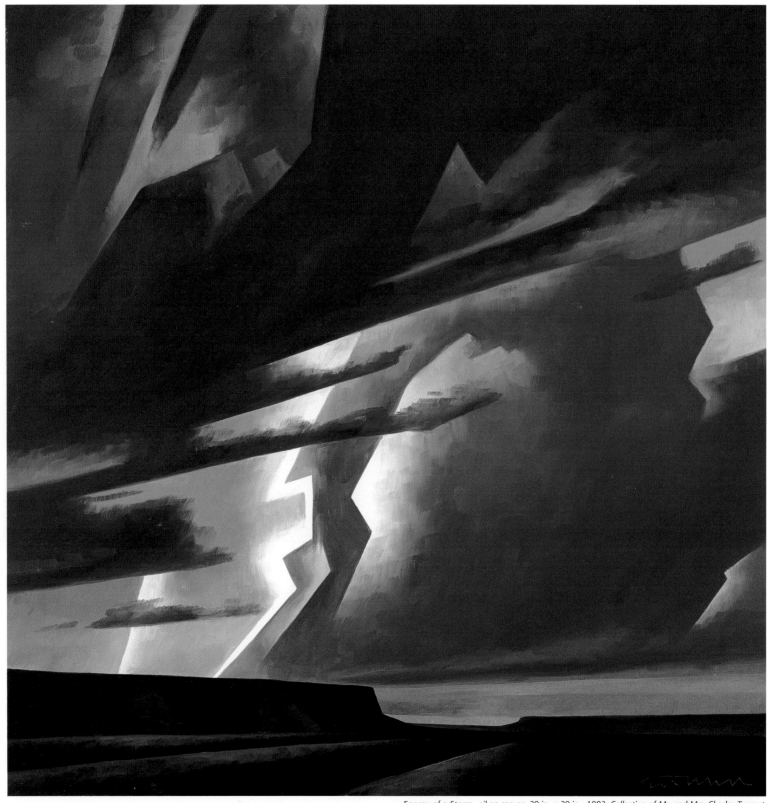

Energy of a Storm, oil on canvas, 20 in. x 20 in., 1993. Collection of Mr. and Mrs. Charles Taggart.

Grand Canyon Blanket, *wool, 80 in. x 64 in., 1996. From the Pendleton Woolen Mills Signature Series.*

The Grand Canyon has inspired another interpretation of Mell's art. Through his Dewey Trading Company in Santa Fe, Ray Dewey has worked closely with Pendleton Woolen Mills in the creation of limited edition blankets. Dewey asked Mell to design a blanket, part of Pendleton's Signature Series honoring people and places in the West, that would express the spirit of the Grand Canyon. Mell turned to a stylized abstraction when he created the design for the blanket. In the center are abstract forms that represent the topography of the canyon, while on each side are combinations of Native American designs and architectural themes used in the 1930s. A portion of the proceeds from the sale of the blanket are designated for the Grand Canyon Association and the Museum of Northern Arizona.

Attracted by Mell's ability to capture the visual significance of the Grand Canyon in his paintings, the Grand Canyon Chamber Music Festival approached him in 1985 with a request to reproduce a Grand Canyon painting as a poster for their September concerts, and which also would be used on other promotional literature. A nonprofit orginization, the Festival promotes traditional and contemporary chamber music through a concert series at Grand Canyon National Park and outreach programs at northern Arizona schools. Since 1985, festival organizers have used a Mell painting of the Grand Canyon as the image for their annual poster. In every Grand Canyon store, on both south and north rims, Mell's posters from various Grand Canyon Chamber Music Festivals are prominently displayed, and are purchased in large numbers by park visitors eager to take part of the canyon landscape home.

As the lines and color begin to emerge in an abstract landscape painting, Mell still has no idea how the final product will look. It is as if the paintings take over and dictate how they want to be fabricated. He distills and pares down until he finds the painting's essence, then that rawness must somehow be resolved into comprehensive color and form. Not until a painting is finished will he deem it a success. Sometimes the paintings will not be successful. While these abstract landscapes seem tangible realities, they are his innermost thoughts, his reflections made visible on canvas. He does not relate a particular scene or place, but instead responds to it. Yet his use of lines, color, and shapes still suggest landscapes to the point that we can interpret reality from the abstract. The paintings are of nowhere in particular, yet anywhere on the Colorado Plateau.

He invents reality, and makes us, as viewers, see the reality better. — *Bill Schenck*

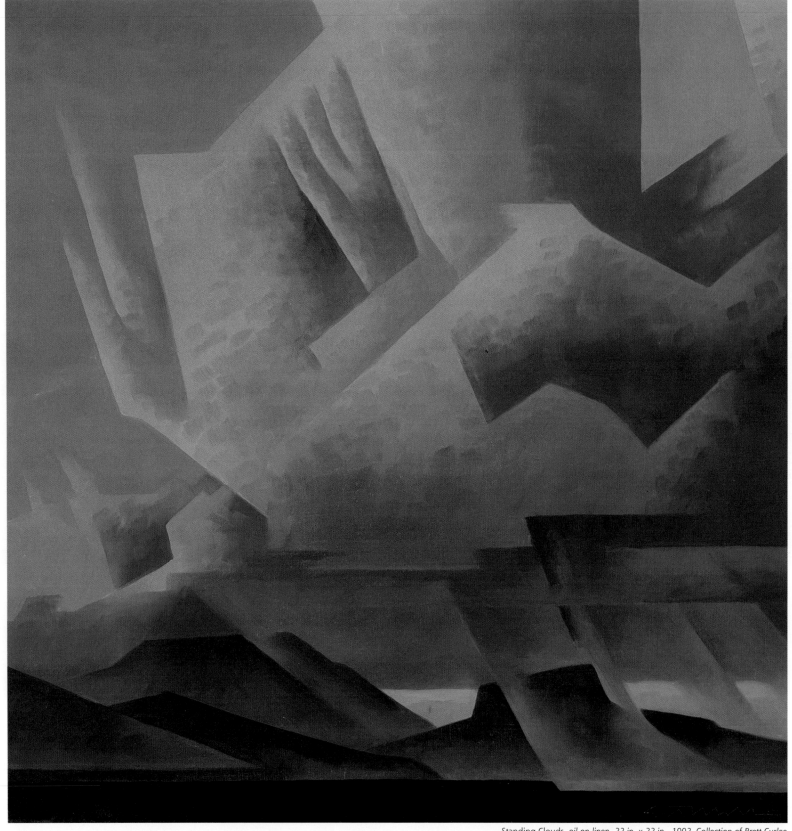

Standing Clouds, *oil on linen, 22 in. x 22 in., 1992. Collection of Brett Curlee.*

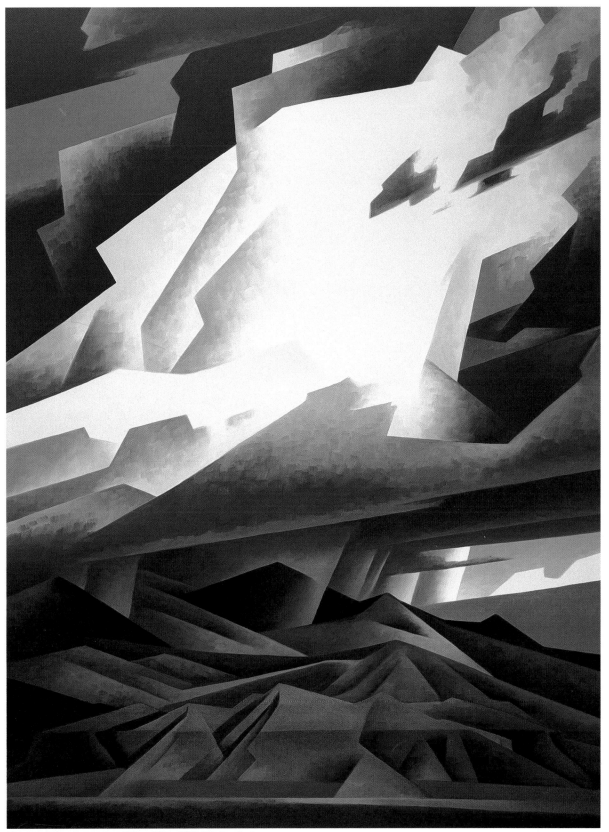

Mountain Rain, *oil on canvas, 40 in. x 30 in., 1995. Private collection.*

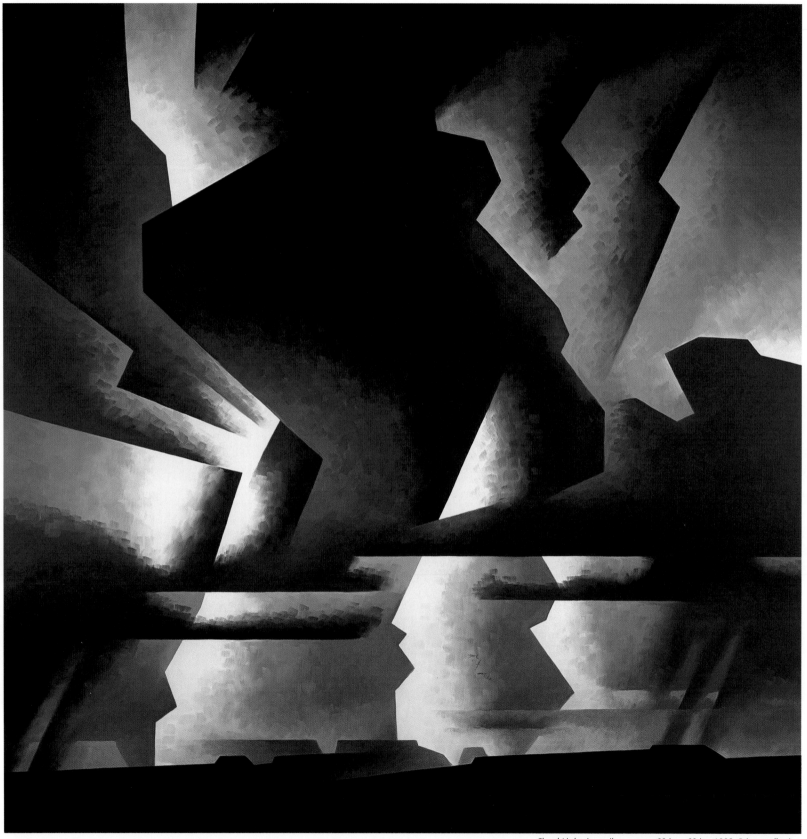

Cloud Lightning, *oil on canvas, 60 in. x 60 in., 1992. Private collection.*

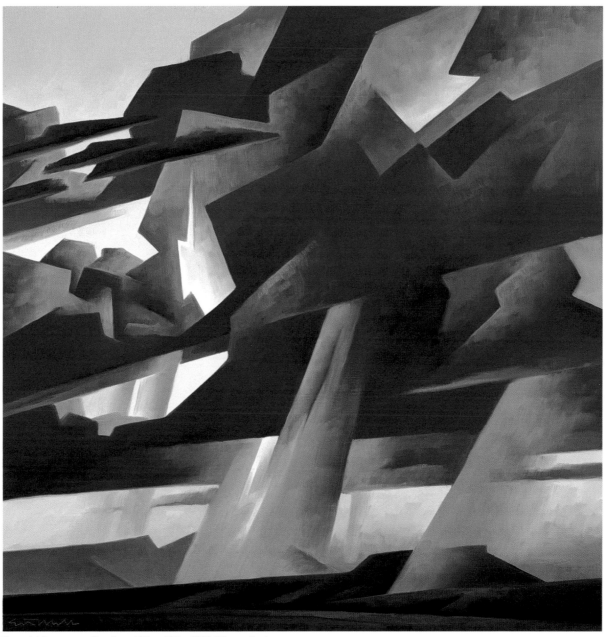

Torrential Downpour, *oil on linen, 20 in. x 20 in., 1996. Private collection.*

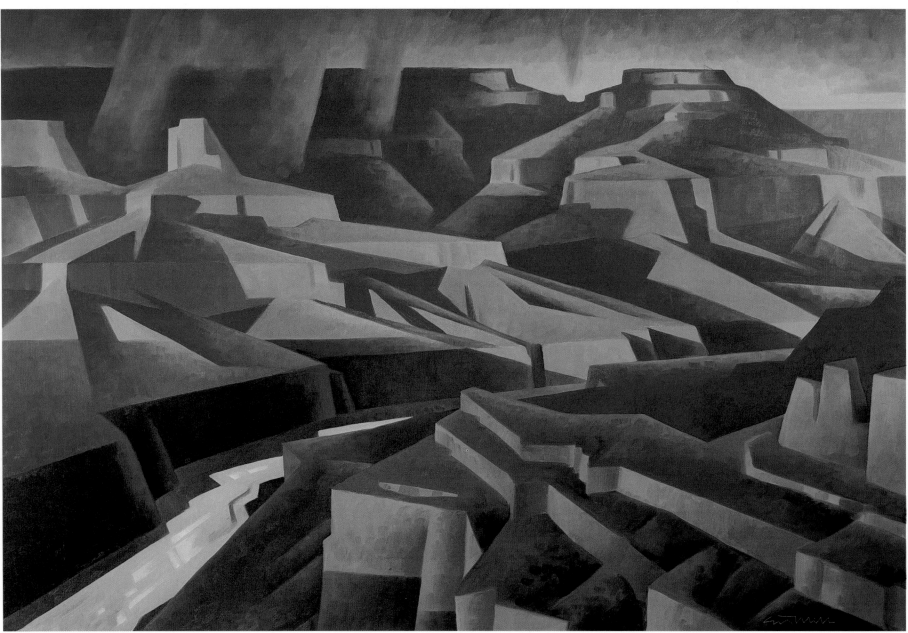

Rolling River, Grand Canyon, *oil on canvas, 24 in. x 36 in., 1994. Private collection.*

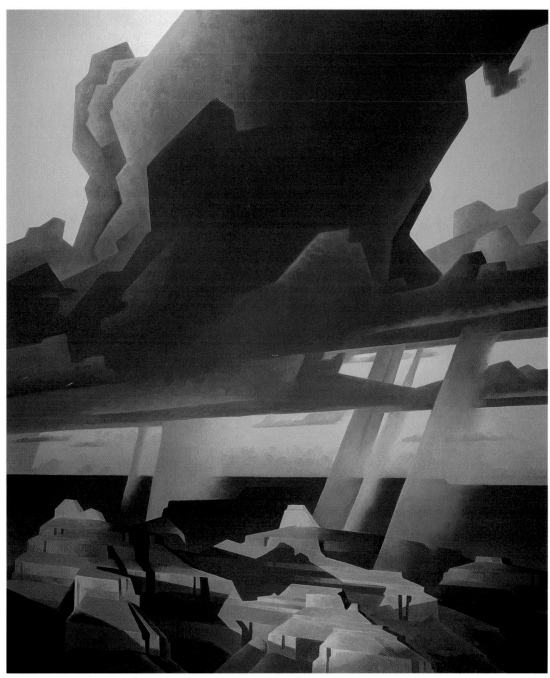

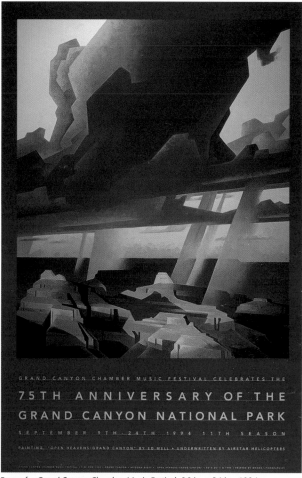

Poster for Grand Canyon Chamber Music Festival, 36 in. x 24 in., 1994.

Open Heavens, Grand Canyon, *oil on canvas, 48 in. x 40 in., 1995. Private collection.*

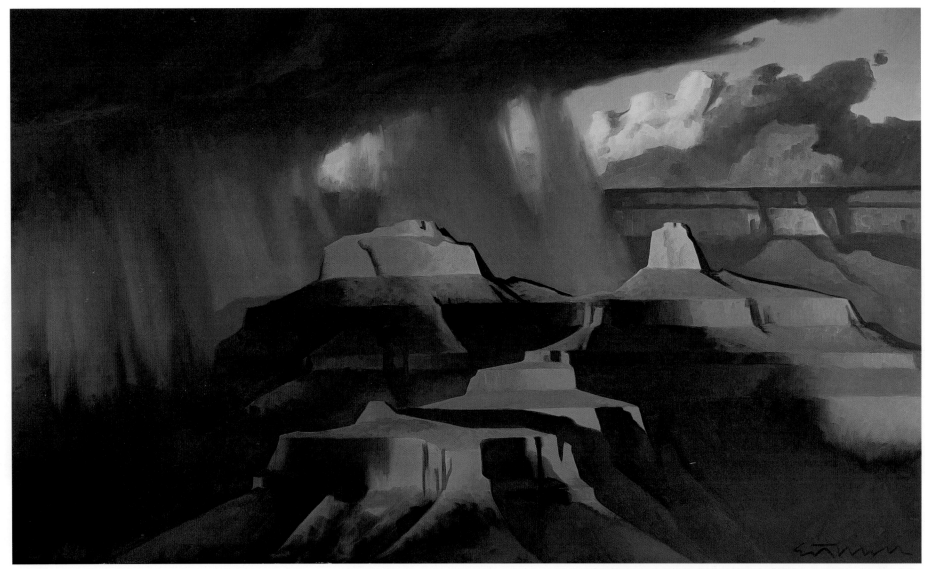

Canyon Rain, oil on canvas, 36 in. x 60 in., 1991. Collection of John and Carrie Hedberg.

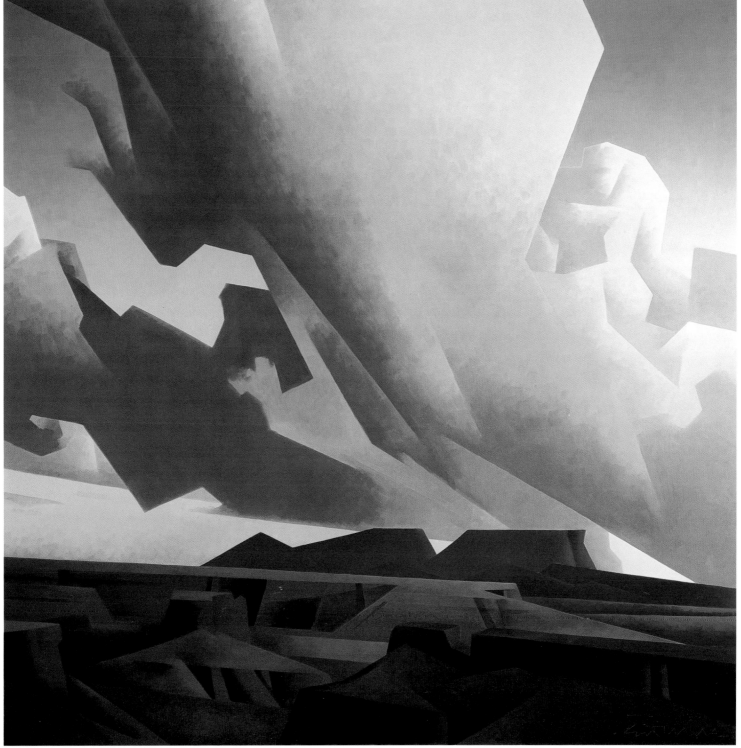

Rising Storm, *oil on canvas, 60 in. x 60 in., 1995. Collection of Mr. and Mrs. Bruce James.*

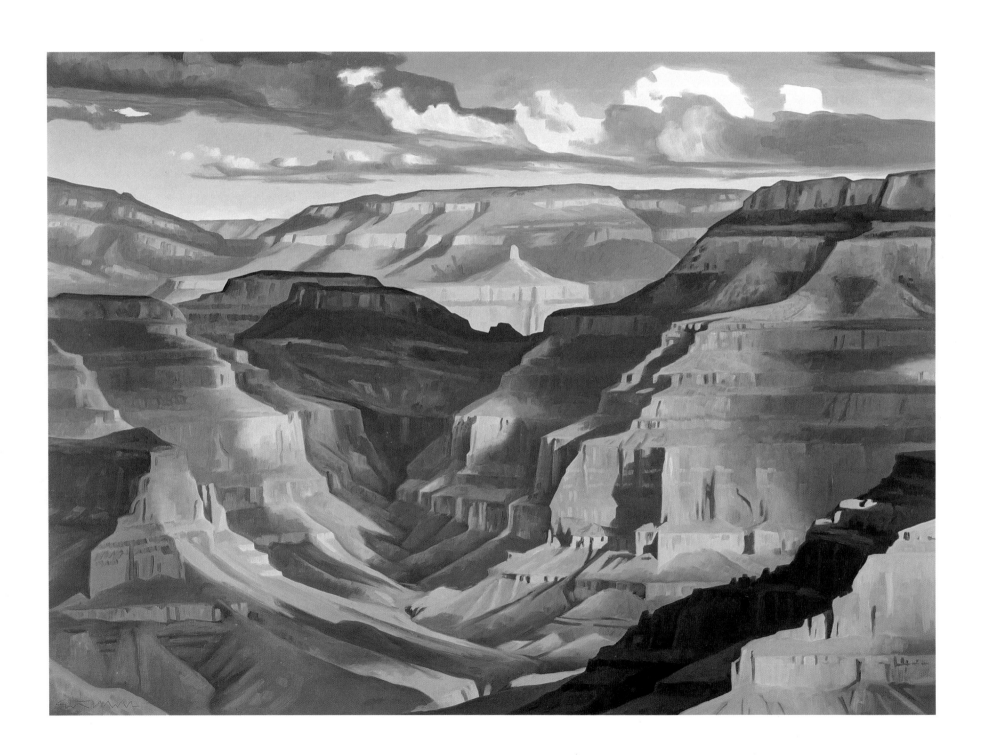

Opposite: Canyon Ridge, Grand Canyon, oil on canvas, 26 in. x 36 in., 1993. Private collection.

The paintings of Ed Mell symbolize the Colorado Plateau's sense of aloneness, its wildness and solitude. Unlike many contemporary painters working in various forms of realism, Mell does not emphasize the relationship of man to the land. No human presence intrudes upon his art, yet the human spirit reverberates in his work. We raise questions, imagine, ponder, or reflect on what we see because of his intuitive, personal response to the objective world of the plateau. His paintings are metaphors, not only for the plateau's landscapes, but for his experiences and emotions.

Mell, of course, does not pursue the search for a pristine wilderness experience. He much prefers the cosmopolitan environment of Phoenix and Scottsdale: four-star restaurants, the pulse of a fine automobile, Phoenix Suns basketball games, and the company of close friends and family. From time to time, whenever his busy painting schedule permits, he escapes to a small house he built in Prescott.

Occasionally Mell's strong work ethic is derailed, when he is ensnared by "that long black feeling" as a personal crisis surfaces. One occurred in March of 1995, when he and his wife Gail decided that a divorce would be in their mutual interests. Gail, who had obtained a degree in nursing from Arizona State University in 1989, worked as a school nurse for a number of years, then started an advanced degree program in community health and family nursing. By 1995, they felt both their marriage and their careers had drifted apart. That month, Mell's younger brother, Lee, unexpectedly died. For several months, the studio remained empty and quiet. Finally, Mell's disciplined work habits displaced the melancholy and brought him back to painting.

Mell's approach to his art is determined by a singular vision, one that demands he take a step back from the earth. Other painters attracted by the Southwest's grandeur and beauty have painted onsite in the plein-aire method. They touch the earth, feel close to it, and experience the sand and rock under their feet firsthand. In contrast, Mell's vision is distant, aloof, and, on the surface, dispassionate. His idea of adventure in the plateau's outback is dictated by where the motels are, not where he can throw down a sleeping bag.

"I still prefer the controlled environment I have in the studio compared to the outdoors, because it is better for the lighting," Mell explains. "You have glare out there, and the harsh realities of wind and sand, for example, which interfere with the development of a painting."

Yet when Mell reviews the slides from one of his helicopter trips and starts a painting, the memories of what he has seen wash over him, and he is transported into his own personal realm of imagination. He sees the spirit of the plateau's landscapes not as isolated fragments, but as a wide-angle encompassing view, a faraway uni-

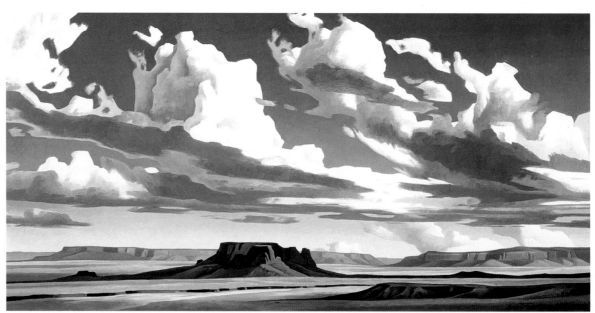

Open Desert Near Ganado, *oil on canvas, 30 in. x 60 in., 1993.*
Collection of Marnie L. MacDonald and James Sommercorn.

verse. He wants to see what lies beyond the horizon, to discover what exists behind a mesa or butte. So he has, through the magic of the helicopter's birds-eye view.

Part of what makes Mell's landscape paintings provocative is their sense of distance. In works like *Arroyo*, which is a composite of scenes he encountered near Moab, Utah, and *Open Desert Near Ganado*, he has transcribed on canvas views that march to and recede over the horizon. Look at the cloud in his painting, *Arroyo*, the faraway one near the bottom left of the canvas, located at the inter- section of the land and the horizon. Mell's eye on the horizon sees the curvature of the earth, as the cloud appears like a great sailing vessel, ready to drop over the earth's rim and disappear from sight.

A large portion of the Navajo Reservation southwest of Hubbell Trading Post at Ganado is a lonesome, open terrain. From the vantage point of the helicopter, Mell's interpretation of the Navajo landscape in *Open Desert Near Ganado* expands the sensations of both space and distance. Formations in the painting's foreground are a visual incitement for the measureless view beyond them, as Mell searches for infinity on the far horizon. Or maybe it is over the next rise.

Silence is as much a component of his landscape art as are distance and the earth's forms. Part of the Colorado Plateau's attraction for Mell is the sense of an unmanipulated landscape. Many of his paintings, such as *Sunset, Painted Desert* (page 154), and *Morning Light on Meeks Mesa* (foldout), done near Capital Reef in Utah, convey a mood in the flash of the eye, as you see an image that rings true.

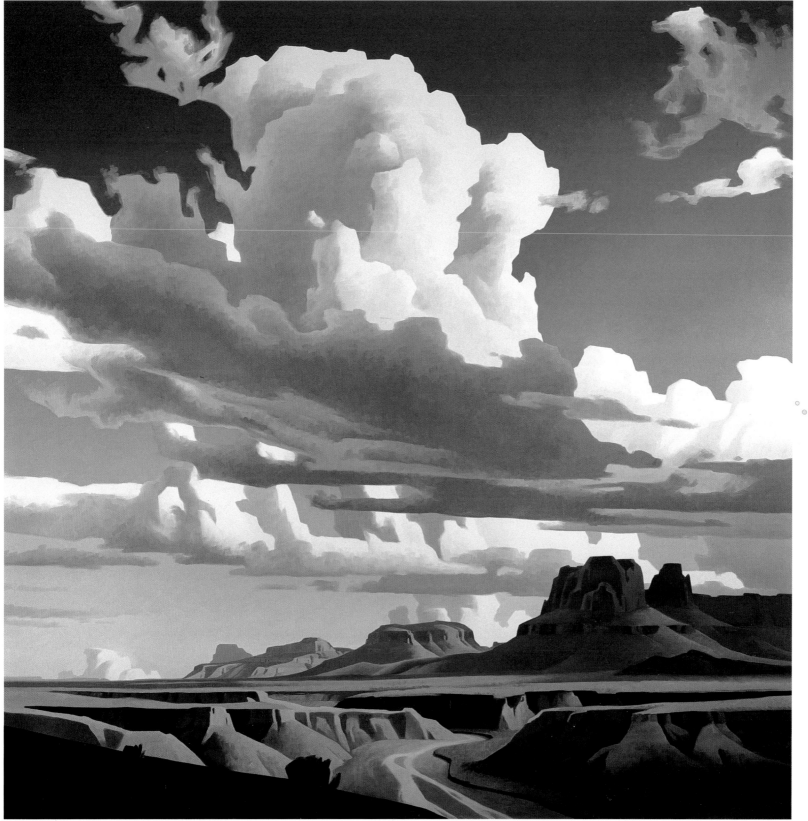

Arroyo, oil on canvas, 60 in. x 60 in., 1994. Private collection.

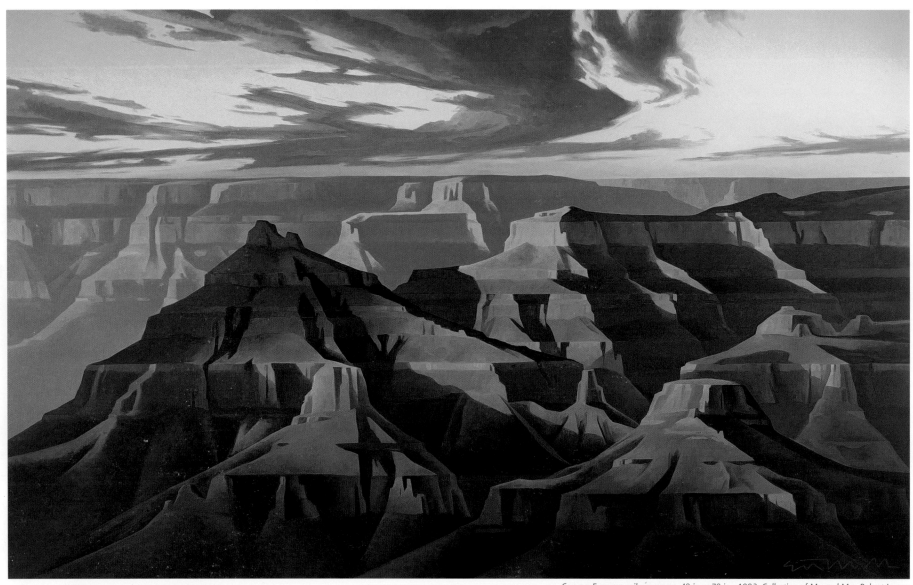

Canyon Expanse, oil on canvas, 48 in. x 78 in., 1992. Collection of Mr. and Mrs. Robert Logan.

While the starting point is nature for Mell, his work is more expressive, even cinematic, with a cautious emphasis on naturalistic interpretation. From what he has seen, from what he remembers, and from what he invents, Mell captures the poetry of a moment in his paintings and makes it stick. Within those categories, he disassembles then reassembles pieces of the landscape—or for that matter, a flower or a longhorn steer—into a formal simplicity that is instantly recognized as his. Although his cowboy and longhorn paintings are done with an eye for humor and nostalgia, their angular, heroic, and often monumental shapes helped Mell see his landscapes with greater clarity and with renewed enthusiasm.

The paintings of Ed Mell are not real—that is, they are not transcriptions of a particular place, although some titles may indicate a precise location or the name of a specific flower—yet they are believ-

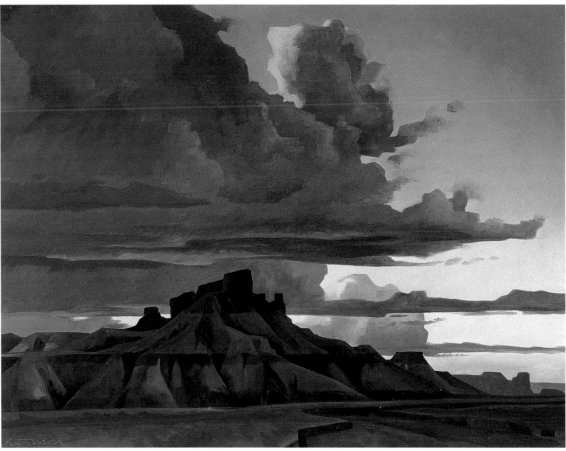

Sunset, Painted Desert, oil on linen, 18 in. x 24 in., 1990. Private collection.

able. They venture beyond strict replication of reality into the realm of imagination. There are no extraneous details, and every form on a canvas is honed down to essential color and shape. His signature on a painting has become the style that pervades it. As he rides the line between literal and non-literal representation, realism and abstraction, his art opens new visual impressions, and serves as an equivalent for the theatrical space that is the Colorado Plateau and the confidential universe of flowers. He perceives different worlds of far, lonely places, with their endless distance, and of things close at hand.

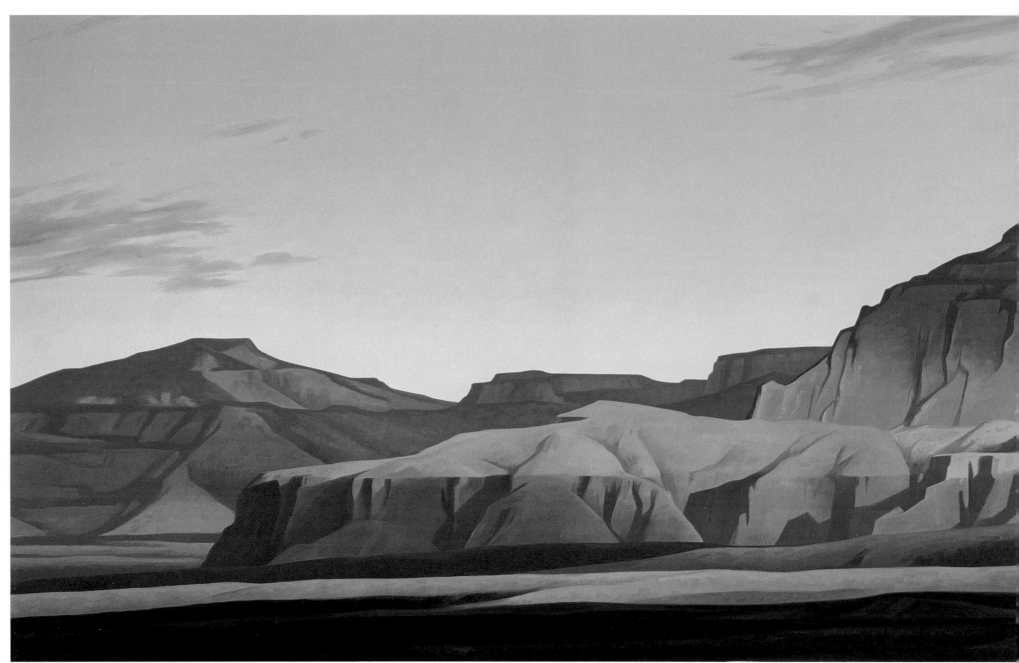

Morning Light on Meeks Mesa, *oil on canvas, 30 in. x 96 in., 1996. Collection of Latham Companies.*

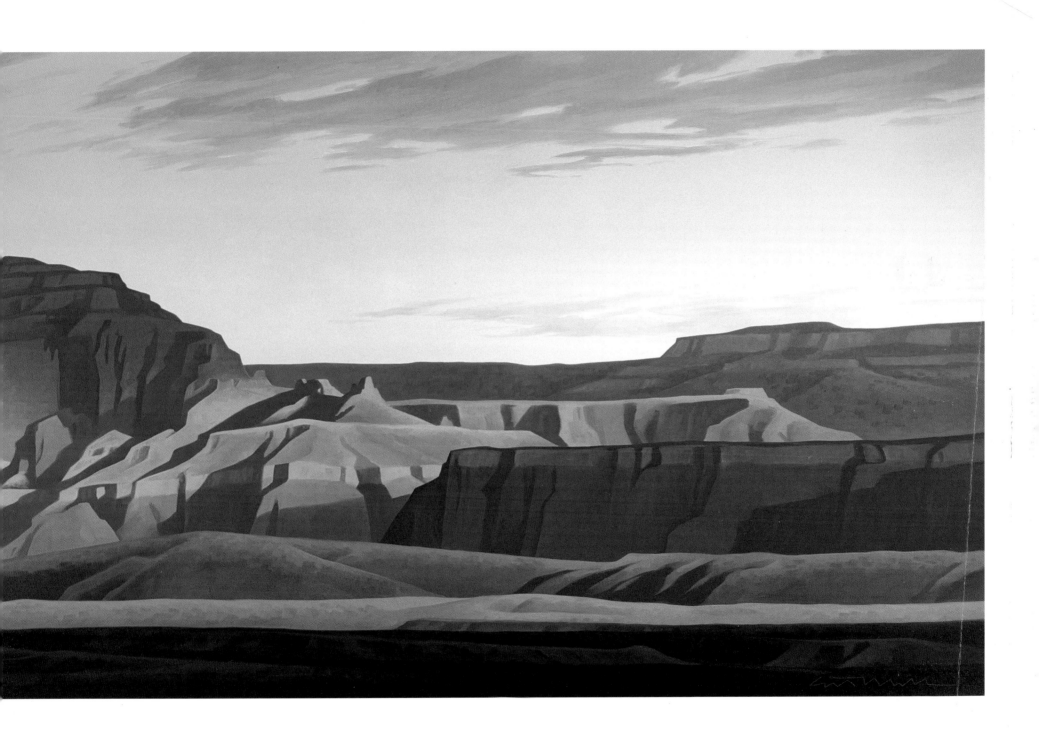

The landscapes are still, the motion of clouds arrested. Mell's vision has become a conduit as he intensifies the feel of silence, articulated by the slowly fading evening light or by the first flush of morning. Tranquillity is the dominant feature, as the light just before dusk or from the impact of an emerging sun endows the landscape with a stillness unbroken by sound. While he denies any spiritual overtones in his works, perhaps *chindi*, the Navajo term for spirits or apparitions, is manifest in these quiet paintings.

If distance and silence are part of Mell's personal painting vocabulary, then so is monumentality, which can be found in examples like *Canyon Expanse*. The painter John Marin once declared that the true artist must go from time to time to the elemental big forms that recharge the battery. For Mell these heroic forms are the large-scale, dramatic expressions of the plateau's shining spaces and natural architecture.

Within this country are mesas, buttes, spires, pinnacles, alcoves, arches, plateaus, and oxbows, not to mention hoodoos, goblins, fins, needles, and joints. The land is a diverse, immense, magical cacophony of topography joined together by colored sandstone. As is the case for all landscape painting, the views Mell chooses for inclusion in his paintings are fragments, for he knows landscapes extend beyond the frame of the canvas. However, through his perception of imagined landscapes rather than actual ones, and through his skill, Mell is able to suggest limitless space in his work by the use of imaginative designs and a selective eye. His landscapes, with their nearly stripped-to-the bone design, make little attempt to detract the eye with realistic detail.

Mell finds the plateau's landscapes attack the senses, the inanimate earth animated by the constant changes of intense, variable light. In response, he has become a painter of light, as much as a recorder of the dialogue between form and color, with many of his canvases devoted to the expansiveness of light from sky and clouds. He has, through accumulated skill and experiences, acquired an instinct for managing an accurate and delicate balance of natural light and color. The colors on his canvases are clear in distinct shadows, and iridescent in areas drenched by light.

If you ask Ed Mell to describe or analyze or articulate some personal, philosophical statement about his art, he cannot. He does not possess or endorse any high-minded evangelism or rhetoric in regard to his art. He might readily confess that not all of his art is a success in his mind. Realism in art to him is the process or the act of description in paint, but Mell's landscape painting is the result of remembered and subjective experiences, not observed, tightly described ones. As such, they are filtered through a combination of memories, intuition, technical skill, and the process of painting.

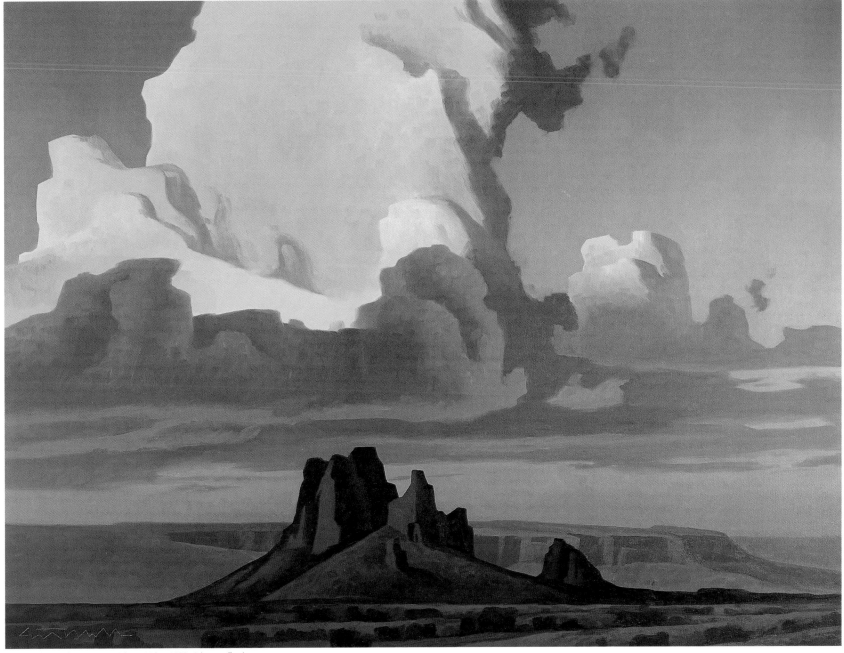

Stilled Vulcan, *oil on canvas, 30 in. x 40 in., 1993. Private collection.*

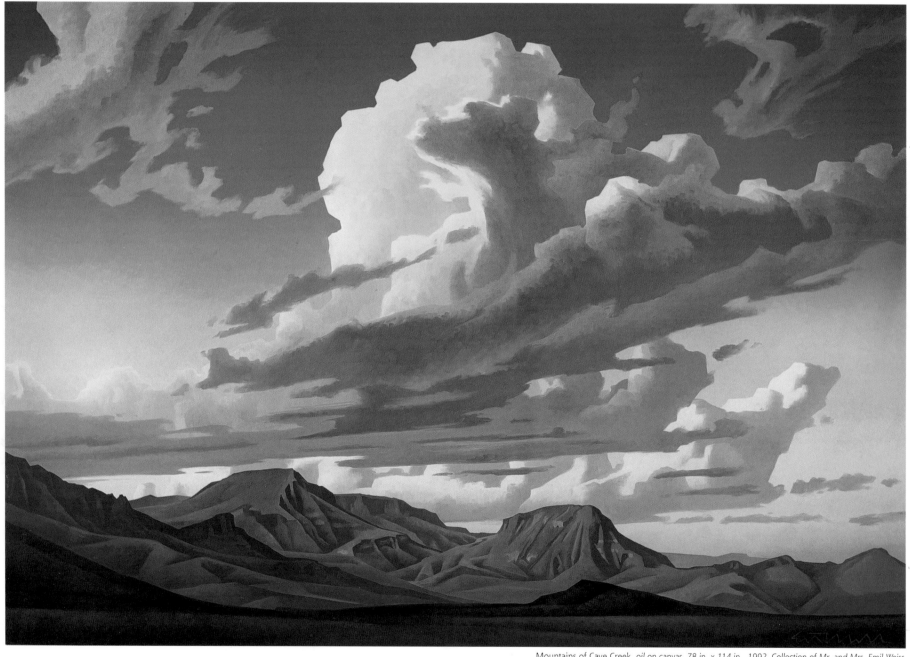

Mountains of Cave Creek, oil on canvas, 78 in. x 114 in., 1992. Collection of Mr. and Mrs. Emil Weiss.

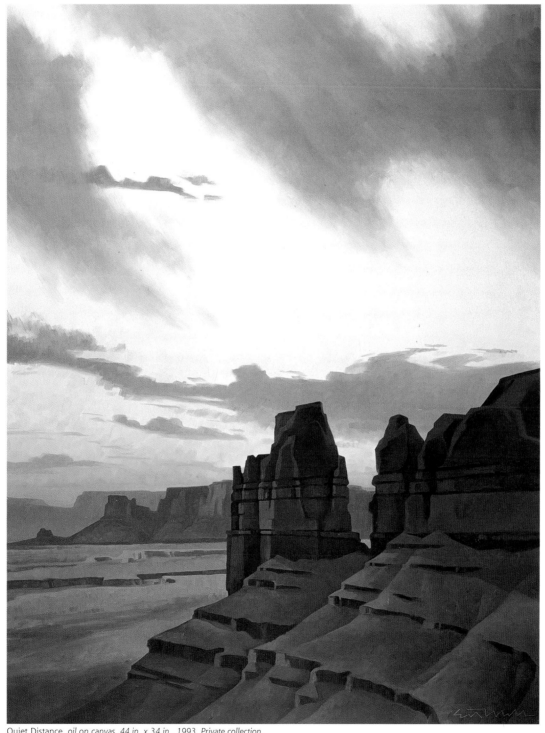

Quiet Distance, *oil on canvas, 44 in. x 34 in., 1993. Private collection.*

works held

Corporate Collections

Arbys, Phoenix, Arizona

Atlantic-Richfield Corporation, Los Angeles, California

Brown and Bain, Phoenix, Arizona

Camelback Executive Park, Scottsdale, Arizona

Century 21, Phoenix, Arizona

Discount Tire Company, Scottsdale, Arizona

Empire Bank, Denver, Colorado

Fannin Bank, Houston, Texas

The Federated Group, Phoenix, Arizona

Gammage and Burnham, Phoenix, Arizona

Greengard and Finley, Phoenix, Arizona

Latham Companies, Scottsdale, Arizona

Loew's Ventana Canyon Resort, Tucson, Arizona

Mary Kay Cosmetics, Dallas, Texas

Milestone Petroleum, Englewood, Colorado

Mountain Bell, Denver, Colorado

Palo Verde Laboratories, Phoenix, Arizona

Richardson Savings and Loan, Richardson, Texas

Rickard Collection, Brookfield, Connecticut

SamCor, Phoenix, Arizona

Sills, Cummis, Attorneys, Newark, New Jersey

Syntex Corporation, Phoenix, Arizona

Texas Commerce Bank, Middleton, Texas

Tri-Star Pictures, Hollywood, California

Valley National Bank of Arizona, Phoenix, Arizona

Western Savings, Phoenix, Arizona

Public Collections

City of Glendale, Glendale, Arizona

City of Scottsdale, Scottsdale, Arizona

Fruitlands Museum, Harvard, Massachusetts

Office of the Governor, Phoenix, Arizona

Phoenix Art Museum, Phoenix, Arizona

Scottsdale Center for the Arts, Scottsdale, Arizona

Supreme Court Building, Phoenix, Arizona

Private Collections

Sandy Alderson, Oakland, California

Mr. and Mrs. Bruce Babbitt, Washington, DC

Craig and Barbara Barrett, Phoenix, Arizona

Mr. and Mrs. Edward Beauvais, Phoenix, Arizona

William Benner and Patrick Maas, Paradise Valley, Arizona

Mr. and Mrs. William C. Blackstone, Flagstaff, Arizona

Erma Bombeck, Scottsdale, Arizona

Richard B. Burnham, Phoenix, Arizona

Mary Case, New York, New York

Mr. and Mrs. Morris W. Cohn, Phoenix, Arizona

Bill and Marian Cook, Scottsdale, Arizona

Mr. and Mrs. Joseph Coors, Golden, Colorado

Jon and Rita Cordalis, Durango, Colorado

Mr. and Mrs. Robert Diamond, Scarsdale, New York

Mr. and Mrs. Charles Dirsch, Phoenix, Arizona

Max Fluckinger, Switzerland

William Franke, Phoenix, Arizona

Jerry and Vicki Foster, Phoenix, Arizona

Mr. and Mrs. Abraham Friedman, Paradise Valley, Arizona

Mr. and Mrs. Stephan Gebert, Paradise Valley, Arizona

Senator Barry Goldwater, Paradise Valley, Arizona

John and Carrie Hedberg, Phoenix, Arizona

Susan Howard, Los Angeles, California

Mr. and Mrs. Stan Hurt, Indianapolis, Indiana

Mr. and Mrs. Lloyd Isler, Paradise Valley, Arizona

Edward Jacobson, Phoenix, Arizona

Mr. and Mrs. Bruce James, Scottsdale, Arizona

Stephane Janssen, Scottsdale, Arizona

Dr. and Mrs. Frederick N. Jensen, Phoenix, Arizona

Mr. and Mrs. James Jundt, Wayzata, Minnesota

David and Kim Knotter, Phoenix, Arizona

Dr. and Mrs. Vladimir Kovacevic, Bayside, Wisconsin

Jerry Littman, New York, New York

Mr. and Mrs. Robert Logan, Phoenix, Arizona

Marnie L. MacDonald and James Sommercorn, Livermore, California

Bruce and Leslie Male, Andover, Massachusetts
Edward J. Martori, Phoenix, Arizona
Mr. and Mrs. Jerold Miles, Fountain Hills, Arizona
Mr. and Mrs. Jerry Moyes, Glendale, Arizona
Royal and Nancy Norman, Phoenix, Arizona
Dr. and Mrs. Russell Ohta, Phoenix, Arizona
Van and Debbie O'Steen, Phoenix, Arizona
Mr. and Mrs. John O'Toole, Washington, DC
Roy and Marilyn Papp, Phoenix, Arizona
Donald Roelke, Phoenix, Arizona
Steve and Mitzi Schoninger, Phoenix, Arizona
Arnold Schwarzenegger, Los Angeles, California
Daniel and Linda Sharaby, Phoenix, Arizona
Linda and David Sheppard, Phoenix, Arizona
Mark and Charlene J. Shoen, Sunflower, Arizona
Mr. and Mrs. Irwin Smith, Greenwich, Connecticut
William and Becky Smith, Scottsdale, Arizona
Dr. and Mrs. Robert Sundahl, Phoenix, Arizona
Faith Sussman and Richard Corton, Cave Creek, Arizona
Dr. and Mrs. Charles Taggart, Scottsdale, Arizona
Robert Urich, Los Angeles, California
Patti Valdez and Michael Collier, Phoenix, Arizona
Veloy Vigil, Taos, New Mexico
Mr. and Mrs. Emil Weiss, Carefree, Arizona
Mr. and Mrs. John Winandy, Scottsdale, Arizona
Al Wolfe, Chicago, Illinois
Elizabeth Young, Midland, Texas

exhibition record

1975
Four Corners Biennial, Phoenix Art Museum, Phoenix, Arizona
One-person exhibition, Limner Gallery, Scottsdale, Arizona

1978
One-person exhibition, Elizabeth C. Burns Gallery, Scottsdale, Arizona

1979
One-person exhibition, Marilyn Butler Gallery, Scottsdale, Arizona

1981
One-person exhibition, Harris Gallery, Houston, Texas
One-person exhibition, Marilyn Butler Gallery, Scottsdale, Arizona
Group Show, *Cowboys: The New Look*, Marilyn Butler Gallery, Scottsdale, Arizona

1982
One-person exhibition, Suzanne Brown Gallery, Scottsdale, Arizona
One-person exhibition, Art Resources Gallery, Denver, Colorado
Group show, *Artists of Arizona*, Center of Modern Art, Guadalajara, Mexico
Group show, *Arizona Invitational*, Scottsdale Center for the Arts, Scottsdale, Arizona

1983
One-person exhibition, Long Beach Museum of Art, Long Beach, California
One-person exhibition, Dewey-Kofron Gallery, Santa Fe, New Mexico

1984
One-person exhibition, Nicoaysen Art Museum, Casper, Wyoming
One-person exhibition, Harris Gallery, Houston, Texas
One-person exhibition, Dewey-Kofron Gallery, Santa Fe, New Mexico
One-person exhibition, Suzanne Brown Gallery, Scottsdale, Arizona

1985
One-person exhibition, Suzanne Brown Gallery, Scottsdale, Arizona
Group show, *Past and Present: Images of the Southwest by Maynard Dixon and Ed Mell*, Dewey Galleries, Santa Fe, New Mexico

1986
One-person exhibition, Suzanne Brown Gallery, Scottsdale, Arizona

1987
Group show, Suzanne Brown Gallery, Scottsdale, Arizona

Group show, *Capturing the Canyon: Artists and the Grand Canyon*, Mesa Southwest Museum, Mesa, Arizona
Group show, *Boundless Realism: Contemporary Western Landscape Painting*, Rockwell-Corning Museum, Corning, New York

1988
One-person exhibition, Suzanne Brown Gallery, Scottsdale, Arizona
Group show, *The Wild, Wild West*, Dewey Galleries, Santa Fe, New Mexico

1989
Group show, *The Wild, Wild West*, Dewey Galleries, Santa Fe, New Mexico
One-person exhibition, Suzanne Brown Gallery, Scottsdale, Arizona

1990
One-person exhibition, *The Art of Ed Mell*, Scottsdale Center for the Arts, Scottsdale, Arizona
One-person exhibition, Dewey Galleries, Santa Fe, New Mexico
One-person exhibition, Suzanne Brown Gallery, Scottsdale, Arizona
Group show, *New Artists of the American West*, Eiteljorg Museum of American Indian and Western Art, Indianapolis, Indiana

1991
One-person exhibition, Suzanne Brown Gallery, Scottsdale, Arizona

1992
One-person exhibition, Suzanne Brown Gallery, Scottsdale, Arizona

1993
One-person exhibition, Suzanne Brown Gallery, Scottsdale, Arizona

1994
One-person exhibition, Suzanne Brown Gallery, Scottsdale, Arizona

1995
One-person exhibition, *Ed Mell: Paintings of the Colorado Plateau*, Kolb Studio, Grand Canyon National Park, Arizona
One-person exhibition, Suzanne Brown Gallery, Scottsdale, Arizona

1996
One-person exhibition, Suzanne Brown Gallery, Scottsdale, Arizona
One-person exhibition, *Beyond the Visible Terrain: The Art of Ed Mell*, Scottsdale Center for the Arts, Scottsdale, Arizona

Cather, Willa. *Death Comes For the Archbishop*. New York: Alfred A. Knopf, 1925, 96.

Cortwright, Barbara. "The Bones of Nature." *Southwest Profile*. (March 1990): 27–30.

Hagerty, Donald J. *Past and Present: Images of the Southwest by Maynard Dixon and Ed Mell*. Santa Fe, NM: Dewey Galleries, 1985.

———. "Reflection Made Visible: The Art of Ed Mell." *Arizona Highways* (July 1985): 40–45.

McGarry, Susan Hallsten. "Mesas Made Visible." *Southwest Art* (September 1982): 50–57.

Nilsen, Richard. "Clouds Catch Artist's Eyes." *The Arizona Republic* (July 26, 1992).

Nordling, Karl. "Simplifying Nature's Complexities." *Arizona Arts and Travel* (November/December 1984): 15–18.

Walker, Kathleen. "The Mell Style." *Southwest Profile* (January 1987): 21–24.

In addition to the above published material, in preparing this text the author referred to interviews conducted with the following individuals: Bob Boze Bell, Suzanne Brown, Michael Collier, Jon Cordalis, Linda Corderman, Ray Dewey, Jerry Foster, Troy Irvine, Vernon Masayesva, Ed Mell, Edmund Mell Sr., Gertrude Mell, Royal Norman, Nat Owings, Gail Petersen, and Bill Schenck.

index

Page numbers in *italics* refer to photographs and artwork.

V P Studios

Donald J. Hagerty recently retired from the University of California, Davis, after twenty-two years as a faculty member. Since 1981, he has also been a research associate in anthropology at the California Academy of Sciences in San Francisco. He now works as an independent scholar and consultant on the art and culture of the American West.

In 1981, Hagerty organized the first important exhibition on Maynard Dixon, *Images of the Native American*, held at the California Academy of Sciences. His biography of Dixon, *Desert Dreams: The Art and Life of Maynard Dixon*, was published in 1993 by Gibbs Smith. In conjunction with the book, Hagerty served as guest curator for a major retrospective exhibition of Dixon's work, also called *Desert Dreams*, which originated at the Museum of New Mexico in Santa Fe and traveled to six other museums.

Hagerty has written on art and artists for *Arizona Highways, Southwest Art, Pacific Historian, El Palacio, Russell's West, Art of California, American Art Review, Crosswinds*, and the Book Club of California. In addition, he has given numerous lectures for museums and other institutions. His most recent book, *Canyon de Chelly: One Hundred Years of Painting and Photography* was published by Gibbs Smith in 1996.

Don Hagerty lives in Davis, California, with his wife and two children.